W9-AUO-343

ERIC HOSKING'S
C L A S S I C
BIRDS
60 Years of Bird Photography

Notes by Eric Hosking and Jim Flegg

Text by Jim Flegg and David Hosking

HarperCollins*Publishers*

HarperCollins*Publishers*
London . Glasgow . New York . Sydney . Auckland . Toronto . Johannesburg
First Edition 1993

©Eric Hosking, David Hosking and Jim Flegg, 1993

The authors assert their moral right to be identified as the authors of this work
All rights reserved

ISBN 0 00 219975 0

Printed and bound in Italy by Amilcare Pizzi Spa, Milan

CONTENTS

FOREWORD

It is an honour to write a foreword to a collection of Eric Hosking's matchless bird photographs – in this artform he will reign supreme for all time.

Pioneers in the field, Oliver Pike and W. Bickerton, who were promoted and encouraged by my father Charles Rothschild at the turn of the century, took pictures mainly for ornithologists. Eric Hosking brought birds into all our lives. He opened our eyes to the beauty of their world, their grace and fascination. He probably achieved more for avian conservation than any other naturalist of our day.

Time rolls on, and cameras and equipment are perfected, and techniques such as the electronic flash and the zoom lens now make photography a relatively simple matter. Eric Hosking, however, had an eye which gave him a relationship with nature far outdistancing a brilliant and accurate record of bird life. For all of us his camera distilled the poetic essence of wings.

Miriam Rothschild

INTRODUCTION

BY DAVID HOSKING

For over sixty years Eric Hosking enjoyed a long and distinguished career as one of the world's best loved and most respected wildlife photographers. The breath-taking quality of his images, his obvious love for his subjects and his boundless enthusiasm inspired three generations of young naturalists to look more closely at the world around them. Some went on to pursue careers in natural history, some bought cameras and began to take their own photographs, some developed a passion for the wonders of nature. How many of us, I wonder, can pin-point the origin of our fascination with birds or animals to a chance encounter with a book, photograph, television programme or lecture by Eric Hosking. The deep wave of popular concern for the living world owes much to the sheer visual impact of his work.

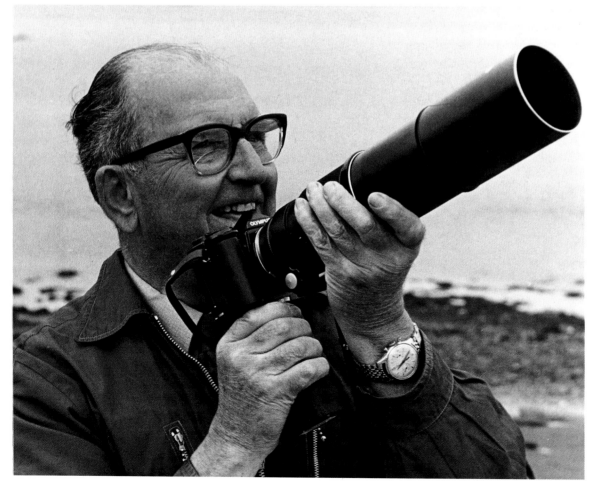

In 1935 my father, already six years into his career, became a member of the Zoological Photographic Club (ZPC) and, once a month for the rest of his life, he submitted his work to the critical scrutiny of his colleagues in that society. Founded in 1899, the ZPC has, at one time or another, numbered most of Britain's most eminent wildlife photographers amongst its members. This selection of Eric's classic black and white photographs and the captions which accompany them, have been compiled from his ZPC contributions over more than fifty years. Eric's detailed notes offer a fascinating glimpse into a period of photographic history which is sometimes forgotten by modern enthusiasts.

The Eric Hosking Trust has been established to commemorate my father's life and work in a more practical manner. Its stated aim will be to sponsor ornithological research through the media of photography, art and writing. Thanks to the generosity of HarperCollins*Publishers*, the proceeds from the limited edition of the book will be used to foster the work of the Trust. Professor Richard Chandler, Dr Jim Flegg, Robert Gillmor, Edward Keeble, Derek Moore, Dr Tim Sharrock, Martin Withers, and Paul Williams have all kindly agreed to become its Trustees. My father would have been delighted that the Trust is focused on three of his great interests: photography, wildlife art and ornithological writing.

Many people have helped with the production of this book and the development of the Eric Hosking Trust, but I would like to offer particular thanks to all of the following: my brother Robin who first suggested the idea; Myles Archibald at HarperCollins who made the book a practical possibility, and Jim Flegg, a friend of my father, who produced the text and edited the captions most skilfully. I am also indebted to John Tinning for help with the manuscript and to Harold Hems and Jeff Martin for technical advice. My wife, Jean, and my mother have been generous with their support and advice throughout both projects.

AN UNLIKELY CAREER

Hosking, you'll never make anything of your life.' These were the words, spoken by the Headmaster of the Stationers' Company School in Hornsey, London, that echoed in the ears of the 15 year-old Eric Hosking as he left to face the world. Not an auspicious start, but perhaps not surprising, as Eric felt much the same about school as the school felt about him. His schooldays had not been plain sailing, marred by frequent absence due to illness - usually bronchitis. From the day of his birth, on 2nd October 1909, he was what his parents and grandparents would have described as a sickly child, and in the days after his birth there were doubts that the weak, skinny baby would survive at all - but survive he did, for another 81 years!

Though there were problems with schooling, Eric's childhood was far from troubled, and in other ways he flourished in a close-knit, hard-working family. His maternal grandparents lived in Kings Road, Chelsea, next door to the cinematographic pioneer William Friese-Greene, and two of his uncles were enthusiastically addicted to photography. No doubt some of this enthusiasm rubbed off on the young Eric, and, blended with his parents' enthusiasm for animals in general and London Zoo in particular, spurred the urge to own his own camera. This, a Kodak Box Brownie, then costing five shillings (translating to a modern 25p) was given to him by his parents when he was eight. His early photographic attempts with this very simple piece of optical equipment with its fixed focus, single aperture, poorly-ground lens and slow, simple shutter, were not very satisfactory, and he determined to improve on them. Good solid saving of pocket money and the small sums received for doing odd jobs allowed him, two years later, to buy (for 30 shillings - £1.50) his first wooden-made plate camera, taking 4 1/4in x 3 1/4in glass negatives. His father bought him the first box of a dozen plates to get under way. By this time he had the necessary developing and fixing dishes and chemicals to use in a make-shift dark room, but the first bird photograph of his long career was doomed to be a failure! The subject was a Song Thrush nest, but the excited photographer had forgotten the need to focus the lens. The plate that emerged from the hypo dish was simply a disappointing, misty blur.

At school, despite difficulties with the academic side of life, both natural history and photography were encouraged and flourished. At his primary school, he and other eight-year-olds formed a nature club, collecting and keeping all manner of creatures from earwigs

and slugs to toads - doubtless all classified as 'creepy-crawlies' by their horrified mothers when they discovered them lovingly concealed in boxes in the boys' bedrooms. At the Stationers' Company School, Eric joined not only the Natural History Society but the Photographic Society. Combining these interests, Eric helped an enthusiastic and (for his generation) unusually forward-looking teacher in his attempts to photograph a perch in the school aquarium. Maybe it was here, and under Dr Rost's guidance, that the inventiveness and attention to detail that characterised the rest of his career began to emerge. The two took great trouble to confine the perch behind a sheet of glass to minimise focussing problems, and were at pains to set the lamps lighting their subject in such a way that reflections did not mar the picture. A series of plates was exposed (Eric being allowed to press the shutter release for one of them) before the pair retreated to the darkroom to do the developing. But the plates were blank, all of them, because in error the hypo or fixing solution had been poured into the tanks before, not after, the developer, destroying the photographic images. Perhaps mistakes such as this, and failing to focus the lens, are inevitable among beginners, but they made a great impression on the young Eric, and were a formative influence in developing his meticulous attention to detail.

Stone Curlew, 1936

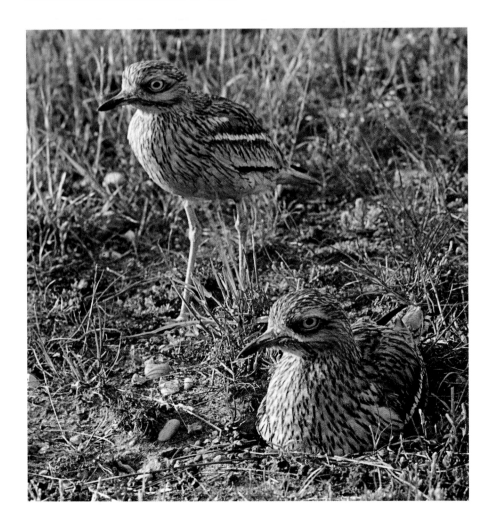

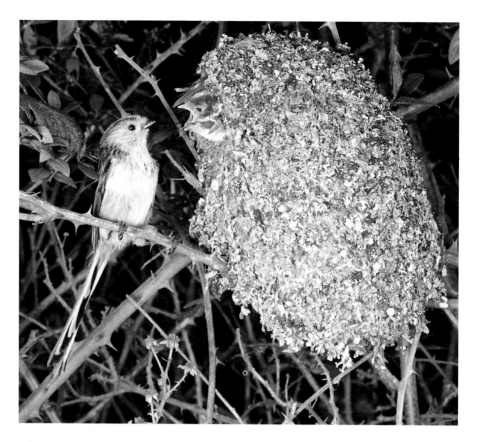

Long-tailed Tit, 1949 There were no obvious career opportunities in either photography or natural history when Eric left school in 1925, and he became an apprentice to a car-dealing firm, Stewart and Arden, and then, when they moved their premises, to George Johnston Ltd, suppiers of body-building parts, also for cars. It was here that the first of two accidents, each with a profound impact on his life, occured. Several of Eric's toes were crushed in an accident with a lift, and for the remainder of his life he had to wear special footwear and suffered considerable discomfort covering rough ground.

However improbable it may seem, the mechanical skills learnt as an engineering apprentice, and the filing, record-keeping, accounting and salesmanship (demanding accuracy and, again, an attention to detail) all had their part to play later in Eric's career. In 1929, Britain plunged into the deepest and longest economic recession ever known. The slump forced thousands of companies into liquidation, including Johnston's, and Eric, at twenty, was on the dole. Then, as now, this was a harrowing experience - in Eric's words 'the most degrading, depressing period of my life'. But as mercifully seems to happen to a surprising number of redundancy victims today, this awful interlude was actually responsible for setting Eric off on what was to become his life's work and career as a professional photographer. More than that, he was forever grateful that it forced him to freelance, so not only had he shed a job that he did not enjoy, but he had become his own boss.

A fortunate train of events triggered off his photographic career. Knowing his photographic capabilities, his interest in animals and

his familiarity with London Zoo, Freddie Reekie, an old school friend working on the *Sunday Dispatch*, contacted Eric wanting a special photograph for his paper. This was to be of the Zoo's recent acquisition, a young Elephant Seal, and the paper favoured the idea of a shot of this already huge mammal beside a child. For this commission, Eric 'borrowed' the daughter of a friend, the four-year-old Mary Parkinson, and photographed her feeding fish to the elephant seal. Mary became as much of a star as the Elephant Seal (or Sea Elephant as it was probably known) following publication of the photo spread over half the back page of the *Dispatch*. This photo was to be turned into a greetings card, and Mary, pretty, completely fearless and loving all animals, was to feature in many more zoo photos. A compilation of these formed Eric's first book, *Friends at the Zoo*, published by Oxford University Press in 1933 and running on to sell about 50,000 copies!

Interestingly, William Friese-Greene had turned to portraiture to keep the wolf from the door and to finance his experimental and unprofitable cine work. Rather more than a decade later, Eric himself was to base his career on portrait photography, using this to subsidise his natural history efforts while he amassed a sufficient collection of photographs to be commercially viable. As well as the Mary series, photographs of weddings and children provided the bread-and-butter of his business. Both demanded skills and attention to detail akin to that required by natural history subjects, and as with wildlife, frequently only offered one chance, which had to be successfully seized.

The high point of Eric's child photography came in 1935, when he was called back by telegram from a session with Bitterns on the Norfolk Broads to photograph the Royal Princesses, Elizabeth (now Queen Elizabeth II) and Margaret Rose. As with all child photography, this proved no easy assignment, with the Princesses doing their best to avoid the lens despite Eric's attempts to follow the guidance of the Duchess of York (now the Queen Mother) and remain unobtrusive. Eventually, a Punch-and-Judy show at the party provided the necessary opportunities, and *Country Life* was able to publish a portrait of them both, intently involved, as only children can be, in the performance.

Despite the fact that they distracted him from his target of becoming a full-time bird photographer, the variety of these professional assignments and freelance opportunities fascinated Eric, be they portraits of children, news shots of fires or accidents, or even documentary accounts of the daily work of dustmen. He gave his full attention to them all with equal enthusiasm, always seeking the best possible results. Even his bird photography had some spin-offs. Through their advertising agents, a famous brand of matches, Swan Vesta, were urgently seeking a photograph of a Mute Swan. With none on his files, Eric accepted the commission and cycled to Waterlow Park in Highgate. There he tempted the swans within range by offering them bread, and took his

photographs. The prints, taken off plates still wet from processing, were in the post that evening, and were soon displayed on hoardings everywhere. A drawing from one of them became the Swan Vesta symbol, and stayed as one of the longest-lived of all such commercial logos. Eric's professional photographic career was just about under way when he was twenty - and in that year he amassed the grand sum of £23! But he was beginning the continuing process of up-grading his equipment by purchasing a quarter-plate Sanderson field camera, built of mahogany and brass in 1909, the year in which Eric himself was born, and this served him well until after the war - a working life for the camera, a hard, versatile working life at that, of around forty years. He was also learning fast that in the world of freelance photography, persistence pays, as does seizing any chance when it is offered, as in the case of Swan Vestas. Eric used to recount his adventures in penetrating the Editor's Office of *The Times* with some relish. This would have been a far tougher task then than even today, but, refusing to be put off, he eventually got his face-to-face meeting with Geoffrey Dawson, the legendary figure at the head of 'the Thunderer'. Though the portfolio he had with him was unsuited to the starchy, almost unillustrated, columns of *The Times*, Eric got to meet their art editor and occasionally provided photos for the illustrious daily. More importantly, he made a sufficient impact for Dawson to telephone the *Daily Mirror* and arrange an introduction that led to the publication of a spread of 'Mary at the Zoo' photographs.

The natural history work had not been forgotten, and the first of many summer field seasons away from home began in the spring of 1930. It was to East Anglia, to Suffolk - always a favourite area - that Eric first went. From an initial base with a kindly aunt in Ipswich, he made contact quickly with the photographer George Bird, and with George Boast, the gamekeeper (or should he better be called gamekeeper-naturalist?) at Staverton Park near Woodbridge. Then, just as much as now, this part of the world was supremely rich in birds, including rarities like Stone Curlew, Red-backed Shrike and Montagu's Harrier. Eric set up home in the primitive conditions of a candle-lit corrugated iron hut close beside George Boast's cottage, taking his meals (which seem perpetually to have consisted of rabbit) with George and his daughter. George introduced him to the wonders of the area, and it was here that Eric's first serious session of bird photography from a hide took place. The subjects were a pair of Bullfinches, with their nest and young set in a gorse bush. It was not simply the beauty of the birds, seen in extended detail on many occasions and at close range, that fascinated Eric and produced the substance of his photographs, but also their behaviour. In the case of the Staverton Park Bullfinches, he noted that the pair normally came to the nest together, and that in seed-eating birds, gaps between visits are often extended to half an hour or more as the adults collect more seed and allow their salivary secretions to soften it and begin the digestive process before feeding it to their young. This respect and total absorption in his subject, both pictorially and in its way of life, was to characterise the remainder of Eric's career as a bird photographer.

OUT FOR A WALK WITH MARY AT THE ZOO

"Shortly after I was made redundant in 1929 an old school friend who was working on the *Sunday Dispatch* phoned and, knowing my interest in wildlife photography asked if I could photograph a six-month-old Elephant Seal at London Zoo with a child beside it to show its size. This picture was to become one of many that I took at the Zoo with Mary Parkinson and she became the subject of my first book, which was published in 1933." Thus, at the age of the age of twenty, Eric was launched on a career as a professional wildlife photographer.

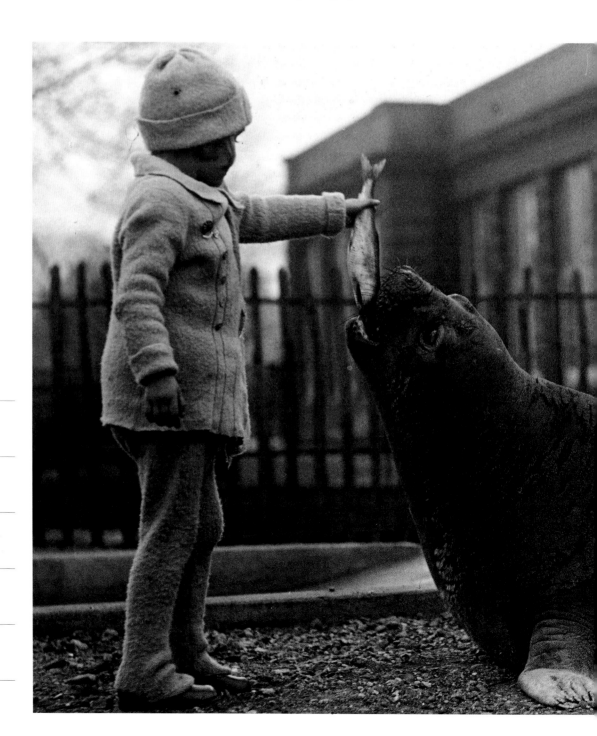

Date
October, 1929

Camera
Sanderson

Lens
Dallmayer Serrac 8 1/2"

Aperture
F 11

Shutter
1/10th second

Film
Gold ISO Zenith

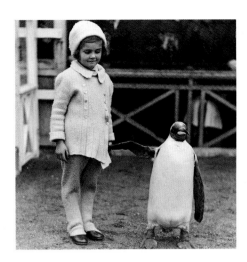

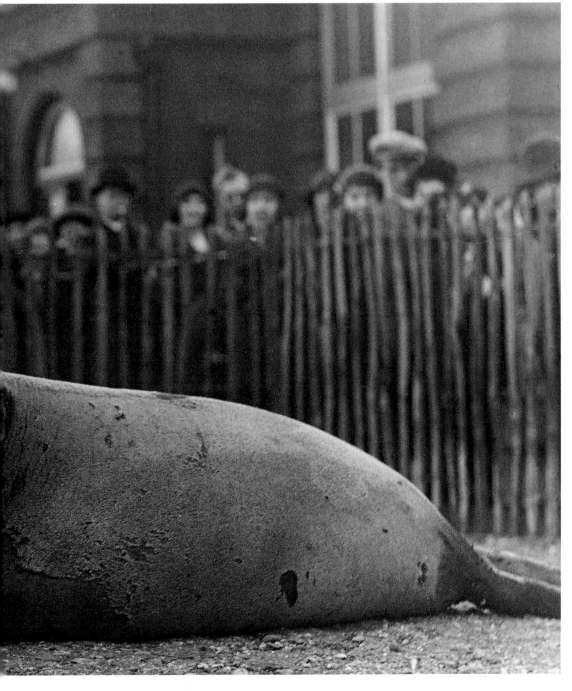

SWAN OF SWAN VESTAS

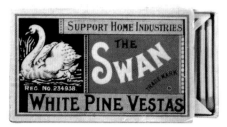

"One day an advertising company phoned wanting a photograph of a swan. Not having a suitable one in my file, I quickly went up to our local park and photographed one.

This picture of a superb male Mute Swan, his wings raised galleon-like in defence of his mate and their nest, was used in an advertising programme for Swan Vesta and a drawing from this picture has been their logo ever since."

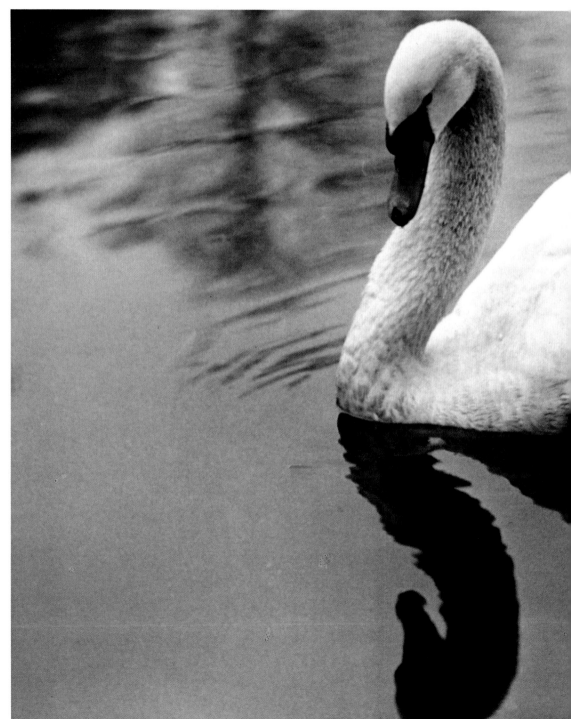

Date
April, 1931

Camera
Sanderson

Lens
Dallon 12"

Aperture
F/8

Shutter
1/100th second

Film
Golden ISO Zenith

Long-tailed Tit

"This photograph, taken with available light, shows how the Long-tailed Tit's head and body are nearly still, while balance is maintained by the wings and tail. The flask-shaped nest gave rise to its old colloquial name, 'Bottle Tit'. The nest is made of moss, hair and feathers bound together mostly with spiders' web and camouflaged with flakes of lichen. As the young moved about inside the nest, I could see the walls bulging, a tribute to their flexibility and particularly to the strength of the spiders' silk threads. I am told that over 2000 trips may be necessary as the pair build their home."

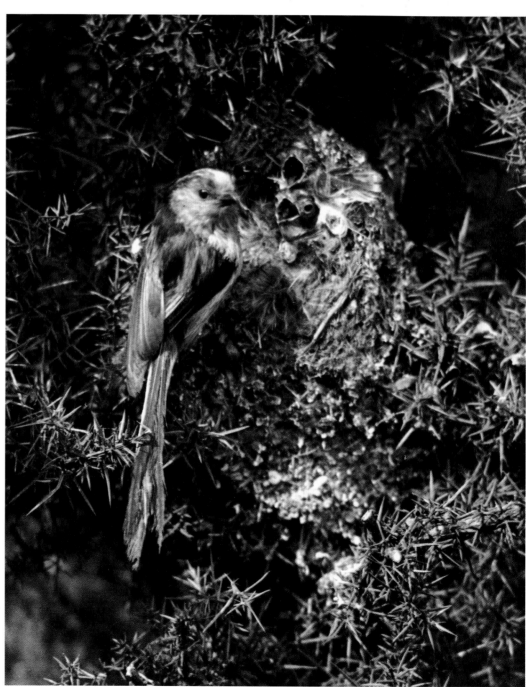

Date
9th May, 1933

Camera
Sanderson

Lens
6 1/4" Cooke

Aperture
F/8

Shutter
1/25th

Film
1/4 plate negative, Soft Gradation Pan

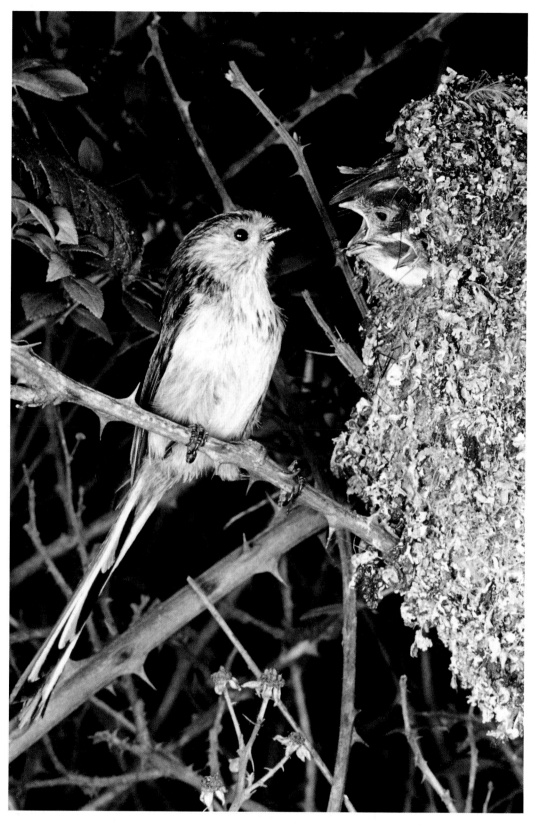

Long-tailed Tit

"I found this nest in a very dark situation, where ordinary daylight would have made photography extremely difficult so I used two high-speed flash heads with a flash duration of 1/5000th of a second to obtain this result."

Date
June, 1949

Camera
Brand 17

Lens
Ektar 8″

Aperture
F/32

Shutter
High Speed Flash 1/5000th

Film
P 1200

GREAT SPOTTED WOODPECKER

"Great Spotted Woodpeckers excavate their own nest hole, often in hard live timber, using their beak like a combination of hammer and chisel, twisting off flake after flake of wood. While the birds hammer, their heads are protected by pads of cartilage, which act as shock absorbing cushions between their beaks and skulls. The young were nearly ready to leave the nest when this photograph was taken, hence with the long exposure the great movement of the young. It was raining at the time and the nest site was in a wood, but by developing with the Knapp method I was able to get out a fair amount of detail, although underexposure is noticeable under the old bird. The print has been over-exposed and reduced considerably with iodine."

Date
11th May, 1933

Camera
Sanderson

Lens
Cooke 6 1/4"

Aperture
F/3.5

Shutter
1/30th second

Film
Soft Gradation Pan

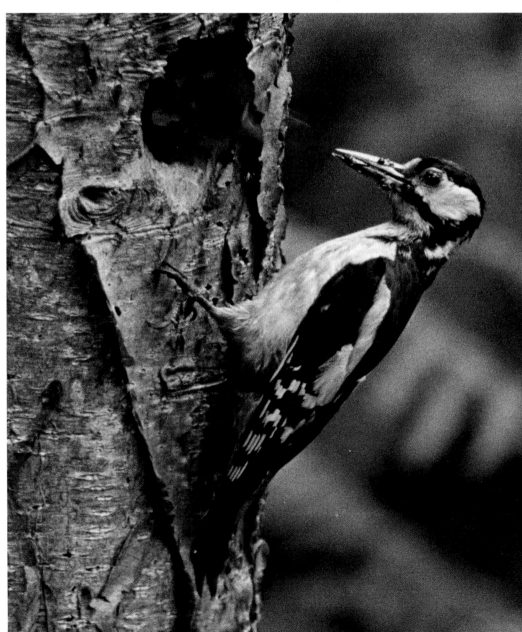

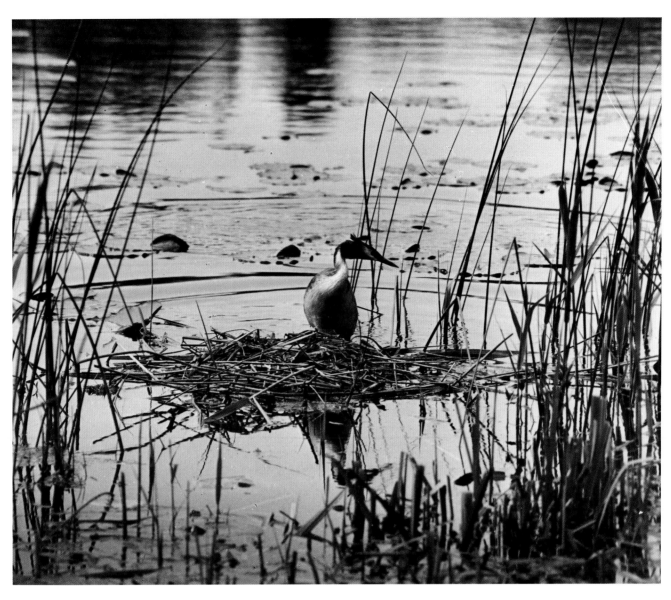

GREAT CRESTED GREBE

"The floating nest of these birds was near enough to the bank for us to be able to build a hide on dry land and, by moving just a few of the reeds, we were able to get a clear view of the adult bird incubating. Anchored by a strand of waterweed to a nearby clump of reeds, the nest could rise and fall with changing water levels, protecting the eggs against sudden flooding that would destroy the nest of a Moorhen or Coot."

Date
June, 1934

Camera
Sanderson

Lens
Serrac 81/2"

Aperture
F/8

Shutter
1/150th Second

Film
Soft Gradation Pan

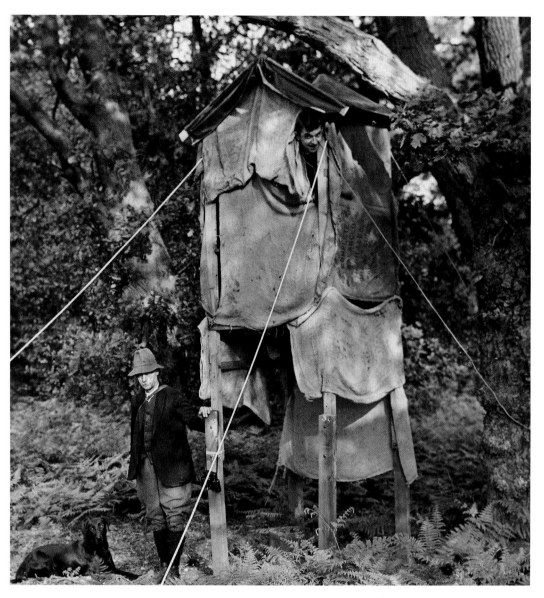

Hawfinch

Date
17th June, 1934

Camera
Sanderson

Lens
8 1/2" Serrac

Aperture
F/11

Luc Shutter
1/20th

Film
1/4 plate negative, Soft

"During the 1934 season I found ten nests of the Hawfinch in Staverton Park, Suffolk. Nine of these were in photographically hopeless positions. This nest was only 15 feet from the ground and well out in the open, I was able to get level with the nest with the hide shown in the glossy print. I had always assumed the Hawfinch to be an extremely shy bird, but this pair were not and both birds came to feed while I was fitting my camera up and while the hide was still open at the back. The Hawfinch's very powerful beak, the most powerful of any finch, can be clearly seen. I have been told that it can exert a pressure of 200 pounds per square inch strong enough to crush damson stones and extract the kernels for food."

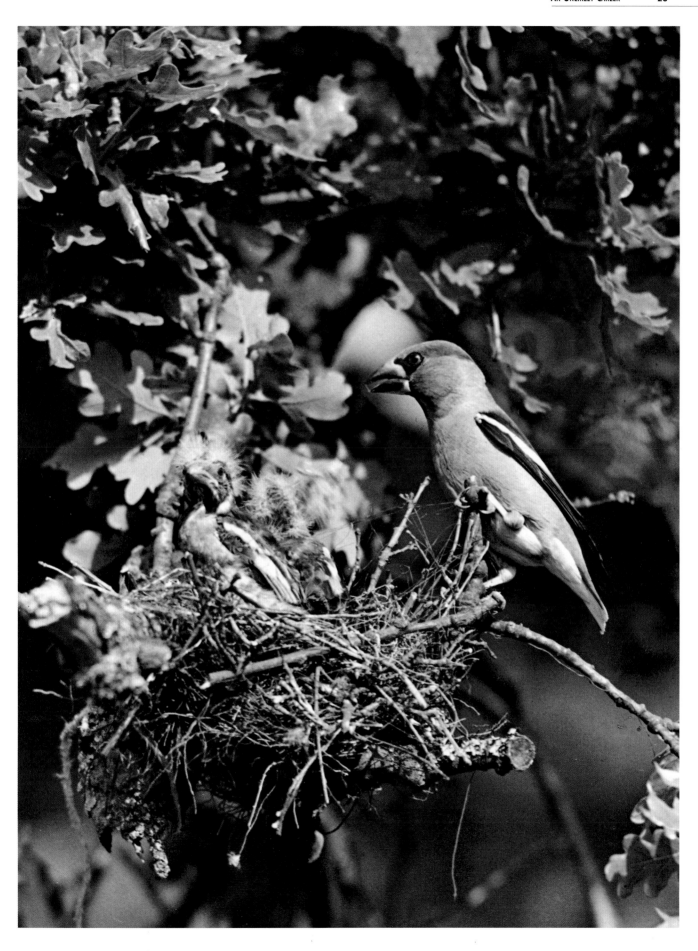

Red-backed Shrike

"The nest of the Red-backed Shrike was about 2ft below the branch on which he is perched. Every time he and the hen came to the nest, they perched here, but the main snag was the very contrasty light. The reason for the rapid exposure was the tail, which was moving up and down all the time. Red-backed Shrikes are sometimes called 'Butcher-birds' because of their habit of impaling surplus prey on nearby thorns until they are hungry. Their food is mostly insects, but they will catch any small animal, including nestling birds and small rodents, in their powerful hooked beak."

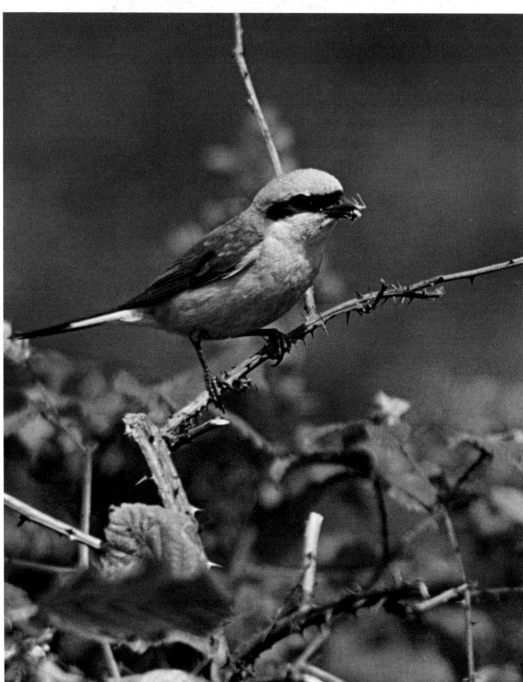

Date
5th July, 1934

Camera
Sanderson

Lens
Serrac 8 1/2"

Aperture
F8

Shutter
1/150th

Film
Soft Gradation Pan

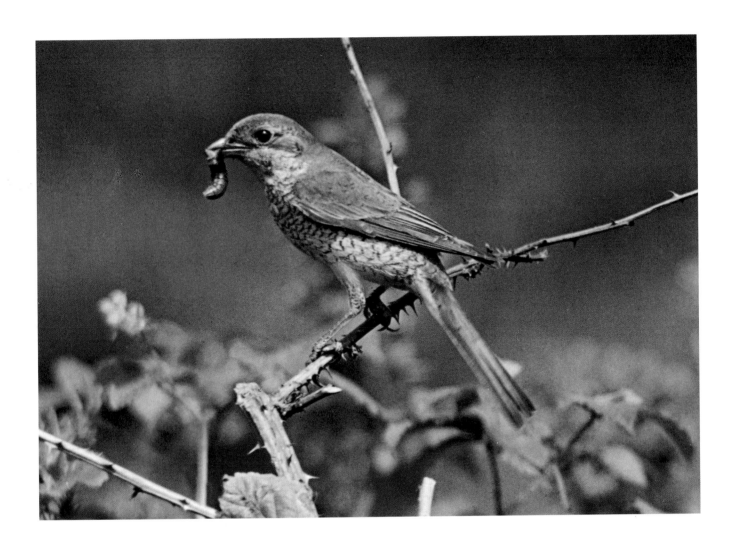

GREENFINCH

"Greenfinches, with their slow-motion 'butterfly' display flight, are among my favourite suburban birds. Their purring song is as typical of warm summer afternoons in the garden as is the chink of teacups or the chatter of lawn mowers. This nest was in a macrocarpa hedge about 7ft above ground. It was almost impossible to photograph during the daytime because of heavy contrast, hence evening exposures were the best."

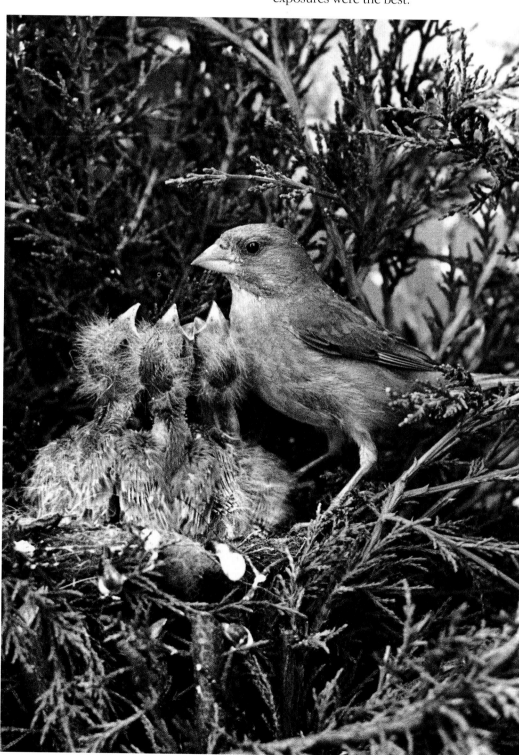

Date
25th June, 1935

Camera
Sanderson

Lens
Serrac 8 1\2"

Aperture
F/8

Luc Shutter
1/10th

Film
Soft Gradation Pan

Grey Partridge

"It was not until well into the season at Eyke in Suffolk that I gained permission to photograph Grey Partridge, but fortunately this was a very late nest. I found them easy to photograph, though, as the nest was at the base of a tree, the light was very awkward and I obtained the best results without the sun shining. I think to get the best out of these birds the hide and everything else must be prepared when the hen is away feeding. This bird brooded for 4 hours at a time and was away from the nest for 20 to 30 minutes, though these times altered a lot with the change of weather. The first egg hatched at 9.40am. All the eggs were hatched and the chicks had left the nest by 2pm. The wire in the background of the prints was part of a fence separating two fields and was attached to the tree."

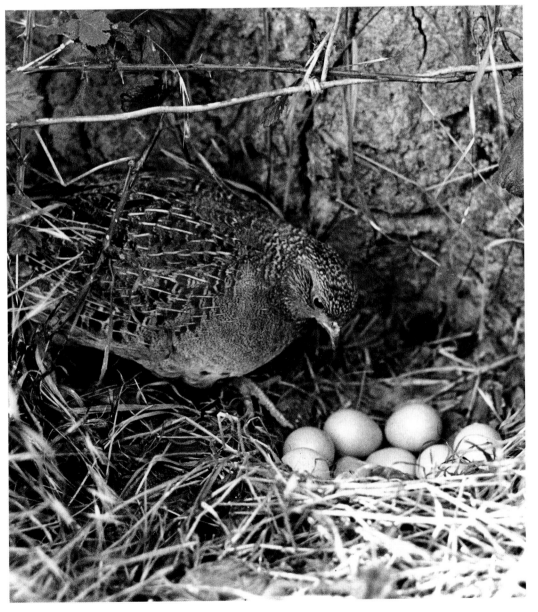

Date
July, 1935

Camera
Sanderson

Lens
Serrac

Aperture
Various

Shutter
Various

Film
SGP

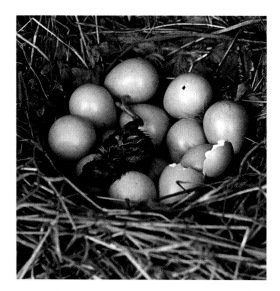

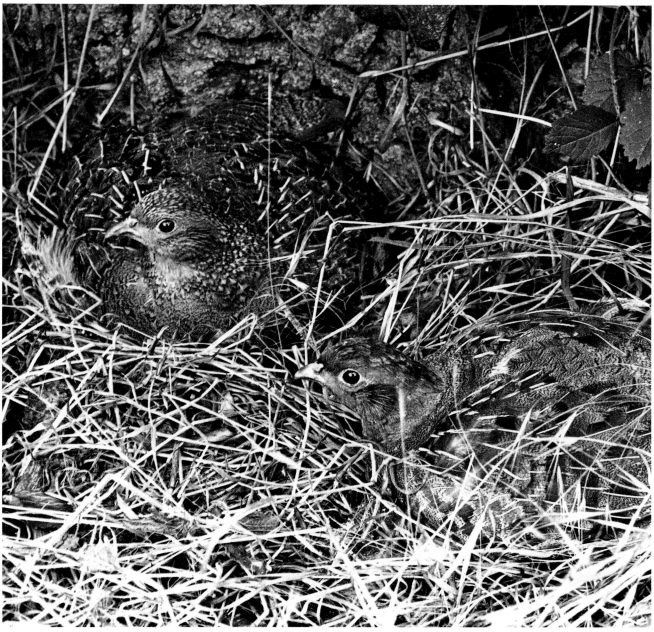

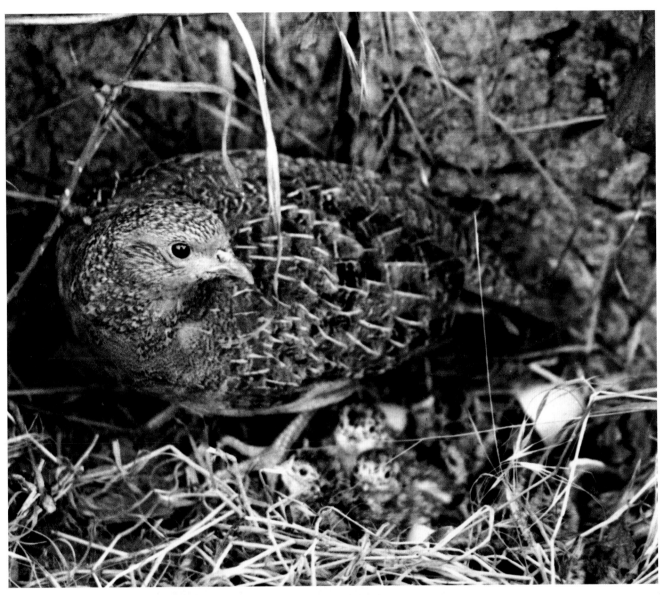

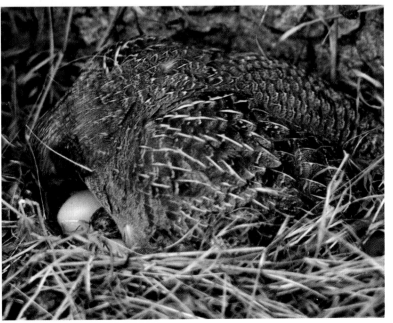

Date
July, 1935

Camera
Sanderson

Lens
Serrac

Aperture
Various

Shutter
Various

Film
SGP

BLACKCAP

"The underparts of this adult bird are very underexposed and development has been rather forced, hence the appearance of highlights. Blackcaps love tall, old woodland, where the light is almost always poor, even on their chosen song post. This makes photography difficult. One bonus of sitting in the hide waiting for the right opportunity was that I could listen to his beautiful solos, briefer, but almost of Nightingale-quality."

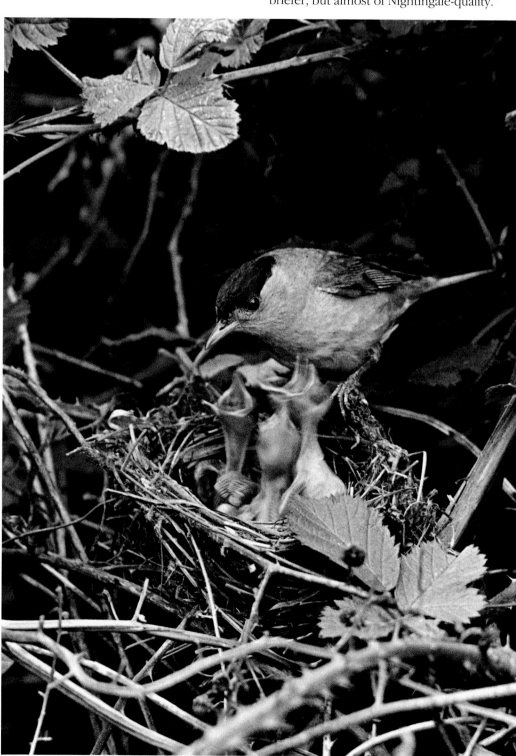

Date
3rd July, 1935

Camera
Sanderson

Lens
Dallmeyer Serrac 8 1/2"

Aperture
F/6.8

Luc Shutter
1/10th

Film
S.G.P. 1/4 plate

Stone Curlew

"This pair of Stone Curlew was extraordinary in several ways. Firstly they nearly always changed over at the nest and not at a distance like most of the pairs I have watched. In all I saw 15 changes at the nest and the same procedure took place on nearly every occasion. The brooding bird would whistle to its mate who kept watch at the observation point. The latter on hearing the call would answer and hurry to the side of the brooding bird who would not attempt to get up until the other was ready to come on. The whole change over took about 20 seconds and I actually exposed 7 negatives in 15 seconds by keeping one hand on the film pack and the other on the release of the Luc shutter."

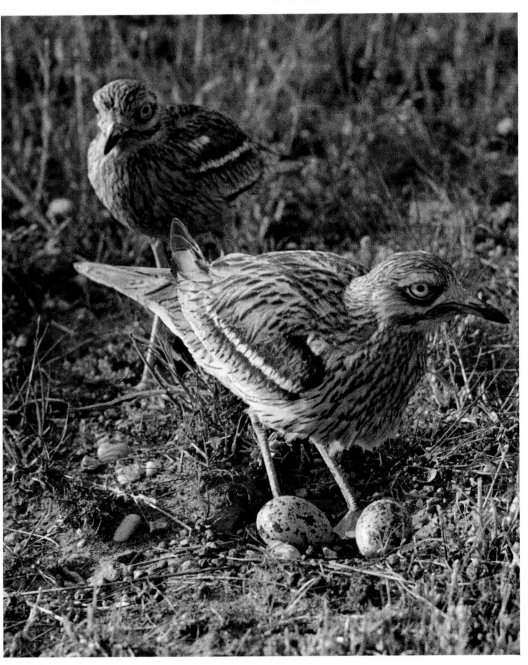

Date
25th May, 1936

Camera
Sanderson

Lens
Serrac Lens 8 1/2"

Aperture
F/11

Shutter
1/25th second

Film
Hyper Pan Film Pack
These were flat films which allowed rapid change during use

2 A CAREER DEVELOPS

Lecturing formed a substantial component of Eric's early career, and it was not until he had presented some 1500 lectures over thirty-two years, that he eventually decided to call it a day and retire from the circuit. As an amateur at the tender age of sixteen, he had endured his 'baptism by fire' by speaking to that most difficult of audiences, teenagers. A life-long Baptist himself, this first performance was appropriately enough in a north London Baptist church, and the subject was natural history, although the slides were not his own. When he 'turned professional' six years later, Eric had as the basis for his talks 3 1/4 inch square monochrome slides which he made from the original negatives based on the Mary at the Zoo theme. Following summer seasons spent in the field photographing birds at the nest the list of lectures steadily expanded in both breadth and depth, with titles such as 'Wild Natures' Charm' and 'With a Camera in Birdland' being joined by the rather more serious 'Birds in Action', which featured pho-

Sand Martins, 1936

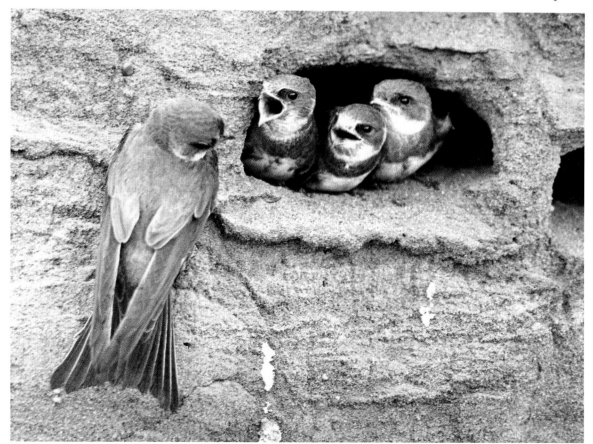

tographs taken with high-speed flash.

Eric had the knack of being in the right place at the right time. In *An Eye for a Bird* co-written with Frank Lane, he identifies Gerald Christy as the doyen of lecture impressarios. Christy began his career as an agent in Victorian times, and his business was at its peak through the Edwardian era. To most people today the very idea of an impressario in this field, in Britain, would be astonishing, although 'lecture tours' in the USA are recognised as being part of the lives of prominent politicians once they have retired from high office but continue to wish to influence public thinking! Back in the 1930s, Christy took the young Eric Hosking onto his books which at one time or another had included such luminaries from other fields as Sir Winston Churchill, Hillaire Belloc, J.B.Priestley, Scott of the Antarctic, and the victor of the race to the South Pole, the Norwegian Raould Amundsen.

These lectures took not only photographic time in the field, but hours of meticulous preparation to ensure that the performance, for that is what it was, remained first class. An acute assessor of audience reaction, Eric was always upgrading not just the photographic content but also his presentation techniques. He became brutally familiar, too, with the rights and wrongs of welcoming a speaker, which ranged then from the completely uncaring and off-hand minority through to the caring and competent majority - a scene with which any present-day lecturer is familiar. As unthinkable today as the impressario is the idea of an ornithological lecturer topping the bill at the old Trocadero, the cabaret restaurant just off Piccadilly. Not through Gerald Christy but through his budding association with the magazine *Country Life*, Eric appeared (following the usual good dinner and preceeding the dancing girls, singers and comedians) to present a perfectly straight talk - albeit briefer than his norm - on birds and their lives, with details of the techniques he used to obtain his photos. The subsequent reviews by the Critics in the press indicate just how successful the venture had been.

As well as his superb timing, which allowed him to seize an opportunity when it was offered just as much as to hold the attention of a cabaret audience, Eric had the vision to see the end before it actually arrived. Natural history presentations, in some of which he was involved, on radio and in the cinema, and the astonishing rise in the popularity of wildlife subjects on television, which began in the 1960s, have eliminated the role of the large-audience lecturer, leaving only photographic and natural history clubs and societies in need of speakers for their winter programmes. Travel and readily available high-quality camera equipment allow many more people to travel, to photograph, and to tell of their experiences to such audiences, greatly reducing the place of the true professional. Add to this the inevitable stresses and strains of lecture preparation, and particularly of travel and nights away from home and family, and Eric's conclusion in 1963 that he should retire from the cir-

cuit and concentrate on his main skill - the photography itself - was entirely appropriate.

The 'home and family' centred on Eric's wife Dorothy, to whom he was married in April 1939. During their two-year engagement, Dorothy became familiar with the zoo and its animals and keepers, and later with the real thing, natural wildlife, for which she evidently had a strong instinctive affinity. As much a part of planning for their wedding day itself were the plans for the honeymoon. This was to be an extended one judged by any standards, and was destined to be spent in the Highlands of Scotland, with the majestic Golden Eagle as its main target. Perhaps appropriately, it is Dorothy's diary account of the honeymoon that lives on, and presents the most telling account. The diary describes many of the vicissitudes of bird photography in remote areas, pursuing a subject so rare and widely scattered as the Golden Eagle. Even today, many of us would consider the road network of the real Highlands, with its bends and its single track stretches 'with passing places' (inevitably in the wrong place) to leave a great deal to be desired, and it is difficult to imagine just how poor it was in 1939. Trouble struck the honeymooning Hoskings before they had even reached the Borders: just past the famous Scotch Corner, they were overtaken by a solitary car wheel - one of their own! They came down to earth with the proverbial bump, and after a couple of hours of roadside waiting (so sparse was the traffic) they were rescued by a friendly lorry driver and his mate and towed back to Old Catterick. Hosking persuasion and determination and numerous telephone calls had them repaired and on the road again by the subsequent evening. A day later, after some heart-stopping groundings on the rough part-made roads, they were in the heart of the Highlands, in eagle country.

With typical thoroughness, Eric had made numerous enquiries and contacts during the months before their wedding, and had identified the whereabouts of several pairs of Golden Eagle. These they visited in turn, taking the time en route to enjoy other Highland specialities, including Red Deer. Time after time for one reason or another, the eyries were unsuitable for photography. Dorothy recounts with a feeling undimmed by the years the horrors of breaking-in new boots, the long walks from the nearest road, the scrambles up breathtaking screes and crags, followed by the dejected homeward trek from yet another unsuitable site. But such was, is, and always will be the lot of the bird photographer in such terrain, no matter how thorough the planning.

At last a site apparently with potential was located in Argyll - accompanied by the offer of Highland hospitality from the baliff of the estate. This climb was the toughest of all - around 1000 feet in a mile and a half of rocky going - but the eyrie was occupied and was 'just right' for photography. 'Just right' was perhaps too optimistic an assessment of the situation. Eric quickly located a sawmill and the necessary timber for the hide. Two handymen were employed

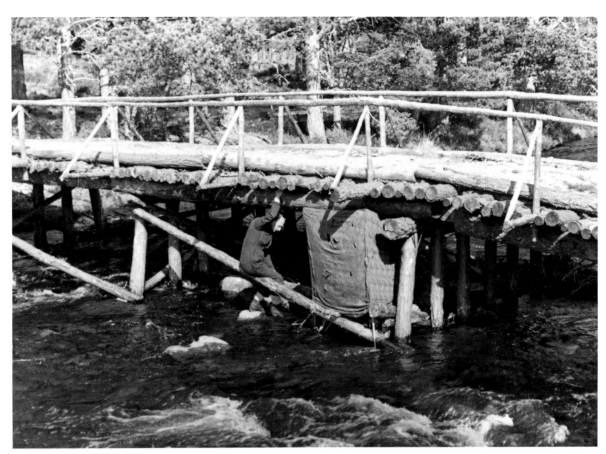

Dipper nest, 1954

to construct the hide over the next few days so as not to disturb the birds. Eric and Dorothy then continued their work elsewhere, only to discover on checking by 'phone that delay had followed delay - and, in essence, nothing had been done. The hide material had been left by the roadside at the foot of the hill, but no hide builders had appeared, despite many promises. Recruiting the local plumber and a couple of lads, Eric, with typical energy and determination, embarked on the task himself - and extremely tiring it was, for the timber had to be carried up the hillside to the nest site.

Eventually the hide was built, and left untennanted for a few days for the eagles to get accustomed to it, before with mounting excitement Eric and Dorothy were escorted in by the gillie for the first day's photography. Dorothy's description of the wait once the gillie had left is fascinating. With meticulous attention to detail, the sandwiches were unwrapped immediately - not to be eaten, but so that rustling paper did not create a disturbance later. She was amazed at the way Eric could remain motionless for so long, waiting - but equally amazed that when at last, with a rush of wings, the eagle returned, there was no 'click' of the shutter. Eric, alongside her, was ashen-faced, probably due to a mixture of cold and sheer tension and excitement, and seemed close to passing out. Despite this, he managed to take about twenty exposures, and Dorothy's fears as to how she was going to get him down from their precarious perch evaporated. Eric enjoyed a few more spells in the hide before the eaglets flew, and the couple managed some more gen-

eral bird photography. This included a period with a pair of Golden Plover, those birds with a wild plaintive call so well suited to their moorland home, and whose chicks - 'little balls of pure gold fluff' - obviously impressed Dorothy as much as did their elegant parents.

The marriage was destined to be enduring and successful: Eric always maintained that his own strengths and happiness were based on the secure foundation of a united and loving home and family. Not long after their return from honeymoon, Eric and Dorothy moved to the four-square Victorian house at 20 Crouch Hall Road that was to be their home until Eric's death. They moved in just before the outbreak of the second World War.

Eric volunteered for active service, hoping to put his photographic skills to good use in the RAF, but he was rejected on health grounds. Instead, he was diverted to fire-watching duties, coupled with another of his skills as he went on lecture tours around the RAF stations. Together he and Dorothy endured the constraints of food and petrol rationing, and of the blackout, though this should have presented fewer problems to a photographer familiar with darkrooms than to most families. The blitz - the nightly and daily bombing raids - dramatically affected their lives, just as it did those of every Londoner. However they survived the bombs, the land-mines and the rockets, though not without several near-misses and narrow squeaks when explosions threatened the fragile but invaluable slide collection, which at that time was made of glass. Through the darkest hours in the house or in the air-raid shelter, deprived of electricity and with the radio off the air they even managed to enjoy their classical music favourites on the gramophone: being hand-wound it escaped this interference.

Hardly surprisingly, but much to their distress, the extensive lecture programme planned had to be cancelled, and their income from the sale of photographs and articles also almost dried up. But not entirely: there were 'news' photographs to be taken for the papers, and to lighten the national gloom, magazines like *Picture Post* continued to publish on a wide variety of themes, including natural history. There were occasional broadcasts, but right in the middle of the war in late 1942, Eric met with Julian Huxley and James Fisher to discuss a proposed extended series of definitive natural history books. The outcome was the famous *Collins New Naturalist* series, which, now nearing eighty volumes, continues to the pesent day. With Professor L.Dudley Stamp and John Gilmour, he was asked to join the editorial board with the particular responsibilities of photographic editor. That the detailed planning was underway for such a detailed and profusely illustrated series, covering all natural history topics, during the darkest hours of the war when photographic materials were virtually unobtainable and most potential authors and photographers were away fighting is in itself an amazing example of positive thought and forward planning.

One of the photographers that Eric recruited was John Markham, whom he regarded for many years as the best British

mammal photographer. Eric admired his skills, his patience and tenacity, and above all his dedication to obtaining a superb end-product no matter what effort it cost. Eric was always free with his praise, even of potential rivals or competitors, when these were merited. In the same way, he would not flinch from criticism, kindly meant and courteously and constructively delivered, if he felt that the exacting standards of quality and behaviour demanded by wildlife subjects had been compromised.

But the account is running ahead of itself: lecturing and the provision of illustrations depend on a large and continuously up-dated collection of photographs to satisfy a wide range of customer needs, and since 1932 Eric had regularly spent the 'summer' - which to him meant the breeding season of the birds he was photographing - on extended expeditions, often to the less accessible parts of the country. In those early years, these were normally to East Anglia, and often to Norfolk, and formed the basis of his life-long love of that area. The people he met and the friendships formed were to influence his career development, just as much as the photographs he took.

GREEN WOODPECKER

"The hide from which I took this Green Woodpecker picture was one of the biggest I have ever built and it took a week to erect, as it was only possible to work near the tree for about one hour at a time. Green Woodpeckers spend much less time on trees than their cousins, the Great and Lesser Spotted Woodpecker. Large though their beak is, it is not as strong as other woodpeckers', and they use it to probe in sandy soils. Their main food is ants, which they collect by probing along ant runs, collecting their prey on the sticky saliva that coats their tongue."

Date
June, 1936

Camera
Sanderson

Lens
Serrec 8 1/2"

Aperture
F/11

Shutter
1/10th second

Film
Hyper Pan Film Pack

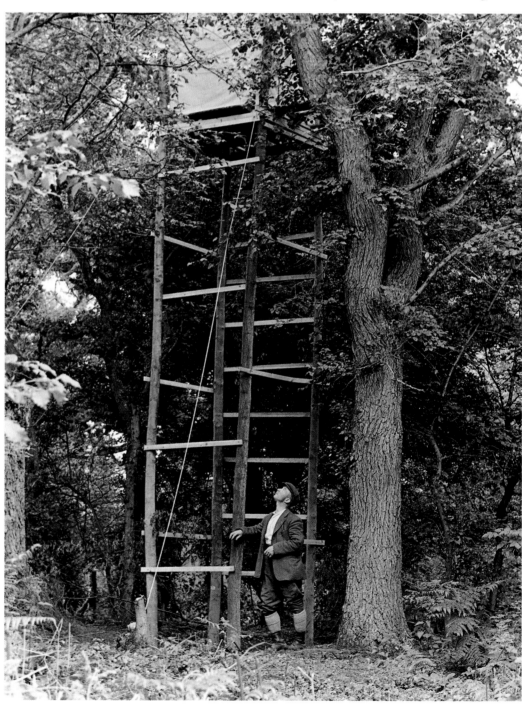

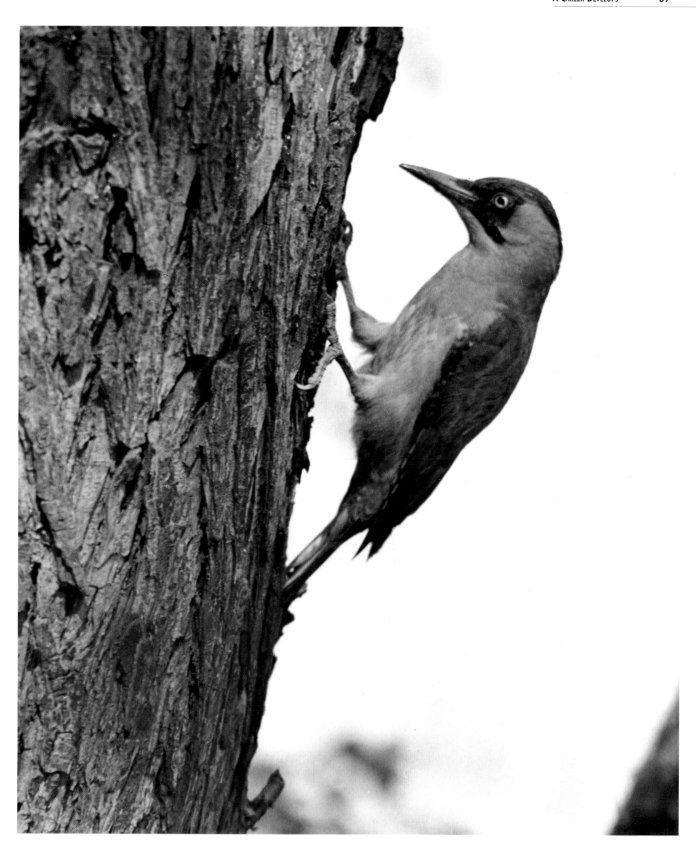

LESSER SPOTTED WOODPECKER

"The wire seen above the woodpecker hole was there to hold the greengage tree together. The nest entrance was only 42 inches from the ground. I was astonished at how small the Lesser Spotted Woodpecker seemed at close range, hardly bigger than a House Sparrow, but very distinctive with its ladder-like black and white barred back. This shot shows how it rests back on its stiff central tail feathers, using its tail almost like a shooting-stick to reduce the strain on its legs and feet."

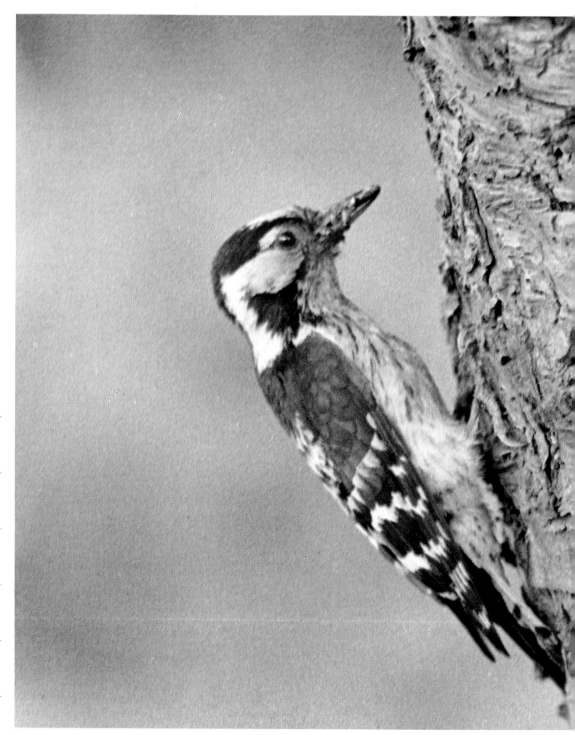

Date
June, 1936

Camera
Sanderson

Lens
Serrac 8 1/2

Aperture
F/11

Shutter
1/10th Second

Film
Soft Gradation Pan

SAND MARTIN

"This Sand Martin colony, in a freshly exposed face of the sand pit, was always busy with birds coming and going to their nest holes. Both sexes share the task of digging out the burrows, which can be as much as a yard deep. Looking at their tiny legs and feet, I was surprised how much sand they could move. This family, close to fledging, was particularly obliging, coming to the nest entrance and posing in the sunshine each time a parent returned with food. They were obviously anxious for their meal."

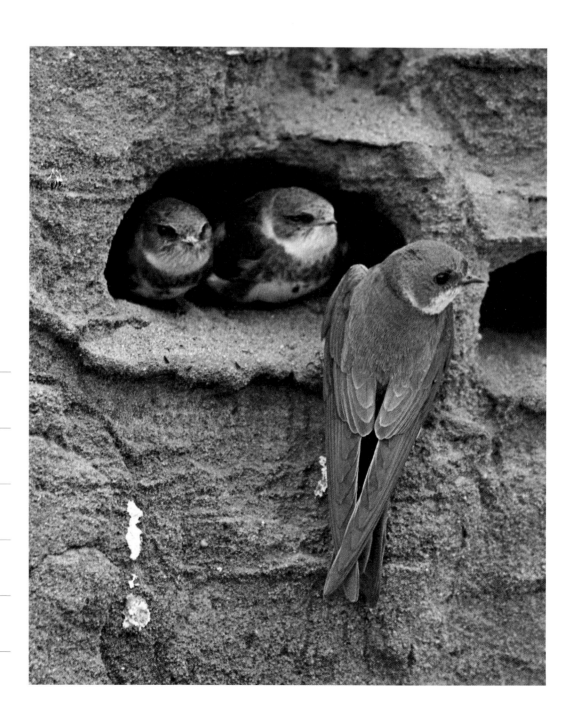

Date
June, 1936

Camera
Sanderson

Lens
Serrac 8 1/2"

Aperture
F/11

Shutter
1/25th second

Film
SGP

BARN OWL

"I could not see anything from the hide when this photograph was taken. It is the luckiest shot I've ever had. Several times when I thought I saw the owl in front of me, I released the flash only to find that I had been seeing things, so I had to rely on my ears and flash when I heard scratching at the hole. The hen's approach was absolutely silent, apart from the sound of talons on wood. This is the only exposure I got where the prey can be seen, but young rats appear to form the main diet as fresh ones were found each day in the hole. It is unfortunate that the rat's tail is wagging and that there is movement in the owl's wings, but I could not see anything when this was taken. I have been told that this is an unusual place for a Barn Owl to nest, but, in the part of Suffolk where I am working, it is rare to find them in any other place but in holes of trees. In fact, I have found nine such nests this season."

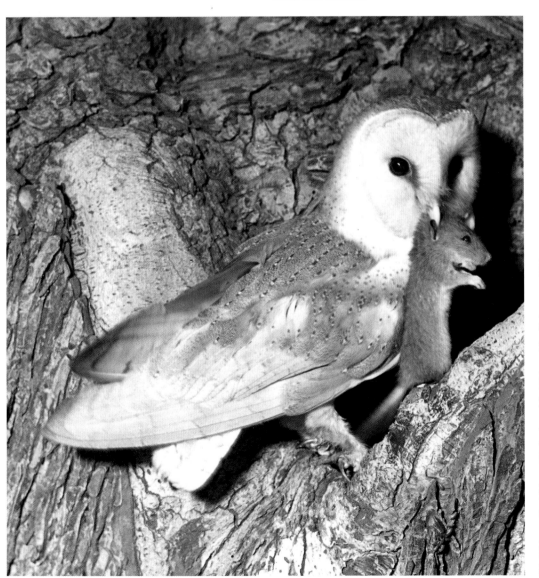

Date
14th July, 1936

Camera
Sanderson

Lens
Serrac 8 1/2"

Aperture
F/16

Shutter
One Flash Bulb

Film
Hyper Pan Film Pan

BLACKBIRD

"The wire netting had been bought by the gamekeeper to put around his vegetable garden to keep the rabbits out, but, before he had time to use it, this pair of Blackbirds had selected it as their nest site. They were allowed to rear their brood before the netting was put into use. Blackbirds will take any opportunity to nest in unusual places. I have seen nests in stacks of pots and on shelves in garden sheds, and have even heard of one nesting under the mudguard on top of the front tyre of a lorry."

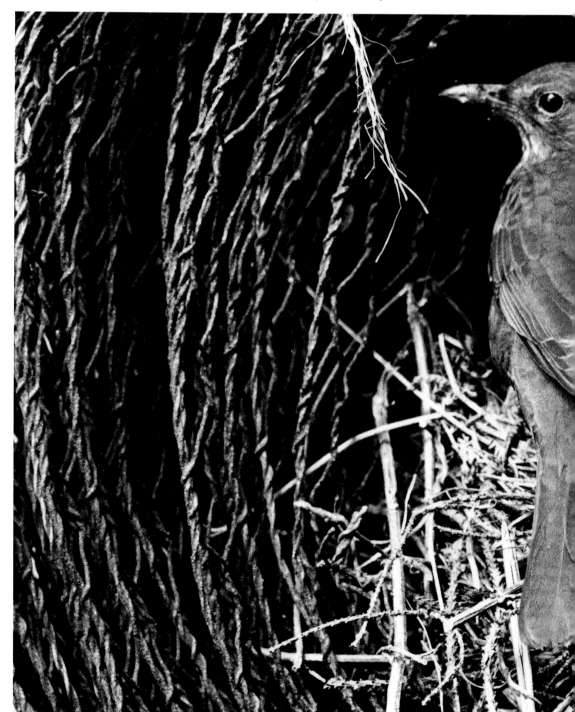

Date
4th May, 1937

Camera
Sanderson

Lens
Serrac 8 1/2"

Aperture
F/11

Shutter
1/5th Second

Film
SGP

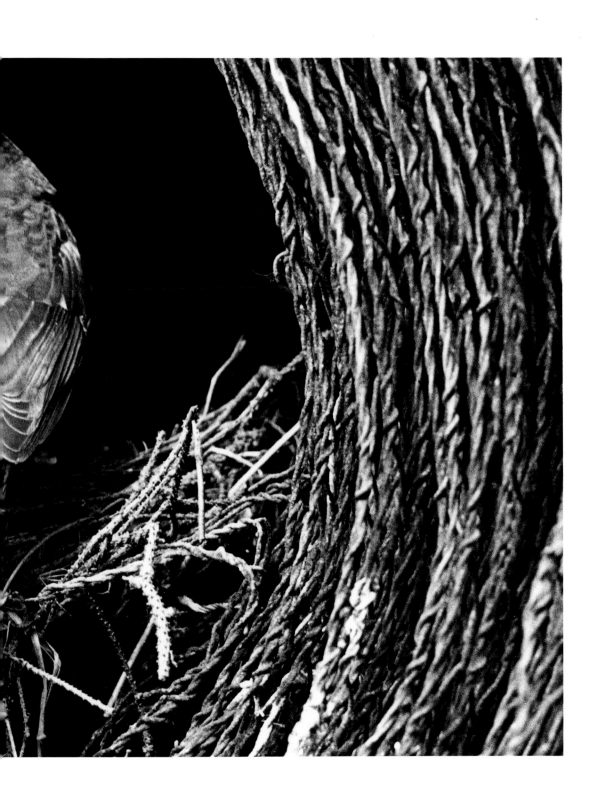

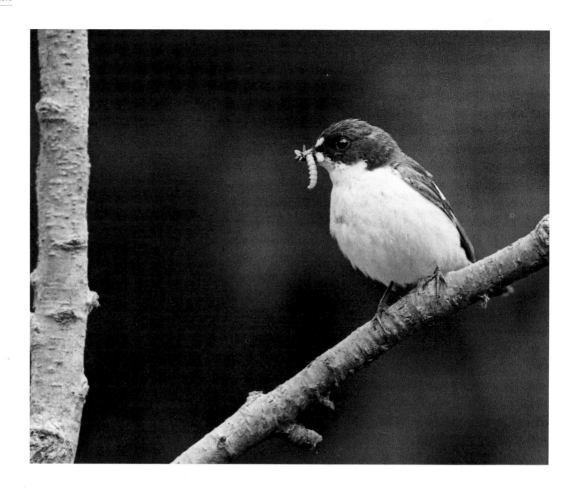

Date
12th June, 1937

Camera
Sanderson

Lens
Serrac 8 1/2"

Aperture
F/16 Second

Shutter Speed
1/5th Luc Shutter

Film
HFP

It is interesting to note that this picture was taken only four weeks after Eric lost his eye

PIED FLYCATCHER

"The perch was artificial and fixed about 3ft from the nest, in a brick wall. It was used by both cock and hen, before and after they fed the chicks. Pied Flycatcher males often lead a bigamous life, supporting two females and their families usually with their territories next to one another. In this case, the male was so attentive that I felt he could only be helping to raise one brood."

DIPPER

"This was taken in a very dark place below overhanging rocks, where ordinary daylight photography was impossible. Dippers, with their jaunty cocked tails, resemble giant Wrens with white bibs. They always seem to nest under a sheltering overhang, building a bulky nest of moss and grass with a side entrance, rather similar to a Wren's nest but much larger. One Sashalite bulb was synchronised with a Luc Shutter. The result is by no means good, but it shows the possibilities for this type of work."

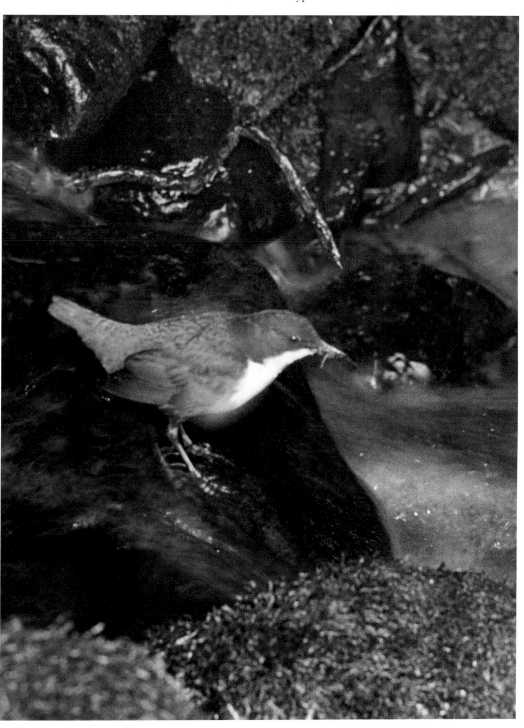

Date
June, 1937

Camera
Sanderson

Lens
Serrac 8 1/2"

Aperture
F/11

Luc Shutter
Open with Flash Bulb

Film
HFP

DIPPER

"This nest was situated beneath a bridge that passed under a main road in central Wales. The hide stood in some 3ft of water and access to it was by means of an improvised foot bridge. When I last worked in this neighbourhood in 1938, there was a nest in exactly the same place. Local residents have told me there has been one there each year ever since. Dippers get their name from their habit of walking off a rock in the middle of a stream, and submerging completely beneath the tumbling water in pursuit of the aquatic insects and the small fish on which they feed."

Date
June, 1954

Camera
Brand 17

Lens
Tessar 21cm

Aperture
F/35

Shutter
60th second
with HSF

Film
Super xx F.P.

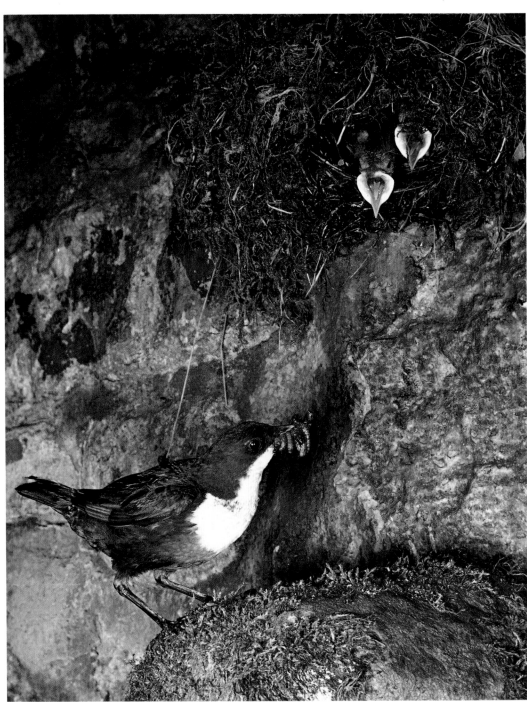

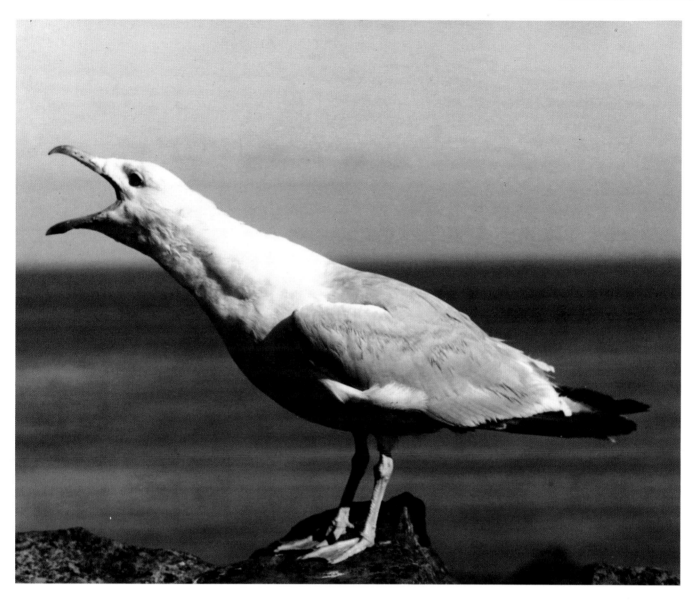

HERRING GULL

"There has been so much talk of late regarding miniature cameras that I thought it would be fun to try one out and this picture was taken with a Leica camera fitted with a Leitz Hektor lens. While the picture has its faults, I think that for general purposes a print of this kind is good enough. A photograph of this sort could quite easily have been taken on a larger camera, but one does not always feel inclined to carry a large camera about, whereas the Leica can be put in a pocket and is of no inconvenience."

Date
10 September, 1937

Camera
Leica

Lens
Leitz Hektor 13.5cm

Aperture
F/16

Shutter
1/40th Second

Film
Agfa Isopan F

TAWNY OWL

"Well! What do you think of her? She did not nest in the same hole, but one only a few yards from last year's site, so I think I am safe in assuming her to be the same bird that got me. She did not attempt to attack us this year, but, for safety's sake, we wore fencing masks. After this exposure, she flew straight at the camera lens and nearly knocked it over, but I think that this was due to her being blinded by the light of the flash bulb and was not intentional."

Date
19th April, 1938

Camera
Sanderson

Lens
Serrac 8 1/2"

Aperture
F/16

Shutter
1/75th second with Flash Bulb

Film
Hyper Sensitive Film Pack
The reference to "her" is referring to that fateful evening in May 1937, when Eric was struck in the face by a Tawny Owl as he returned to the hide. A claw, almost certainly belonging to the bird in this picture, sank deep into his eye. Shortly afterwards the eye was surgically removed to prevent an infection spreading to the other eye.

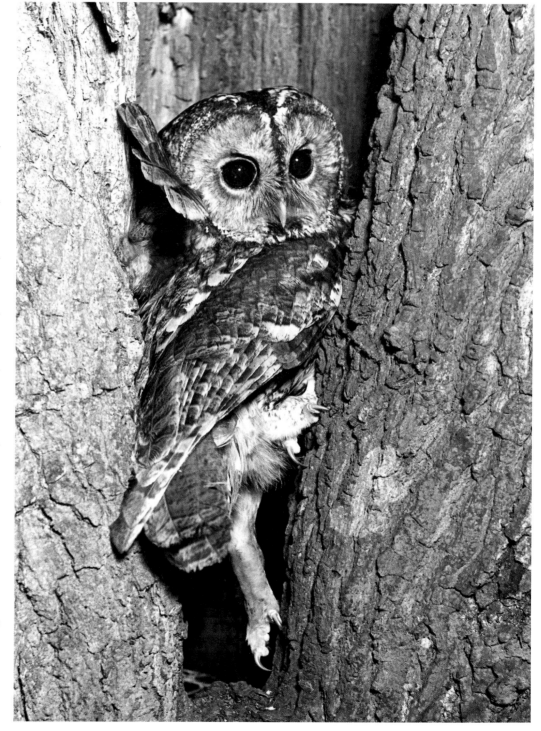

AN OWL ROBBED ME OF ONE EYE

By
E. J. Hosking

The Hide-out. Arrow marks owl's nesting-hole

Hundreds of readers wrote to Eric J. Hosking, many of whose Nature Photographs have appeared in the N.C., when he was attacked by an Owl in May. He might have lost his life had help not been at hand. We asked him to write this article as much as a warning to other naturalists as a description of his work.

AT the age of two I began to take an interest in wild life. "Wouldn't it be awfully decent if we could catch a lot of beekles (beetles) and put them in a mashbox," was how I used to worry my parents for empty match-boxes.

My parents would never dare to empty my trouser pockets for fear of finding snails among the sundry things that are usually found in a boy's pockets.

When I was six years old I began to take a serious interest in nature and took my first nature photograph. It was a song thrush's nest and eggs. The camera cost 35s. second-hand, and I paid for it with halfpennies and pennies saved after great effort.

★

Now, in my files at home, I have 10,000 pictures of wild life. I am now 27 and have been studying nature, and photographing it, ever since I took that first snap at the age of six.

It has been a good career. School hobby developed into work. I have been happy: the money has been satisfactory. For 21 years I have watched and noted and pictured the drama of birds, animals, trees.

I have seen love and hate and life and inevitable death. I have sat from seven in the morning until half-past ten at night in June watching two kestrels, those splendid hawks that look so ferocious, tending their chicks with almost human love and devotion.

I have heard the sharp cry of pain when a stoat, savage little animal, has given a rabbit, three times its own size, the death bite.

I have seen a sparrow-hawk, darting silent, low, beside a hedge, leap the hedge and kill a bird, before you could count three.

And in a Suffolk daybreak in May I have listened to the dawn chorus of the birds. That is no whimsy expression: naturalists so describe one of the most remarkable events in nature, when every bird flies up to greet the sun and sings and sings until you would think every tiny throat would burst with joy and you stand silent, a

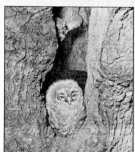

The owl's nesting-hole with one chick in view

bit awed, by the mighty orchestra.

All these things, and many more, I have seen and heard in 21 years of study of nature. And ever since I was a boy I have hated the kind of naturalist who must kill, who kills the unborn bird in the coloured egg, the animal for its skin.

There is one kind of naturalist who, seeing a bird unknown to him, points his gun, pulls the trigger, and takes the body to a museum for identification. It's such hateful waste....

My gun has been a camera. My fun has been in shooting all aspects of nature—and trees and flowers have as many marvellous stories to tell as birds and animals.

And then I was almost killed by an owl.

★

On May 3 I went to Wales with six cameras, complete cinematograph outfit, twelve hiding tents, 3,000 feet of cine film, and nearly 1,000 plates and films for the still cameras.

On May 6 a village boy told me he had discovered the nesting hole of an owl. I went with him and examined it. Two white fluffy balls—brown or tawny owl chicks—were inside. I decided to make a series of photographs of the family.

Three evenings were spent building the hide, a 20-foot high structure, eight feet from the nesting hole. It was left in position, so that the old birds would become accustomed to it.

These dates are important. For May 12 was Coronation Day and the village celebrated appropriately in a field only a few yards from the copse where the hide was built. It attracted people who came across in parties, examined it, talked, laughed. And the old mother owl, already a little upset by the hide, became really angry at the intrusion.

On May 13, celebrations over, my colleague, Cyril Newberry, and I went over to the hide in the evening with two cameras

and flashlight apparatus. We both waited in the hide until 11 o'clock for the parent birds to return and feed their chicks.

But the crowds of the previous day had so upset them that they would not return and, fearing for the lives of the hungry chicks, I decided to suspend operations for a night or two.

We climbed down, leaving the flashlight apparatus in position. I thought the owls would get used to it. We went back to the car. Then I heard voices near the hide. Poachers? That apparatus cost £18, could not be replaced quickly, and I turned back to get it.

It was very dark. The copse was silent. I climbed up the platform. With my hands above my head I unfastened the pins to enter the canvas top. There was not a sound, not a stir of wings in the air when, at that moment, the mother owl attacked me. I knew it was she. It was like a brick hitting me in the left eye. It was all over in a second. She could see me perfectly. I saw absolutely nothing as she flashed past and, in her dive, stuck a savage claw into my eye.

★

I don't know how I got down from the hide, how I got to the car. Newberry took me to a doctor. He motored me to Moorfields Eye Hospital, London. They operated 18 minutes after I arrived, but a fortnight later the eye had to be removed.

The surgeon did a lovely job, but not such a perfect bit of work as that owl did on the night of May 13.

The day I left hospital I went back to my hide in Wales. The owls had left their nesting hole two days before. Keepers wanted to shoot them. I implored them not to. Next year, if she nests there again, I swear to shoot—with my camera—that mother owl who robbed me of one eye.

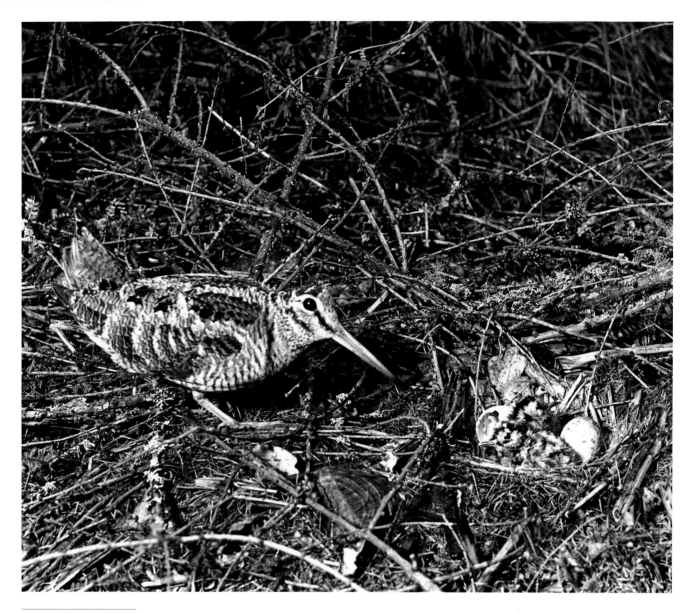

Date
May, 1938

WOODCOCK

Camera
Sanderson

Lens
Serrac 8 1/2"

Aperture
F/22

Shutter
1/25th second

Film
HSFP

"The nest was situated in a thick larch planta-tion, where the estimated exposure in aver-age light went into several seconds. On the morning of the hatch, it was pouring with rain and practically no light penetrated into the wood, so the only thing to do was to work by flash. The old Woodcock took no notice of the flash, and as I put a hand out from the side of the hide to change the flash bulb, she would only walk a few yards away and come back again directly my hand was withdrawn. Gamekeepers have often told me that they have seen Woodcock pick up their chicks between their legs and fly off with them. Ornithologists dispute these observations, and I guess the question will not be answered until some lucky photographer secures a shot of it actually happening."

Montagu's Harrier

"It was while photographing the Montagu's Harrier that we discovered that they are polygamous, with the cock mating with two hens and feeding them alternately. When not in attendance at the nest, the adult birds hunted, quartering their territory low over the ground. Their wings are rather long and narrow for a bird of prey, and, for much of the time, they glide with their wings held in a shallow 'vee', pouncing on their prey which was sometimes small birds, sometimes rodents, having taken it completely by surprise with this stealthy approach. A few years later the RAF asked me if they could use this picture as the crest for 193 Squadron."

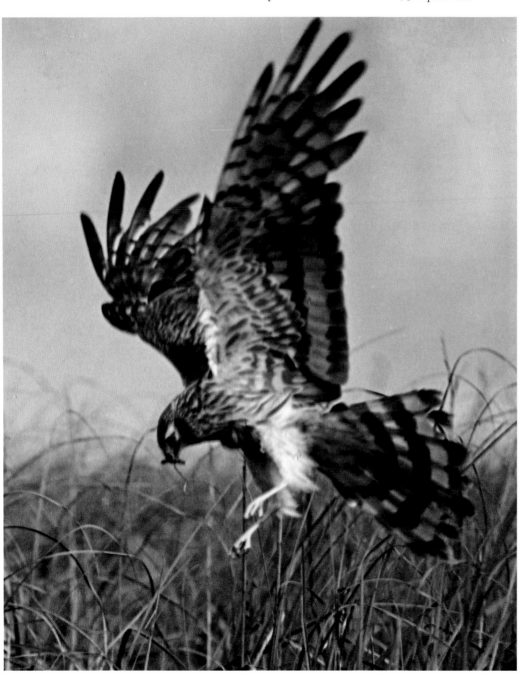

Date
May, 1938

Camera
Sanderson

Lens
Serrac 8 1/2"

Aperture
f11

Shutter
1/50th second

Film
HSFP

GOLDEN EAGLE

"We had decided to combine our honeymoon with the 1939 nesting season and it had been my ambition for many years to photograph Golden Eagle. I had been told about six eyries, but only one was occupied and suitable for photography. Building the hide was fraught with problems, but, after two weeks, we were able to occupy the hide for the first time. Climbing up to the hide terrified Dorothy, and was a struggle for me carrying heavy camera gear, but I shall never forget the first time the Eagle returned. In my opinion, no other bird has such a majestic appearance and commanding aura of power."

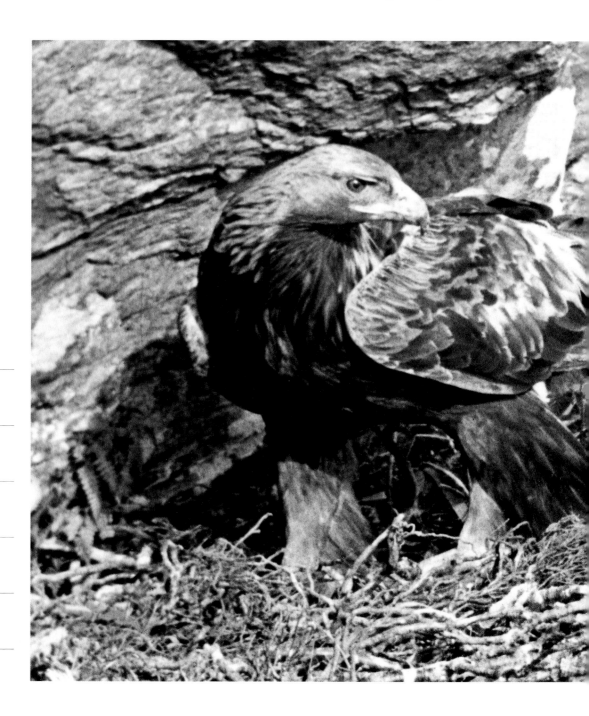

Date
June, 1939

Camera
Sanderson

Lens
Tessera 21cm

Aperture
F/8.5

Shutter
1/25th Second

Film
Super xx Film Pack

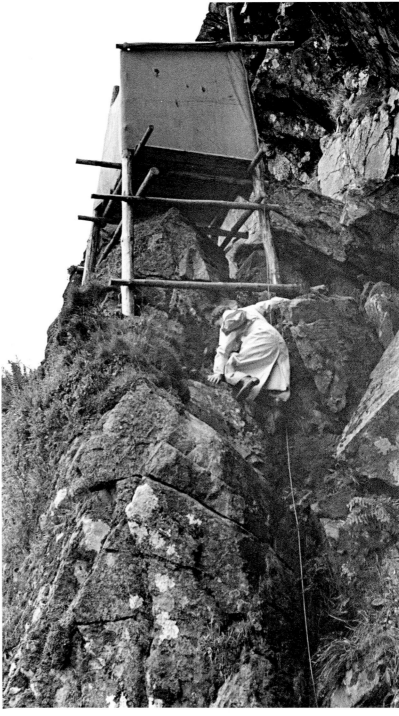

THE BRITISH SCENE

In 1932, close to Staverton Park in Suffolk, Eric met Willy Bilham, a gamekeeper, some of whose countryman's skills he acquired. With Willy he found and followed the incubation and hatching of a Grey Partridge nest, and the account of the day of the hatch is as gripping as the photographs Eric took of the event. Apart from the description of how the chicks actually emerged from the egg (something really only nest photographers are privileged to observe in detail), in particular it is the excited behaviour of the male on seeing his not-yet-dry youngsters, and brooding them for the first time, that remains in the memory.

Visits to East Anglia became a regular feature of each spring and summer, and on many of these Eric was accompanied by George Edwards, a Yorkshireman in whom humour and unflapability were evenly mixed with nest-finding and photographic skills. He was also immensely handy with a hammer and nails (an asset in hide construction) and with small machinery and electrical gadgetry, which made him specially valuable in those early, innovative days when prototype equipment was exposed to habitats (and frequently also climatic conditions) that were far from ideal. Many years later, in 1948, it was to be at Staverton Park that Eric, with Dr Stuart Smith and inevitably with George Edwards, tested out the novel high-speed flash and photo-electric shutter release designed and built by Philip Henry, using a Great Tit nest low in a tree stump as the test-bed.

The principle seems comparatively simple today: as it passed en route to its nest, the bird interrupted a photo-electric beam, which in turn activated a solenoid to fire the shutter. With Eric's knowledge of the way birds normally use the same flight path time after time under the hectic pressure of getting sufficient food to the young in their nest, it was possible to quickly set up the beam in an appropriate position, locate the camera and flash lamps accordingly, and retreat to let the bird take its own photograph. All seemed to go well, and in high excitement Eric rushed to develop his plates at midday, rather than in the evening as was more usual. The results were stunning: not only were details of flight, wing and feather angles revealed, but in crisp detail it was possible to identify most of the insect food that the Great Tits carried in their beaks for the young, a technique subsequently used by many researchers anxious to obtain a food profile for their study species. In the immediate flush of enthusiasm, the team applied their technology just as successfully and revealingly at the nests of Coal Tit,

Wheatear, Whinchat and Swallow. The most famous, and most frequently published, of all Hosking photographs was also the product of this period. In fact one of a series, it is that of a Barn Owl, wings spread in an heraldic posture, with a vole dangling from its beak.

The Norfolk Broads, too, featured large throughout Eric's life. Holidays, and later expeditions, to Potter Heigham, were often accompanied by Cyril Newberry. From Potter Heigham, the two made regular visits to Hickling, one of Britain's foremost wetland areas. Here they met Jim Vincent, a lifelong naturalist and one-time nature-reserve warden, one-time gamekeeper on the Desborough estate at Hickling. He had countryman skills (including a detailed knowledge of local birds and their ways of life) that were without equal in Broadland. In the late 1930s and early 1094s, with Jim's help, they concentrated their efforts on the harriers. Though nowhere common, the Marsh Harrier is a recognised Broadland reedbed speciality, but the Montagu's Harrier is far rarer and far less predictable in its occurences. Eric was able to photograph Montagu's Harriers on their return to the Broads after the 1938 floods, and was able to establish one of the early accounts of polygamy in this species, with the two females whose nests were under observation building nests only 300 yards apart, and sharing the attentions of a single male: both nests successfully raised their young.

Although nest-finding and hide-building occupied a good deal of the time, the detailed observations made of the harriers' lives as the work went on included notes on territorial display, soaring behaviour, and on their 'left-footedness'. Eric had noted that

Redstart, 1947

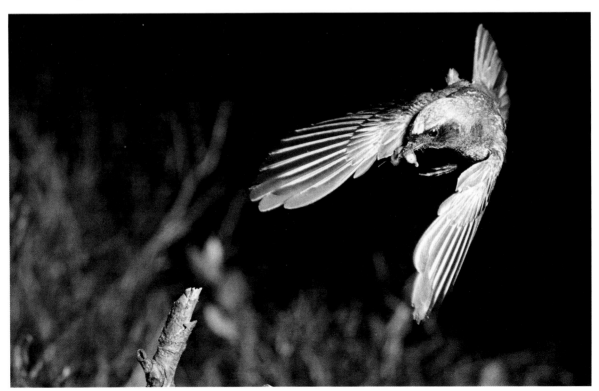

almost all of the raptors that he had photographed, including owls, carried food items in their left talons. Photographers are in the best position to watch the action when a bird of prey approaches the nest, and Eric noted how it was usually just before landing that prey was transferred from the talons to the beak to leave both feet free for the landing. Most spectacular of all were the 'food passes'. Another speciality of the birds of prey, these food transfers take place in flight, sometimes at a height but frequently quite close to the ground, and often at a considerable speed. Male and female approach one another on a collision course, the male carrying recently captured prey. At the last minute, the female rolls over on her back, still in flight, and passes below her mate, snatching the food from his outstretched talons as she passes.

At Hickling, they discovered just how sensitive Marsh Harriers can be at the nest. Despite the care that they had taken in building the hide, and moving it slowly, day by day, closer to the nest, it was the playful activities of local children, enjoying a hot day and a swim in the open water close to the nests that caused one pair to desert, and the pair at whose nest the hide was to loose much of their interest in the young. Though still around, the parent birds made only inadequate and infrequent visits to the nest with food. Eric and Dorothy stepped in as foster parents, managing to keep one chick alive. Just before it fledged, it would hop onto Eric's shoulder as he chopped up its food, but despite the familiarity with man and its boosted diet, it fledged naturally and quickly adopted a truly wild existence, watched by Jim Vincent as it hunted over the reedbeds.

It was here at Hickling in the bleak winter of 1942 that Eric had his first view of what he always considered to be one of the most spectacular of all birds - particularly to an owl fanatic. Driving beside the dunes near Horsey, Jim Vincent drew his attention to a huge all-white bird perched on a stout pole. It was a Snowy Owl, outside the Scottish islands one of the rarest of winter visitors to Britain. Sadly their excitement was short-lived, as their view was abruptly curtailed when a dog, ranging through the dunes, trod on and exploded a mine, part of the wartime coastal defences. It was not until 25 years later that Eric renewed his association with the Snowy Owl, when he was invited by the RSPB to photograph it on its successful debut as a British breeding bird in the Shetlands. In company with Bobby Tulloch, the warden on Fetlar, he recorded all aspects of life at and around the Snowy Owl nest. Quite clearly, the commission thrilled him, and the Fetlar trip remained one of the major landmarks in his long career. Sadly, though further breeding attempts followed, the Snowy Owl - an essentially Arctic species - was at or perhaps just beyond its natural range on Fetlar, and the hoped-for colonisation of our northern isles has yet to materialise.

In company with Cyril Newberry, Eric had visited the Suffolk coast near Sizewell as early as 1933, seeing it in something like its original state, interesting perhaps, remote certainly, but far from

being impressive. It was, ironically, the war that turned this farm-scape into a fabulously rich area for birds and led to the development of one of the most famous of bird reserves in the world, Minsmere. Although it is widely recognised that Minsmere itself is largely shaped by man, less often is it realised that the flooding by man in the earliest days of the war of coastal farmland (as another part of Britain's wartime defences against invasion) created the basic wetland habitat that the RSPB subsequently turned into such a superb reserve.

Many years later, Eric and George Edwards were allowed onto the developing sanctuary to photograph some of its birds. The sheer richness of the birdlife, the beauty of the songs of an extensive 'watch' of Nightingales in nearby South Wood, made a deep impression, and the expedition was most successful. Bonus birds like Peregrine Falcons apart, they managed a stunning tally, including Bittern, Marsh Harrier, Water Rail and Bearded Tit in the reedbeds, and Stone Curlew, Wheatear, Woodlark and Red-backed Shrike on the adjacent heath. Today, Woodlarks are struggling to maintain a toehold as British breeding birds, and the Red-backed Shrike has slipped off the list of regular breeders - a tragedy, for it is a bird with fascinating behaviour, beautiful to see and to photograph, and as Eric pointed out, one with a rather surprisingly attractive song.

From Minsmere, at the invitation of the RSPB, they ventured a few miles south along the coast to visit Havergate to photograph the slowly growing Avocet colony there. The Avocets had returned to East Anglia after the east coast floods of 1947, with a handful of pairs breeding at Havergate and Minsmere for the first time for around a century. As Havergate is an island, setting up the hide and moving it daily closer to the nest was a complicated operation, demanding a daily drive from Westleton, near Minsmere; a boat trip across to Havergate ferried by Reg Partridge, the warden, and finally a slithery scramble across the glistening ooze, at one moment like glass, the next like glue. But eventually all was in place, and George set Eric up in the hide. The photographic stint lasted for nine days, with Eric in the hide for most of the daylight hours. The sheer beauty of the Avocets quickly overcame the photographer's natural worries about disturbing such rare and exciting birds. As it happened, far from being temperamental, the Avocets proved to be positively confiding, and Eric's notes of the parents' behaviour as the first chick pushed aside the cap of its eggshell to emerge, of their evident excitement, and pleasure as the chicks wriggled under the belly feathers to be brooded makes delightful reading.

Most of the 'man-made' development of Minsmere as a reserve took place whilst Bert Axell was warden. Eric had encountered Bert during his period as warden of the RSPB reserve on the immense shingle spit at Dungeness, on the Kent/Sussex border. Among Bert's duties was that of wardening the newly formed bird observatory at Dungeness, and here Eric took many early flight pho-

tographs. Birds trapped for ringing were released down a wide tube, and across the end of the tube the photo-electric beam was set, coupled to the flashes and the camera, so that as they flew out of the tube and off back into the wild, the birds photographed themselves. Bert succeeded Dick Wolfendale at Minsmere in 1959, and immediately applied his intuition and ingenuity to designing a reserve suitable for as many birds as possible. Using local materials (often driftwood scavenged from the beach), and the Army to create lakes and islands with their heavy digging machinery, he transformed the area - particularly the previously dull and ornithologically unproductive parts - and built some of the best timber observation hides anywhere in Britain.

On the other side of Britain, far less known to the general public (though obviously familiar to the local people and to shorebird addicts) are the Hilbre islands in the Cheshire Dee: Hilbre itself, Middle Hilbre and the half-acre Little Eye. Perhaps it is just as well that these are among the least known of our inshore islands, because like all small places, pressure from people (no matter how enthusiastic they may be about nature conservation) could cause them quickly to forfeit their value as a natural high-tide wader roost. Eric clearly regarded Hilbre as one of Britain's natural history gems, and was able, staying in Lewis McAfees' cottage, to demonstrate his support for one of the laws of civilised exploration: "live as well as you can, for as long as you can". Little Eye, the best island for photography, was a mile away from Hilbre over extensive flats of muddy sand. Not just the beauty of a wide expanse of estuary under a huge dome of sky made its impression, but also the lurking

Barn Owl, 1948 fear of the speed with which the tide came in over those flats.

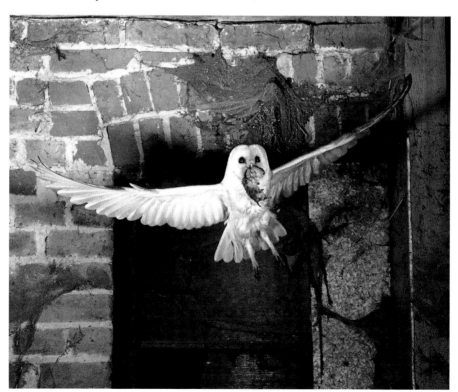

Should the time of the tide have been misjudged, escape across that terrain would have been difficult, hampered as they were with their heavy photographic equipment.

Setting the hide in the correct place demanded good judgement of tide and weather conditions, and then an anxious wait before the birds, mostly out of sight, widely scattered across the whole estuary, began to gather. Eric described as 'unforgettable' the first time (out of forty or more visits) that he witnessed the build up of waders as the incoming tide advanced across their feeding grounds, driving them to roost on Little Eye. He reckoned that on that first occasion, he shared the half-acre of red standstone with 15,000 or more birds, many within a few feet of his hide. So closely-packed were they, particularly the Knot, that newcomers were landing on the backs of those already in position before forcing themselves into a standing place. Eric, even from his close viewpoint, reckoned that it would have been impossible to slide a sheet of paper between one bird and the next. He wrote that in a quarter-century of bird photography, nothing had equalled the Hilbre spectacle. The sweat - raised by the sheer excitement of the occasion - ran down into his eye, making focussing difficult but causing little problem as he was completely out of plates.

For Eric, Hilbre was for some years a centre of annual pilgrimage, in company with a range of ornithological colleagues including Lord Alanbrooke and HRH Prince Philip. Both were as 'hooked' as Eric by the sheer spectacle of the waders and the specially remote atmosphere of the islands, and despite their incredibly busy diaries, they both paid several highly secret return visits. Roger Tory Peterson created some of the wader plates for his landmark *Field Guide to the Birds of Britain and Europe* (with Guy Mountfort and Phil Hollom) whilst with the photographic group on the island.

During one of his pre-war visits to Staverton Park and Eyke, Eric was introduced to Mrs Robert Cobbold and through her, to her mother Mrs Gibson Watt, who had an estate at Doldowlod in mid-Wales. Following an invitation to photograph there, Eric photographed Ravens (a tree nest, using a pylon hide) in 1937, and in 1938, with Cyril Newberry, Buzzards (again in an oak tree and again from a pylon hide). The Buzzards made banner headlines in *The Times* of 27th August, 1938.

Eric was already fascinated by owls above all other birds, and wherever he went on field photographic sessions he sought out local information on breeding owls. There were several pairs of Tawny Owls around Doldowlod, and in 1937 the local schoolchildren told Eric of a nest they had found - again needing a pylon hide as it was 18 feet above the ground. Flash of course was necessary for these strictly nocturnal birds, and on the afternoon of May 13th, Eric and Cyril set up their equipment. That evening, Eric had a fruitless two-hour session in the hide, and summoned Cyril by torch flash. As they were leaving the wood, they heard voices. Concerned that the theft of flash equipment would wreck the

remainder of the season, they turned back to be sure that all was safe. As Eric climbed up the pylon, the Tawny Owl launched a silent and unseen attack in defence of its nest. By ill-luck, one of its fiercesomely sharp talons struck Eric in the eye. The wound was deep and agonising, but somehow they got back to base. Local medical opinion directed them to Moorfields Eye Hospital, in London, where Cyril drove Eric non-stop through the remainder of the night. Not surprisingly, the wound was infected, and as it was before the discovery of antibiotics, Eric was faced with the stark decision of possibly losing the sight of both eyes to an opthalmia infection, or for greater safety, having the injured eye removed. The knowledge that one of the old 'greats' of bird photography and one of Eric's idols, Walter Higham, had only one eye helped with the decision making. Within three days, protected by a fencing mask, Eric was back in the hide, anxious not to lose his nerve. But to no avail - the owlets had flown.

Eric had had his first extended experience of Scotland and the vicissitudes of its climate, habitats and birds while on honeymoon with Dorothy. After the end of the war, he returned first to the Orkneys, with George Edwards, in 1946. They were struck by the unusual tameness of the birds they met, a feature not uncommon

Barn Owl—first flash bulb, 1936

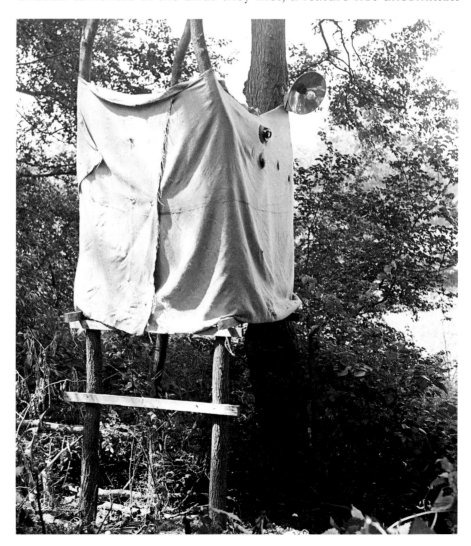

the further north you venture. They complained, too, at the noise of the local Corncrakes: Eric noted that eight pairs produced their monotonous, and seemingly unending, calls within earshot of their lodgings throughout the night. Sadly, the Corncrake population even in the Northern and Western Isles of Scotland is now so depleted that such a volume of nocturnal chorus is almost impossible to acheive anywhere: conservationists would be delighted to be able to endure it!

The next year Eric and George again travelled north for the summer to the Scottish Highlands where they met up with Desmond Nethersole-Thompson, incredibly skilled at nest finding and an expert on the Greenshank, amongst many other things. Despite the weather, a Greenshank's nest was located, and even more surprising as conditions were so poor, Eric achieved a superb series of photographs of the hatch. On the same trip, they found a late-laying Scottish Crossbill, and with the aid of a hastily-erected pylon hide, photographed both adults at the nest in the top of a Scots pine.

That same year, James Fisher organised two aerial reconnaisance flights northwards, and invited Eric as the 'official photographer'. The first, at the end of July, targeted Rockall (a rock outcrop out in the North Atlantic that held a special fascination for James) and sought to see if it held breeding seabirds. It did not, but the flight, by Sunderland flying boat, took the party (at reasonably low, if bumpy, altitudes) over many of the spectacular coastal sights of western Scotland, including a circuit of the St Kilda group. With its huge gannetry on Boreray and its giant attendants, Stac Lee and Stac-an-Armin, and the enormous numbers of Fulmars and other seabirds everywhere, St Kilda was and is very much the Mecca of all seabird enthusiasts such as James Fisher. The second flight, in the far less favourable conditions of late September, aimed to census the Atlantic grey seal populations off the west coast, starting at Skokholm, Skomer and Grassholm, off Pembrokeshire, and turning at Muckle Flugga, Britain's northernmost tip. At the low levels necessary to identify seal calves on boulder beaches, this was for most of the participants a most uncomfortable ride, and the weather conditions made successful photography extremely difficult - but at least one large new seal colony (on Gasker, west of the Outer Hebrides) was located.

Not all summers were spent on photographic expeditions so far away from home. For instance, 1951 offers an ideal example of the varied bag that could be obtained in a single season. Perhaps the main target was the heronry in the treetops of an island in the Walthamstow Reservoirs, only a few miles from Crouch Hall Road. Eric and George Edwards built a pylon hide, and during the season obtained some splendid shots of Herons and their young. Eric in his notes detailed the astonishing furore that followed the return of an adult to the nest with food: the greedy squabbling, the prey gulped down whole (and often still wriggling), and the terrible din

of raucous squawks. He also noted the smell, which rose to a stench on warmer days, and which of course was unavoidable in the hide if the wind was unfavourable! As an incidental bonus, they located a Kingfisher nest while rowing back and forth to the heronry island. This they were able to work using flash and the photo-electric beam trigger mechanism to 'stop' the Kingfisher in flight as it approached its nest hole.

That same season, John Parrinder, the Little Ringed Plover specialist, called for help to take a series of photographs of this comparatively new British colonist. The boom in the construction industry as post-war Britain got itself back on its feet meant that new gravel pits and sand pits were regularly being opened to supply the raw materials for the vast amounts of concrete needed. These diggings, together with new chalk quarries and reservoirs under construction, provided excellent habitat for the expanding 'LRP' population. After considerable effort - because the nest and eggs are so well camouflaged, and to tread on a nest while searching for it was absolutely unthinkable - a suitable nest was located and photographed at Chingford. Eric was pleased to record the assistance he was offered, and the protection the vulnerable nest received, once the bulldozer drivers on site knew what was going on.

London itself had suffered immense structural damage during the blitz, and from rocket attack later in the war. In 1951, many damaged buildings and piles of brick rubble still remained, particularly in the City, and here a strange colonist had appeared, the Black Redstart. On the Continent, particularly in the warm south, the Black Redstart is a common enough city rooftop bird. Elsewhere, it is a bird of mountain screes. It is far from certain what attracted a few pairs to the wreckage of London in the 1940s and 1950s - but perhaps it might just have been the similarity of the rubble heaps to its natural rocky screes that did the trick. Again, nests were hard (and sometimes dangerous) to find, but a famous and frequently used sequence of photographs was the result of the season's efforts.

The early and mid-1950s were exciting times in ornithology. The conservation movement was getting underway, raising the nation's awareness of wildlife affairs and creating the foundations of today's network of nature reserves. In addition, round the coasts of Britain and Ireland, a network of bird observatories was developing, usually centred on a geographical feature that year after year drew crowds of migrant birds - often a point or headland, jutting into the sea. At these observatories, bird movements are counted and logged, but above all, migrants are trapped and ringed. This process aims to discover their migratory routes and destinations, their timing, and to investigate many other facets such as the ultimate causes of death and their state of health (particularly the amount of fat they are carrying as 'fuel' for the long journey ahead).

Eric's first visit to a bird observatory was to Spurn Head, on the

north side of the Humber. 'Once in a while comes a lucky break' wrote Eric of his excursion to Yorkshire, 'you are in the right place at the right time'. At the start of October 1952, fine weather associated with a high-pressure area over Scandinavia encouraged many hundreds of thousands of migrants from the north to set off in the evening from the continent. Aided by strong easterly winds, these migrants drifted across the North Sea, making landfall along the east coast of Britain from the Shetlands to East Anglia. Next day, from dawn onwards, the Spurn peninsula was alive with birds, particularly with Robins, which 'ticked' aggressively from every patch of vegetation. By the end of the day, 189 birds had been ringed - marked with a lightweight aluminium alloy band, stamped with an address for its return if found, together with an individual serial number. Next day in continuing fine weather with strong easterlies, there were even more birds, again predominantly Robins, but also including some of the larger members of the thrush family: Fieldfares, Redwings and Ring Ousels along with Blackbirds and Song Thrushes. Amongst the Scandinavian birds caught was a spectacular Great Grey Shrike which Eric was delighted to capture on film, too.

Spectacular though this 'fall' of migrants undoubtedly was, better was to come, on 3 September 1965. Eric was with Bert Axell at Minsmere, and although not a bird observatory in the strictest sense, detailed daily counts are taken at this as at most other bird reserves. These records serve more potently than anything else to reinforce the part that many of them (including Minsmere) play year-round, rather than simply as protected breeding grounds for birds of a specialised habitat. On this occasion, it was not a high-pressure area but a deep depression with heavy rain, originating in Italy, that caused the migration spectacular. Moving northwest, the low crossed the North Sea and reached East Anglia by midday. The weather, of course, was awful, but suddenly the wind shifted round to the southeast and Minsmere was swamped with birds, tumbling from the skies just as heavily as the rain had been earlier. This turned out to be one of the heaviest 'falls' ever recorded on the east coast, involving not only small passerines but also waders of a couple of dozen species! Amongst the small migrants on the reserve (which has a coastal frontage of about 3/4 mile) that afternoon were several thousand each of Wheatears, Redstarts, Pied Flycatchers and Garden Warblers, and several hundred each of Robins and Tree Pipits. This experience, though not producing much in the way of photographs, provided a further example of Eric's uncanny knack of being in the right place at the right time. Clearly it made a deep impression, revealing to him another facet of the lives of birds. He was familiar with the intimate, privileged view that the photographer has of the behaviour of birds at the nest, but these experiences showed Eric the sheer magnificence of the scale of bird migration, highlighting the challenges that still await researchers attempting to answer the question 'how?'

LONG-EARED OWL

"To my mind the Long-eared Owl is the most nocturnal of all British owls and, while staying with Nat Tracey near King's Lynn, he took me to a nest built in an old Carrion Crow nest in a spruce fir tree. Like the other owls, they never build a nest for themselves. I spent many hours in the hide and found it a most interesting experience. When they are at ease and feel themselves unobserved,

Date
April, 1940

Camera
Sanderson

Lens
Tessar 21cm

Aperture
F16

Shutter
Flash Bulbs

Film
P800

they brood with their feathers fluffed out like a contented cat. However, at the first sign of danger, they clamp their feathers close to their body and become much slimmer, remaining totally motionless and relying on their wonderful camouflage to escape detection. Obviously my presence in the hide did not disturb this bird as she settled back onto her eggs."

GREENSHANK

"On the day this hatch took place, it was raining heavily and most of the time the light was impossible for photography. The bird was very wild and nervous while away from the nest and mobbed us persistently when we were within 300. However, once she was on or near the nest, she took little notice and was easy to portray when the hide was occupied."

Date
May, 1940

Camera
Sanderson

Lens
Serrac 8 1/2"

Aperture
F/11

Shutter
1sec

Film
S.S. Pan

These photographs, taken in available light, of a bird walking about beside its nest and removing an egg shell, were taken at the amazingly long exposure of one second. Few of his photographs pay greater tribute to Eric's photographic skills than these, demonstrating as they do his ability to time to perfection when to press the shutter release to obtain superb pictures with no trace of movement. They remain classics

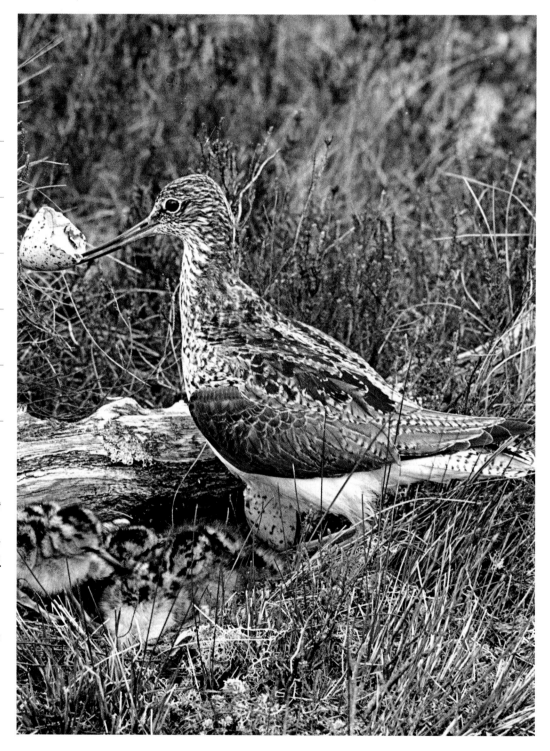

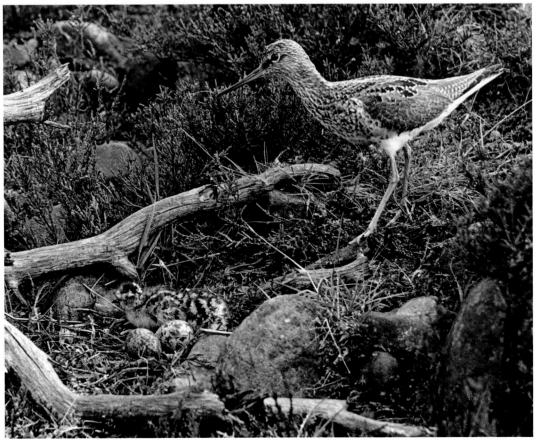

SHOVELER

Date
1941

Camera
Sanderson

Lens
Tessar 21cm

Aperture
F22

Shutter
1/10th

Film
P800

"Of all the bird families the ducks are the most difficult to photograph at the nest and this female Shoveler was no exception. They will desert at the least provocation and a great deal of care must be taken when working a hide into position. It is easy to see how the Shoveler got its name with such a massive spoon-shaped beak. This is ideal for dabbling in soft mud to sift out its plant seed food. On the water, Shovelers float 'down at the bows', another indiction of the size and weight of their beak."

MARSH HARRIER

"The magnificent spread of the cock Marsh Harrier's wings contrasts with those of the down-clad young. Marsh Harriers have much broader wings than the other harriers, but hunt in the same way, gliding low just above the reeds and pouncing down on their prey. The female is just as handsome as the male, with uniformly chocolate brown plumage and bold pale yellow patches on her crown and cheeks."

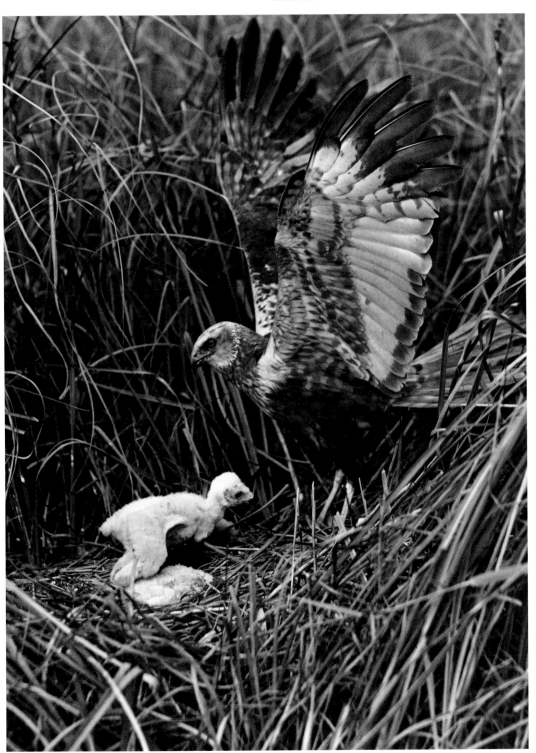

Date
1942

Camera
Sanderson

Lens
Tessar 21cm

Aperture
F16

Shutter
1/100th second

Film
P1200

SHORT-EARED OWL

"Unlike most of the other British owls, the Short-eared shuns the woodlands and we found this nest at Hickling on the Norfolk Broads, under a tuft of tangled grasses on the open marsh and only a few hundred yards inland from the sandhills that fringe the coastline. The Short-eared Owl hunts almost entirely during the daylight hours, gliding low across the marsh on stiffly held wings. The great difference in size between the young owls is because the hen starts incubating when she lays her first egg. Other eggs are laid at two-day intervals, but, as they all have the same incubation time, they also hatch with two-day gaps between. So, in a brood of four youngsters, the oldest is more than a week older and larger than the youngest."

Date
May, 1942

Camera
Sanderson

Lens
21cm Tessar

Aperture
F16

Shutter
1/10th second

Film
P800

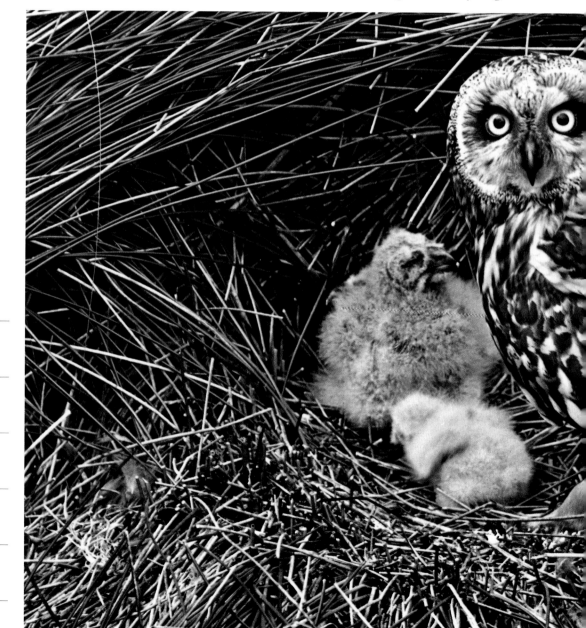

HOBBY

"In many ways this photograph is my favourite of all the exposures I made at this nest." It was at this nest that Eric for the first time shared a hide with Lord Alanbrooke - the first of many. In *An Eye for a Bird* Eric recounts his first meeting with that great man, then Chief of the Imperial General Staff. He wanted to enlist Lord Alanbrooke's help in getting permission to photograph on Water Board land. As he says, he was greeted "by a man wearing an old, open-necked shirt, vivid red braces and old khaki trousers"

Lord Alanbrooke was leaving almost immediately for the vital Potsdam Conference, but managed to secure the necessary permission - provided that he too could use the hide. This was the beginning of a long and fruitful friendship.

Date
July, 1945

Camera
Sanderson

Lens
Tessar 8 1/2"

Aperture
F16

Shutter
1/25th second

Film
P1200

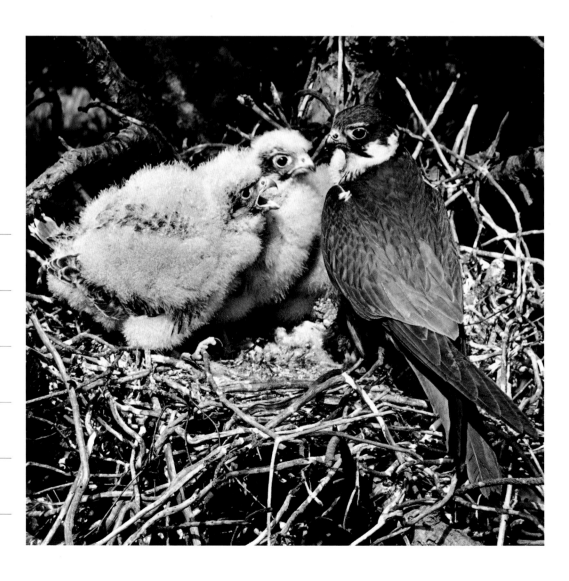

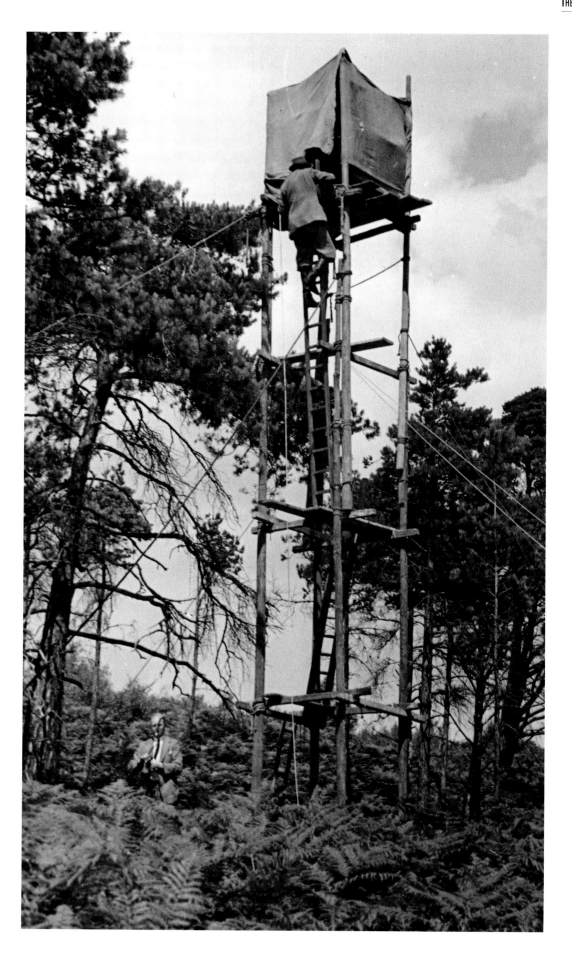

SCOTTISH CROSSBILL

"This photograph shows the attitudes of the female and young at the approach of the male to the nest. On hearing the male, the female would usually rise from the nest, and rapidly quiver her wings and beg for food. On reaching the nest the male wasted no time in feeding. The nestlings were only a few days old, and still blind and naked. At this stage, their beaks were short and had yet to develop the crossed tips that are so characteristic of their parents. The crossed mandibles are used to extract the slim kernels from between the scales of pine cones. Owing to the poor light I used the 'Dawe' electronic flash."

Date
June, 1947

Camera
Sanderson

Lens
Tessar 8 1/2"

Aperture
F/12.7

Shutter
Slow Luc Flash duration
1/10,000th second

Film
P1200
The Scottish Crossbill was recently accorded the rank of full species as Loxia scotica: *When Eric took this shot, it was merely a subspecies of the Common Crossbill,* Loxia curvirostra

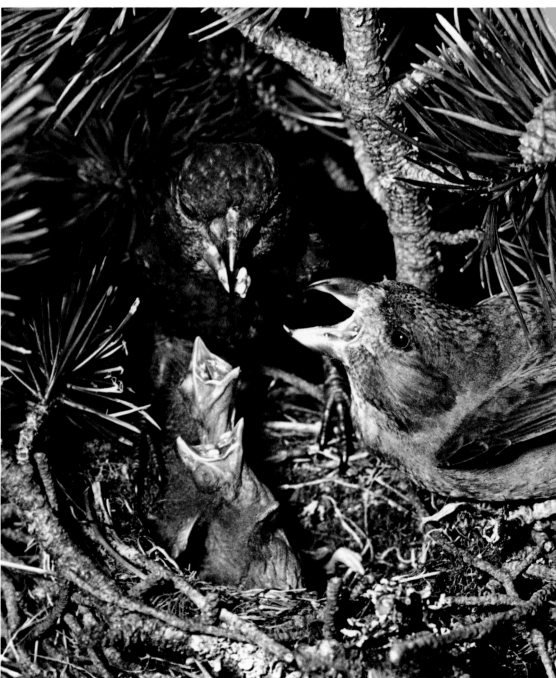

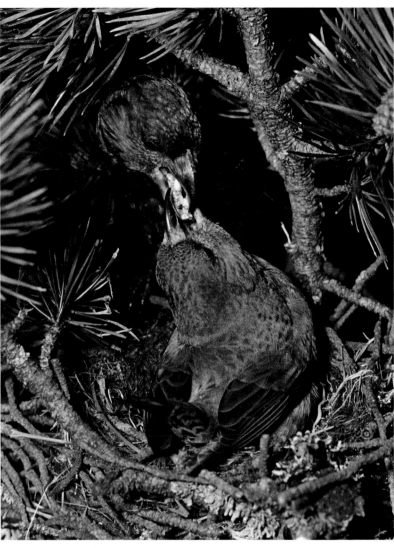

REDSTART

"It is interesting to note the position of the wings and tail and also the rat-tailed maggot carried in the bill. Redstarts almost always nest in holes in the deep shade cast by massive oaks and beeches, conditions that make normal photography and the securing of high-quality shots extremely difficult. This photograph of a Redstart shows the tremendous advantage to be obtained by using high-speed flash. The flash duration of 1/10,000th of a second provided excellent illumination of the subject and froze all movement."

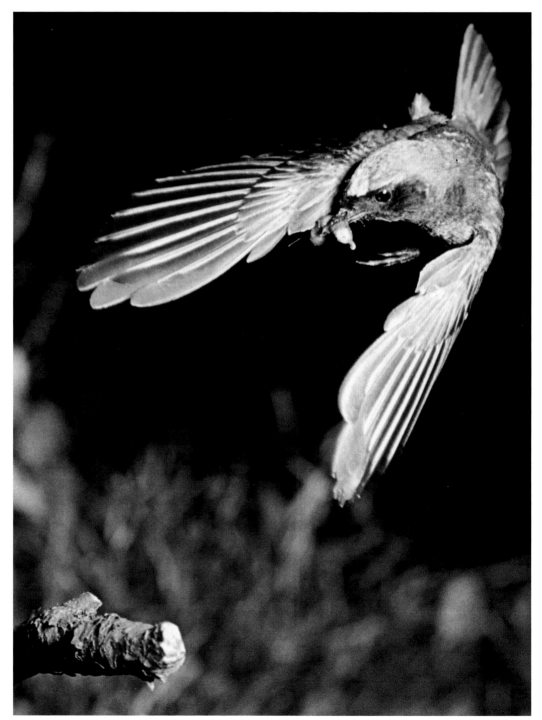

Date
June, 1947

Camera
Brand 17

Lens
Tessar 21cm

Aperture
F32

Shutter
Slow Luc Flash duration
1/10,000th

Film
P1200
This was one of the first successful high-speed flash photographs ever taken of a bird.

NIGHTINGALE

"I wish that I could claim this as a photograph of a male Nightingale in full song taken at night! Not that it would be in this position, even when in song, but at first sight it does perhaps give this impression. The bird is, in reality, 'swearing' at a stuffed cuckoo erected within a few feet of the nest! In *British Birds* for January 1949 will be found a full account of the reaction of these Nightingales to a dummy cuckoo so I will not attempt to repeat it here. Of course all the time we were in the wood photographing our experiments with stuffed cuckoos, we had as background music the glorious song of other male Nightingales. They sing just as much during the day as at night, but there is more competition from other songsters like Garden Warbler, Blackcap and our well-known Blackbird, which is no mean songster in its own right"

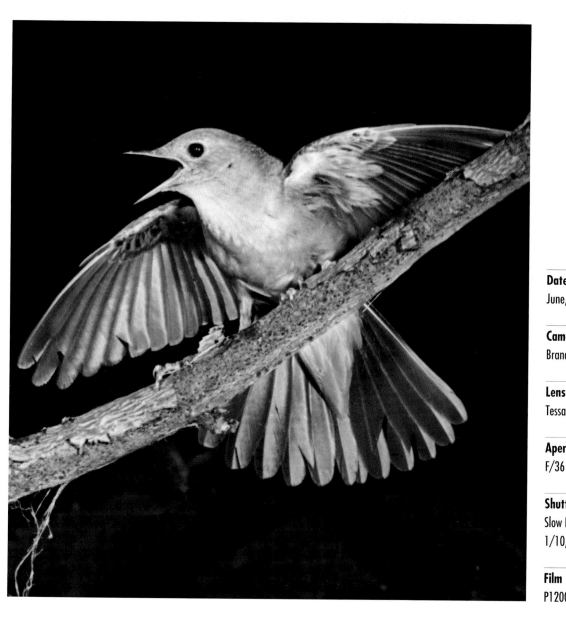

Date
June, 1948

Camera
Brand 17

Lens
Tessar 8 1/2"

Aperture
F/36

Shutter
Slow Luc, Flash duration
1/10,000th second

Film
P1200

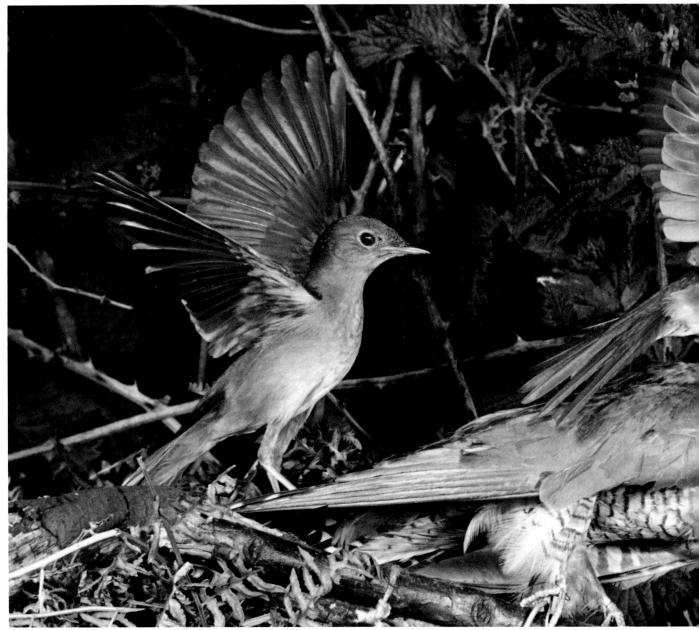

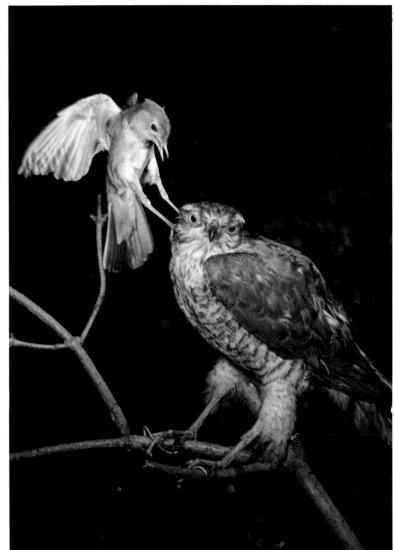

WHINCHAT

"Some people might object to the black background, but, when using the high speed flash, one has to have a flash exposure which is greater than the daylight exposure, to stop a secondary image. I hope you will agree that it still makes an interesting picture."

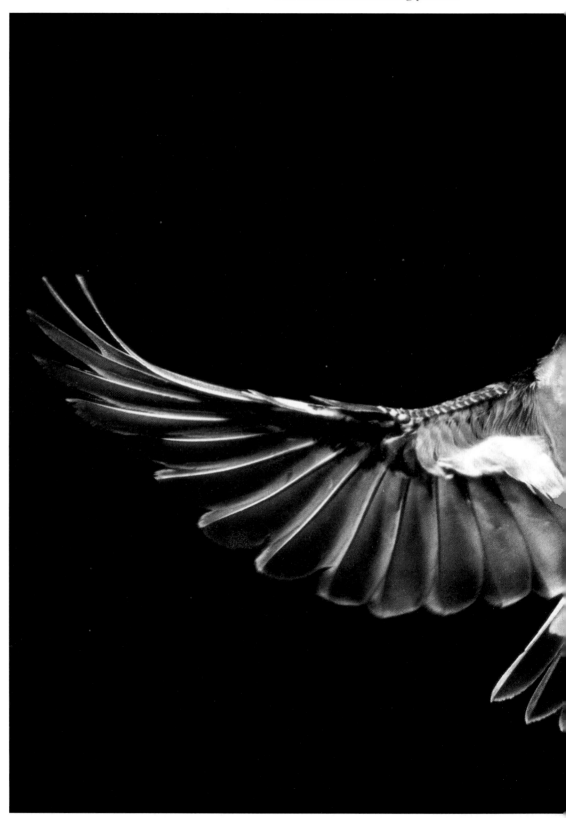

Date
June, 1948

Camera
Brand 17

Lens
Tessar 8 1/2"

Aperture
F/36

Shutter
High Speed Flash
1/10,000th second

Film
P 1200

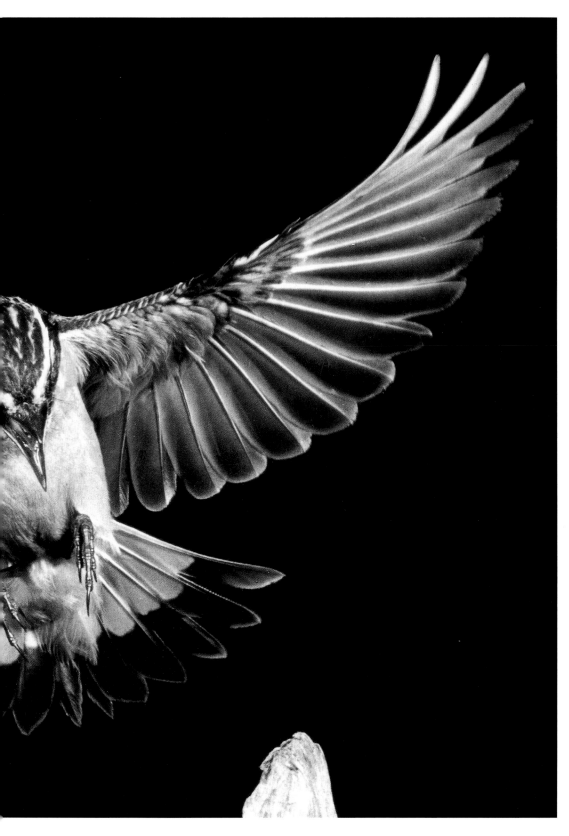

Eric's high speed flash shots in the late 1940s began to provide dramatic evidence of how birds fly: The attitude of the wings and tail of this Whinchat, and the way the primary or flight feathers are splayed so widely, is typical of a small bird braking hard in mid-air as it approaches a perch.

WHEATEAR

"Most of the Wheatear nests that we had been finding in Suffolk were in disused rabbit holes, but this unusual nest in a fallen tree offered an ideal opportunity to use the high speed flash equipment"

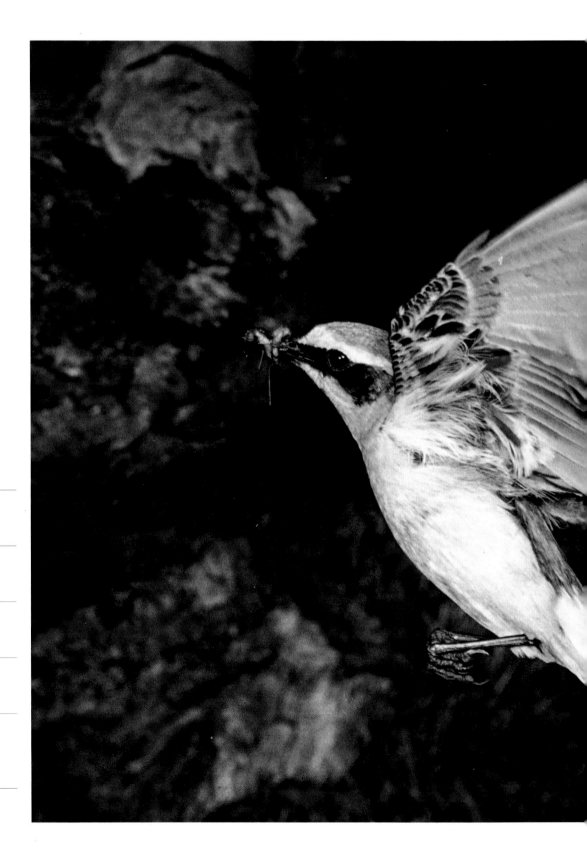

Date
June, 1948

Camera
Brand 17

Lens
Tessar 8 1/2"

Aperture
F/36

Shutter
High Speed Flash
1/10,000th second

Film
P 1200

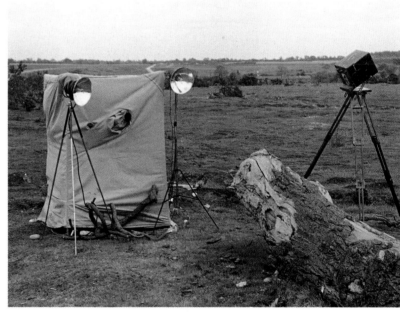

BARN OWL

"This is the first of a series of Barn Owls photographed in flight by high speed flash inside a Suffolk barn. The method used was simply for the owl to fly across an invisible beam which triggered a solenoid that fired a shutter and this tripped the flash. It sounds simple enough but the complete apparatus was exceedingly complicated and very heavy.

On their way to the nest in a grain-hopper inside the barn, the owl flew through a broken window where the high speed flash pictures were taken. Below the owl has just alighted, given food to one of the young and is about to leave. Her visits, when the young were this age, were extremely short.

Opposite is another from the series of Barn Owls taken in flight. The spread of the wings gives the impression of a ballet dancer."

Date
July, 1948

Camera
Brand 17

Lens
Tessar

Aperture
F/36

Shutter
Slow Luc, flash duration
1/10,000th second

Film
P1200

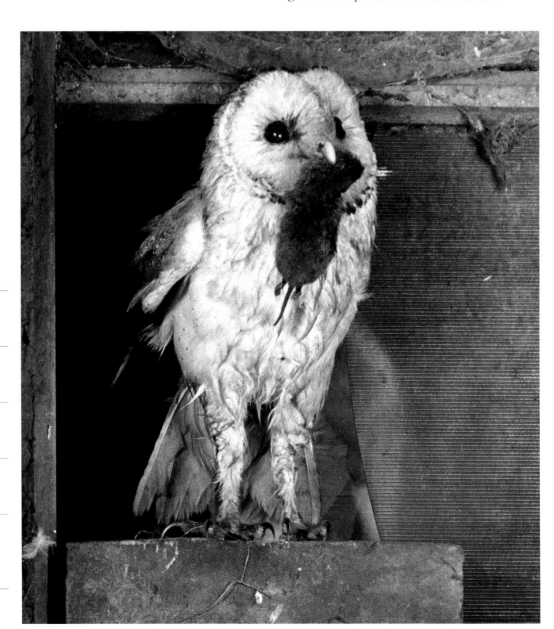

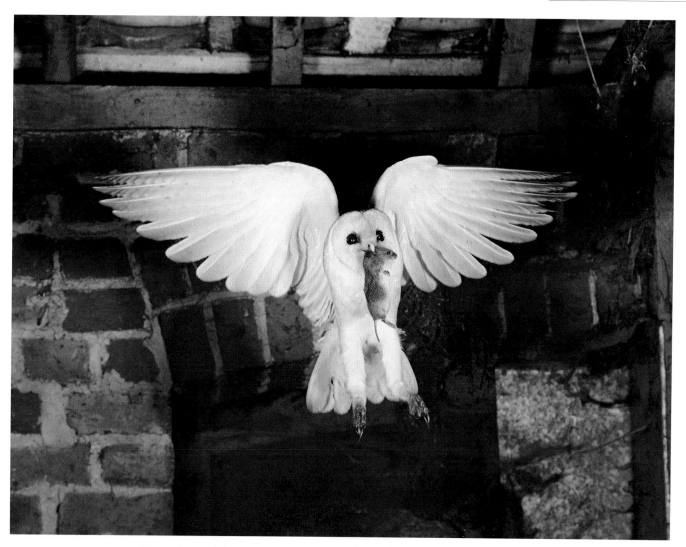

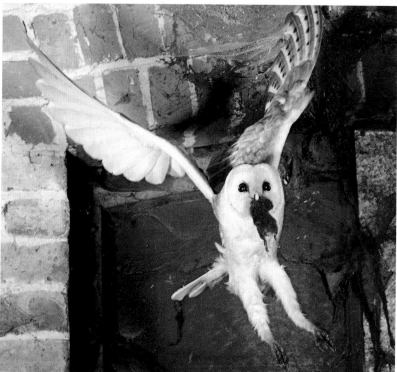

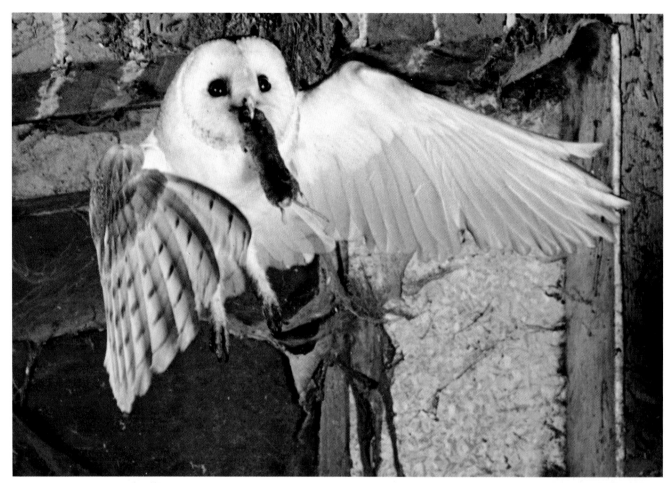

One of the most interesting points about this particular pair of Barn Owls was the variety of food they brought to the nest. Some prints show a wood mouse, while in other photographs there are water voles, shrews, both bank and field voles, moles and rats.

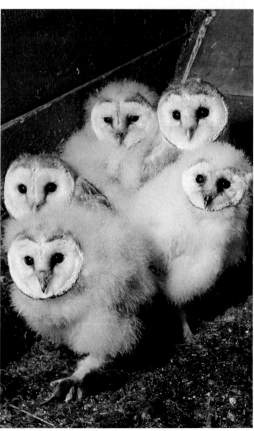

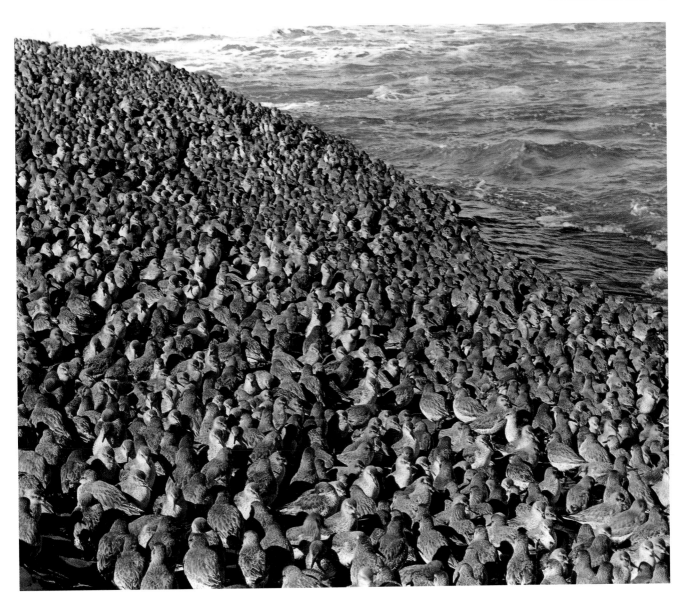

KNOT

"I shall never forget the experience of taking this photograph of Knot. About 200 to 300 Knot alighted at the water's edge and every few minutes afterwards clouds more came down. The rising tide drove them towards me and when a particularly large wave broke near the shore, the whole flock numbering several thousands advanced like a vast army of miniature men, only dividing into two groups as they went by the hide on either side. The two Oystercatchers look like sentinels in the distance."

Photography on Hilbre Island in Cheshire demands an excellent knowledge of bird behaviour, competent weather forecasting, an intimate understanding of local tide tables and the skills to integrate all of these and successfully position the hide: plus, of course, a considerable slice of luck!

Date
March, 1949

Camera
Brand 17

Lens
Ekta 8"

Aperture
F/32

Shutter
1/25th second

Film
P1200

LITTLE OWL

"One of a series of Little Owl pictures taken this spring in Suffolk. A photo-electric trip was used to secure this photograph. The young had only recently hatched and were being fed on a variety of food, including worms and mice. This picture looks as if the worm has a pair of hind legs, but this is only a piece of straw."

Date
May, 1949

Camera
Brand 17

Lens
Ekta 8"

Aperture
F/32

Shutter
High Speed Flash at
1/5000th second

Film
P 1200

Note the emargination to the webs of the outermost primaries, or flight feathers. The 'slots' created by this feather shaping greatly enhance the aerodynamic properties of the wings in low-speed flight, just like the slots on a modern aircraft wing, which are mechanically operated as it comes into land.

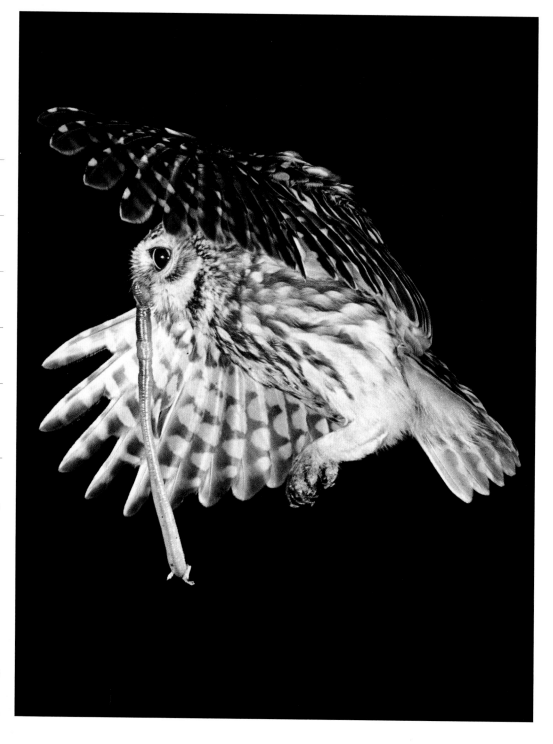

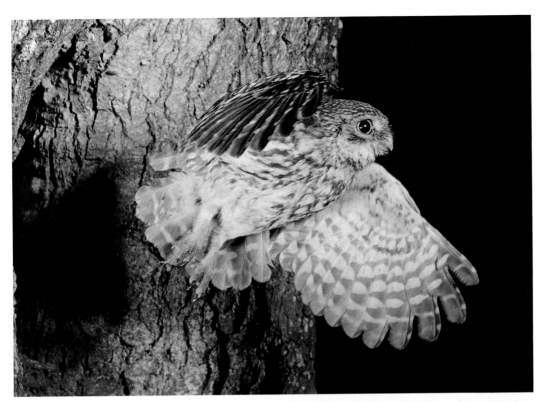

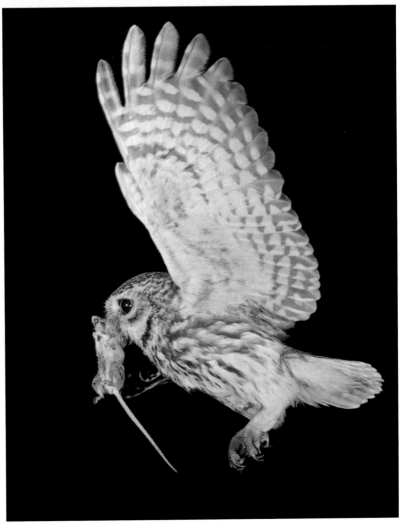

NIGHTJAR

"The male of this pair normally hovered above the nest before alighting, so the photo-cell trip was focused to cover that area. It was pitch dark when this was taken and I had no idea that the bird was anywhere near. I would like to draw attention to the rather curious position of the far wing and for some time I was puzzled by the twist in it, but it would appear that this was caused by the hovering motion."

Top right:"For a long while I have been attempting to photograph a Nightjar yawning to show the enormous spread of the gape, but the action is so quick that it is all over before you realise what is happening. At this nest many attempts were made before the resulting picture was taken. Yawning usually preceeds the casting of a pellet containing the hard and indigestible remains of insects recently caught and eaten. Immediately this shot was taken, the hen did produce a pellet."

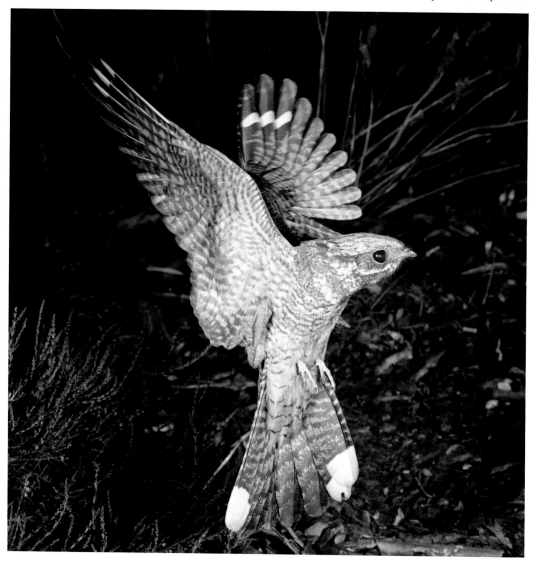

Date
July, 1949

Camera
Brand 17

Lens
Tessar 8 1/2"

Aperture
F/36

Shutter
High Speed Flash
1 /10,000th of a second

Film
P 1200

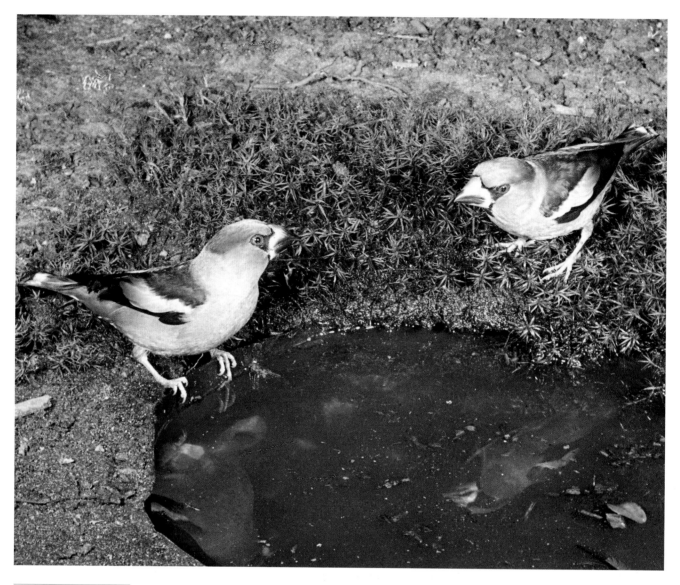

HAWFINCH

Date
June, 1949

Camera
Brand 17

Lens
Ekta 8"

Aperture
F/32

Shutter
Luc Shutter with High Speed
Flash 1/5000th second

Film
P1200

"Here is a print of a pair of Hawfinches drinking at an artificial pool erected in a Suffolk wood. Hawfinches were by far the most frequent visitors and we got to know the various individuals quite well as their plumage variation was most marked and we noted that each bird came to drink regularly every 30 to 40 minutes during the hot weather."

Notes like these, taken by Eric and many other photographers, who had the opportunity and patience to observe and record on paper what they saw, as well as securing high-quality photographic images, were, and remain, immensely helpful to ornithologists in the study of plumage variation and bird behaviour.

HOUSE MARTIN

"We found that, by making an artificial muddy puddle, the House Martins were attracted down to take the mud for nest building. Each bird took away what seemed to me to be a huge and difficult mouthful. Back at their nest under the eaves of a house, the Martins placed each mud pellet in position with the care and skill of a bricklayer. You could see from the different colours of the mud pellets that the birds visited several puddles in different areas to get their building material. House Martins have their legs feathered right down to the toes, and as you can see from this shot, they manage to keep them spotlessly white all the time."

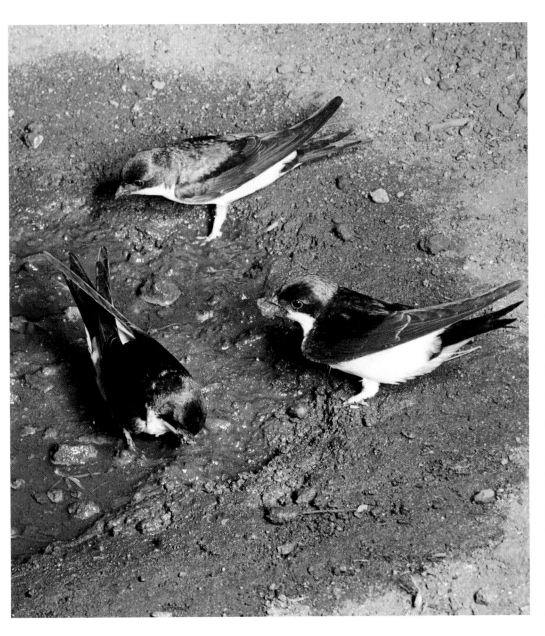

Date
June, 1949

Camera
Brand 17

Lens
Ekta 8"

Aperture
F/32

Shutter
Luc Shutter with High Speed Flash 1/5000th second

Film
P1200

SAND MARTIN

"While working at Minsmere, we noticed that as the Sand Martins arrived they gathered in considerable numbers on an island reed bed in the middle of a jheel. We erected a hide, but the difficulty was to cover sufficient depth of field to get all the birds in focus on reeds that were continually swaying about in the wind. Hence instead of trying to get photographs to show the numbers, we concentrated on small groups."

Date
May, 1950

Camera
Brand 17

Lens
Tessar 8 1/2"

Aperture
F/16

Shutter
Fast Luc

Film
P1200

In 1950, when Eric took this photograph, Sand Martins were widespread and numerous in Britain, perhaps one of the most numerous of all summer migrants. Hardly any sand pit was without a nesting colony and all wetland areas provided ideal feeding grounds for local breeding birds and migrants alike. In the late 1960s, this picture changed dramatically. The droughts that ravaged the Sahel region, south of the Sahara Desert, causing so much human starvation and misery, also almost eliminated the British Sand Martins' wintering grounds. Since that time, there has been little sign of recovery and Sand Martins remain relatively scarce birds today.

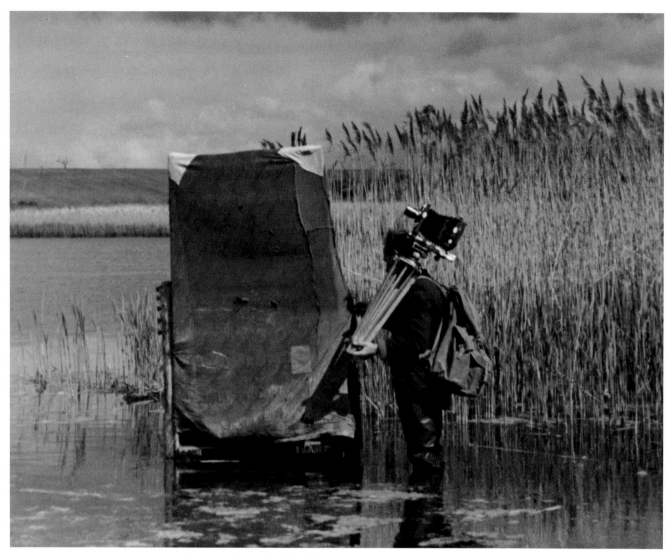

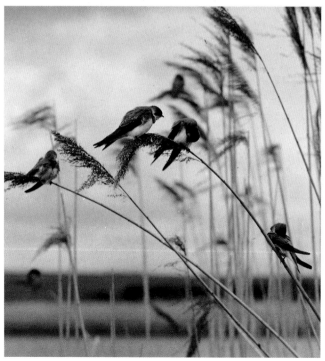

BITTERN

"Shortly after we found this nest, Charles Tunnicliffe, one of our finest bird artists, came to stay and he showed me a portrait of a Bittern he was painting. He seemed to know that something was wrong and asked my opinion. I said that the position of the eyes was inaccurate. He had used the skin of a Bittern as the basis of his painting. This of course did not show that the bird is a trifle boss-eyed, so I suggested he used our Bittern hide. Later, much to my surprise and delight, he sent me a magnificent painting of a Long-eared Owl and this remains one of my most treasured possessions."

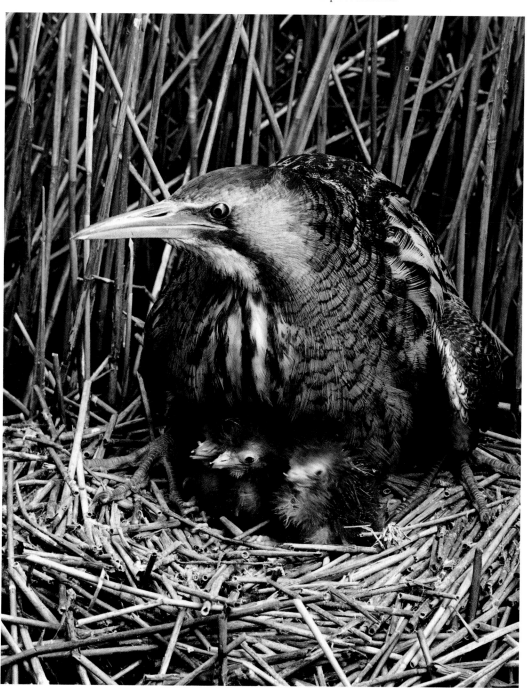

Date
May, 1950

Camera
Brand 17

Lens
Tessar 8 1/2"

Aperture
F/22

Shutter
Slow Luc

Film
P1200

Like other members of the heron family, Bitterns can swivel their eyes in their sockets, almost like a chameleon. This allows them to scan the water and reeds all around for potential prey, without having to move their head. Eye movement is difficult to detect, whereas, were the Bittern to turn its head, movement of that large, dagger-like beak would be an instant give-away.

INTO EUROPE – AND BEYOND

Though adventurous Englishmen and women had been travelling to the less-explored, less-'civilised' parts of the world for a great many years, even as recently as the 1950s they were considered to be perhaps slightly eccentric by their compatriots. The intervention of the war years, and the slow recovery of European economies after the war was an additional impediment to travel. Nevertheless, by 1952, Eric felt that his photographic collection was in need of material from continental Europe, and he embarked with Stuart Smith and George Edwards on his first overseas expedition, to the Netherlands. It is interesting to see that the first thing that struck them, as they approached the Hook of Holland from Harwich, was the presence of neat Little Gulls amongst the plentiful Black-headed Gulls along the coast. Much the same first thought would surely strike the traveller on cross-channel ferries today as the harbour mouth - anywhere from the Hook and Vlissingen south to Ostende - came into sight, how pleasant to see Little Gulls again. In 1952, Holland (and Britain too) had far fewer cars, and indeed the Dutch had the reputation, with their flat landscape, of being *the* cycling nation. Certainly Eric and his companions had something of an ordeal by fire as they approached Rotterdam, apprehensive and cautious about driving on the 'wrong' side of the road, to be confronted by seemingly endless waves of cyclists going home in the rush hour. Staying with Jo den Harings, a knowledgable Dutch ornithologist and botanist, the team had targetted for photographic attention those birds which were real rarities in Britain, yet which were quite routine in the Netherlands. In geographical terms they were so close, just across the North Sea, but in ecological terms they were very much representatives of the avifauna of a major continent, not just one of its offshore islands. These included species such as Ruff, Avocet, Kentish Plover and Black Tern.

The Dutch as a nation have been concerned over wildlife conservation for far longer than the British, and even before the war conservation featured as a routine component of their school curriculum. In consequence, many of the birds that they sought were both more numerous, and considerably tamer than they expected. Nor did they expect to be able to stop schoolboys, cycling past, and be taken enthusiastically in hand and conducted to the nearest nesting sites of the birds they sought. Approachable they certainly were: Eric told in amazement of Kentish Plovers running almost between their feet, and of the Avocet which returned to her nest as

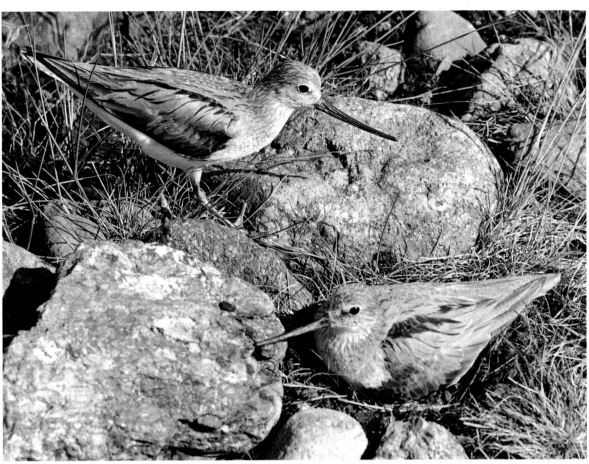

Terek Sandpipers, 1952

they knelt beside it admiring the eggs, and pecked at George Edwards' hand. Sadly, much of the land where they enjoyed the birds and the photography so much has since been swallowed up in dockland, refinery and the other components that have turned Greater Rotterdam into one of the world's major commercial centres: they were lucky to see it in its prime. They accomplished a great deal - Golden Oriole, Hoopoe, Icterine Warbler on dry land; displaying Ruff, floating Black Tern nests, and near-perfectly camouflaged Little Bitterns in the wetlands.

They enjoyed, too, another example of the Hosking luck. Photographing a Black-tailed Godwit nest at the point of hatching, they were returning to base in the car when, with a sharp crack, one of its springs collapsed. They crept home over the bumpy tracks, arriving after midnight with their hopes of a successful day photographing the new-born godwit family the next day fading fast. Their host was out, playing chess with a friend. Summoned home by his wife, he brought the friend with him to be introduced to the English party. As it happened, the friend was not a nurseryman like the den Harings. He owned a small factory nearby, making springs for cars! Within the hour, they had their new spring, and next day, their godwit photographs were in the bag.

It was six years later, in 1958, that Eric visited Finland. The main cue for the trip was the XIIth International Ornithological Congress, taking place in Helsinki. Unlike some international conferences,

Ornithological Congresses are normally timed to allow the participants to see the host country's birds at the best time of year - and Helsinki was no exception. Eric relished these four-yearly meetings with the world's leading ornithological authorities, especially as the Congress knew no political boundaries and drew participants from every quarter of the globe, all with fresh views, fresh scientific knowledge and fresh information. Eric had presented an exhibition of his photographs during the Congress, and business over, headed north into the wilds. The overwhelming impression - and overwhelming is probably the most meaningful word - was of the sheer vastness and amazing wetness (with 60,000 plus lakes) of that largely tundra landscape, so well portrayed in music by the Finnish composer, Sibelius.

Eric's companions on the 400-mile drive to the northern tip of the Gulf of Bothnia were James Ferguson-Lees, George Shannon and John and Eileen Parrinder. The car was laden, the roads poor, and the journey was a seventeen hour endurance test, but they arrived tired but safe in the land of the midnight sun to be greeted almost immediately by one of the local 'specialities', a Yellow-breasted Bunting. Some 200 miles north of the Arctic Circle, the light did (just about) allow photography without flash at midnight. This was the ideal introduction to Arctic birdlife, and they pressed on further north.

Being unused to people, the birds of northern Finland were found to be refreshingly approachable, but in a land where natural predators, both avian and mammalian, abound and where there are no sheltering hours of darkness, they were no less skilful than elsewhere in concealing their nests and well-camouflaged eggs from prying eyes - including those of photographers. But, with several skilled nest-finders in the team, the cameras were kept busy. Willow Grouse proved wary, but Siberian Jays came to investigate the human activity. Shore Lark, Mealy Redpoll, Lapland Bunting and Bluethroat nests were located in the stunted scrub, and in the gnarled pines of the scanty boreal forest, a Tree-toed Woodpecker nest, and later a Siberian Tit nest in an abandoned woodpecker hole.

On the wet tundra were waders aplenty, some familiar year-round in Britain, others occuring only as passage migrants, and sometimes very scarce at that. The novelties for the photographic team included Broad-billed Sandpiper, Temminck's Stint and Dotterel, as always, tame enough to be stroked as he (it is the drabber male rather than the female that endures the chores of incubation in this intriguing species) sat on the eggs. Most spectacular, in Eric's eyes, was the Spotted Redshank, familiar in Britain in autumn with a pale grey speckled plumage, but here on its breeding grounds resplendent in black with just a few white flecks, its dark plumage contrasting with blood-red legs and beak. Returning, several punctures from the rough road notwithstanding, to Tupos, they were joined by Chris Booth in a search for breeding Terek

Sandpipers on a tiny island in the Gulf of Bothnia. This great European rarity was at the extreme western edge of its breeding range. But with mounting excitement, two pairs were located, their nests found, and the first photographs of the Terek at its nest were secured. On this trip detailed preparation, good teamwork, skill, luck and the conditions were so effectively combined that Eric had more birds to work on than time allowed, but by the end of the expedition, he had managed to deal effectively with 14 species, 11 of them for the first time.

Another six years were to elapse before Eric headed northwards into Europe again, this time to Norway in 1964. The objective was more straightforward, to obtain material on two of Europe's largest birds of prey, the Sea Eagle and the Eagle Owl, and on one of its rarest and shyest birds, the Common Crane. The Sea (or White-tailed) Eagle has now been successfully reintroduced into western Scotland, using 'surplus' young birds largely from the Norwegian population. With five of the nine European eagles already under his belt, Eric desperately wanted to add the huge and undeniably spectacular Sea Eagle to his files. Sea Eagles build gigantic nests, which grow in size over the years, sometimes in tall conifers, others on rocky ledges. Once an apparently suitable nest had been located, Eric was forced by a damaged back to leave the hide construction to George Shannon and his colleagues.

Nothing though would stop him undertaking the hazardous trip to the hide once his turn came. It was a cliff nest, protected by sheer rock faces, some of them overhanging, the rock wet and slippery, and set some 300 feet above the sea, breaking on the rocks below. Of all the hides he had used in his career, Eric considered this to be the most insecure and terrifying, but once safely ensconced he relished and made the most of this close-quarters interlude with this magnificent bird, tending her two chicks with such extraordinary delicacy. After eight hours in the hide he faced the terrors of the descent - always worse than the upwards climb - but at the end remained thrilled and delighted with the outcome.

Meanwhile, a Norwegian colleague Dr Johan Willgohs had located an Eagle Owl's nest with two small owlets surrounded by the remains of their prey - largely a catholic range of birds from Oystercatchers to Hooded Crows, Long-tailed Ducks to Blackbirds! Once the hide was safely in position and established for a couple of days, Eric had his photographic sessions. Visits from the adults were few and far between, and the younger and appreciably smaller owlet was suffering visibly from the strength and greed of its older sibling, and from the cold. Such is the brutal way of nature in ensuring that when food is short, at least one owlet reaches fledging age.

This must have been a particularly aggressive bird, even for an Eagle Owl. While Eric was watching it away from the nest, it was mobbed in flight by a flock of Hooded Crows. Most unusually for mobbing birds, one came too close and was instantly killed by the

owl. On their first visit to the nest, the female owl had left at the last moment, flying straight towards them, orange-eyes glaring. Later, when he was in the hide, Eric recorded an incident when one of the parent owls took off from a crag some distance from the nest, and flew straight at the hide, turning off only at the last instant to land at the nest - but by that time, with his past experiences with owls doubtless flashing vividly through his mind, Eric had already thrown up his arms to protect his face. For the last part of the expedition, three ornithological friends, Charlie and Sarah Rose and Jimmy Hancock joined them, and after much searching it was Jimmy who located a Common Crane nest, not too far from the road out in the bog. The weather was less than charitable, with snow in early June, but at least it cooled the enthusiasm of the otherwise pestilential midges. The Crane did not live up to its reputation for shyness and readily accepted the hide, and Eric enjoyed a successful day-long session. But sadly, an egg collector took the eggs and their hopes of further sessions during and after the eggs hatched were dashed.

Although he had visited the Netherlands so successfully during the summer of 1952, Eric remained convinced that so much remained to be studied and photographed of British birds that it *Spoonbills, 1961* would be many years before he seriously considered any sequence

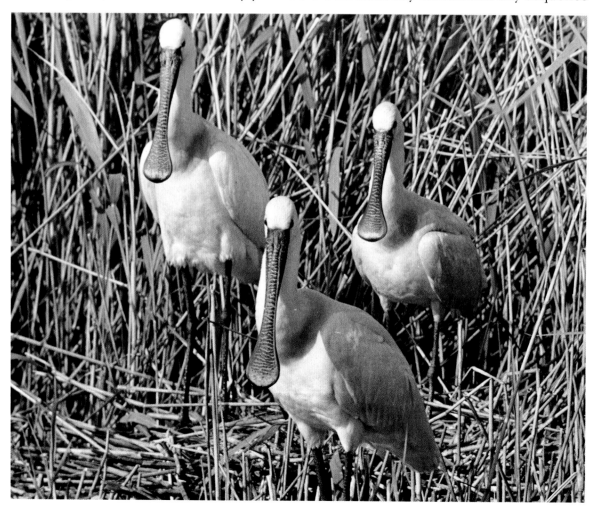

of overseas visits. Or so he thought. That was until the early spring of 1954, when a chance encounter with Guy Mountfort on a radio programme dramatically changed Eric's mind. Once again, an example of being in the right place at the right time? Guy was one of the most forward-looking of conservationists, and had realised that the protection of the natural environment and its inhabitants was only going to be successfully tackled as a world problem, and on a world scale. Not surprisingly, he was one of the crucial people in the formation of what was then called the World Wildlife Fund. A natural leader and superb organiser, he had the advertising man's eye (he had run a large and successful PR company) for the visual spectacle to augment the written word, and indeed on occasion to supplant it in the public eye.

One far-reaching consequence of this was the supremely successful *Field Guide to the Birds of Britain and Europe*, written with Phil Hollom and illustrated with the artistic skills and identification techniques of Roger Tory Peterson. This revolutionised European birdwatching just as its counterparts had changed the American scene. Another was the invitation to Eric to accompany the expedition he had planned for that year as the 'official' stills photographer to provide the best possible record of the expedition's findings in a visual format. Eric was unable to refuse!

The first site of international importance targetted by Guy Mountfort was in the southern tip of Spain, the Coto Donana and the huge adjacent marismas (or marshes) of the River Guadalquivir. The Coto is several hundred square miles of desert, scrub and wetland fronted by 25 miles of sandy Atlantic beach. North and east of the Coto lie the marismas, themselves many hundreds of square miles of superb wetland of several types. After two expeditions, in 1956 and 1957, Guy described the area in telling detail in *Portrait of a Wilderness*, copiously illustrated with Hosking photographs. The expeditions depended heavily on the generosity and enthusiasm of the Coto's owner, Don Mauricio Gonzalez Diez, and the team was housed, in some style, in the huge and magnificently antique Palacio right in the heart of the area. From the Palacio, they set out on foot, by horse or mule, or by boat to study in detail the various important ecological components of the area. Woodchat Shrikes, Pratincoles, Avocets and Stilts abounded, but the first expedition concentrated its photographic energies on one of the huge heronries. The trees were festooned with birds - Little and Cattle Egrets and Squacco and Night Herons - the noise, smell and activity verged on the indescribable, but the photographers made good use of their time. They also constructed a pylon hide to the large and untidy nest of a Red Kite, almost 40 feet up in a cork oak, and largely made of rags, paper and discarded bones. There were problems finding adequate timber to build the pylon, and Eric, no novice in such circumstances, described the final edifice as a 'decidedly rickety 35 feet of eucalyptus and sherry cases'! The birds behaved superbly, and Eric emerged triumphant at the end of a

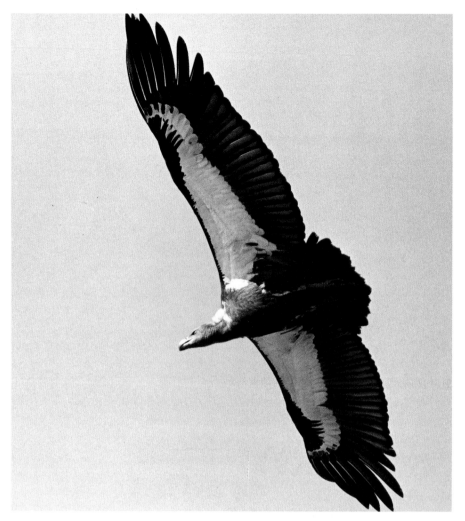

White-backed Vulture, 1966

long, hot (96°F) day. The main photographic goal of the second expedition also demanded a pylon hide. It was the spectacular, but extremely rare Spanish form of the Imperial Eagle, which had never before been photographed at the nest, and for a change, the optimism of local keepers was justified. The nest they had searched for, and found, was in an excellent photographic position in the top of a stone pine.

This time there were no difficulty in building the hide - they had plenty of light duralamin scaffolding - on this occassion the problems were political, and had yet to materialise (see page 143)! After several successful sessions in the hide, Eric still concluded that his first thrilling view of the huge female Imperial Eagle alighting on the massive nest was the best. On this trip, they also secured some wonderful photographs of one of the most interesting of raptors, the Short-toed Eagle. Sometimes, and appropriately enough, called the 'Snake Eagle', this specialises in snakes as its prey, and Eric was fascinated to watch the young handling these reptiles, brought to the nest often still wriggling. He was also amazed to see the eaglets, themselves less than a foot tall, consuming a snake at least double their length inch by inch. When in the midst of this extended and gargantuan meal the eaglet paused to draw breath and let

its potent digestive juices get to work, several inches of snake still dangled from the eaglet's beak.

As a spin-off from the Coto Donana expeditions, Eric was able to enlist the help of Antonio Cano and Dr Tono Valverde as the experts with local knowledge to support his own expedition in search of the nest of one of his favourite birds, the elusive Lammergeier. Lammergeiers are often called 'Bearded Vultures, and an old name 'Ossifrage', which translates literally to 'bone-breaker', accurately describes one of their most unusual attributes. Huge, with long narrow wings (more like a terrestrial albatross than a vulture, remarked Eric) and a long wedge-shaped tail, Lammergeiers arrive later than other vultures at carrion, and despite their ferocious appearance are comparatively timid. This means that often all that they get are the left-overs - the bones. These the Lammergeiers pick up in their beaks, and fly with them to a favourite rocky outcrop, where they drop them, repeating the exercise until the bones shatter. Much of the nutritious marrow jelly they extract with their long thin tongue, which is shaped exactly like a Victorian kitchen marrow-scoop. The slivers of bone, jagged and often fiersomely sharp, they simply swallow, leaving their digestive juices to do the rest.

In 1959, the expedition gathered in the Sierra Nevada of southern Spain. After the normal teething troubles for such an expedition in hostile terrain: punctures, landslides and over-inquisitive local children, they embarked on the arduous task of locating a suitable nest, eventually finding one in a small cave some 1500 feet up a near-vertical limestone precipice. It was hardly convenient for photography: regardless of the drop, the photographic choices of 'perch' for a hide were either at two feet from the nest, far too close, or at 150 feet away, which was rather too far but the best that could be done. Occasional views of the spectacular Lammergeiers encouraged them, and after a lot of hard work and some heart-stopping near-accidents, the hide was in position and the Lammergeier chick had been ringed, weighed and measured. The first day-long session in the hide was endured but enjoyed in great heat. The awful stench attracted flies in clouds so dense that Eric wondered if they would interfere with photography. That was to be the only session: a sudden storm swept away all trace of the hide, though the chick survived. Such can be the way of photography, with an extraordinary amount of effort devoted to securing just a single day in action.

The next Mountfort expedition ventured behind the 'Iron Curtain' that back in 1960 was still very firmly in position across Europe, separating the communist bloc countries from the west. Reasoning that politics should be no barrier to international conservation, Guy persisted in his negotiations, eventually achieving an invitation from the Bulgarian Government, and the group reached Sofia in mid-May. Bulgaria is an ecologically and agriculturally rich country, but it was particularly to the River Danube, and its

pelican colonies that the expedition was directed. Once again, Eric was the stills photographer, and many of his photographs illustrate Guy's book, reporting the work and conclusions of the expedition, *Portrait of a River*. The pelicans - both White and Dalmatian - were persecuted as competitors for fish stocks, and their eggs (and those of most other birds) were taken to augment the local diet, often low in protein. Their best results, particularly with White Pelicans, were obtained at Lake Burgas, near the Black Sea, where huge flocks loafed around in the warm shallow waters while others wheeled and turned overhead on stiff broad wings.

Not all the time was spent at Black Sea level. Hearing of a Wallcreeper nest high in the mountains, they set out to find it. The drive to the Rila Monastery from Sofia, following the Rilska valley, was spectacular in the extreme, and the monastery itself was a superb sight among the snow-capped peaks. The climb to the alpine hut (in whose wall the Wallcreeper was nesting) was unusual in that despite the grave warnings of their guides as to the almost impossible severity of the terrain, it turned out to be little more than a gentle mountain walk. Sadly, because of the guide's pessimism Eric had brought only a lightweight pocket camera with no telephoto lens, and so was unable to photograph the beautiful crimson and grey, rather Hoopoe-like bird.

It was near Varna in the Baltata Forest that they set up a tall pylon hide at a Lesser Spotted Eagle nest. The going was tough, the mosquitoes voracious and the weather dreadful - raining to such an extent that the nearby river burst its banks and turned the forest into a quagmire. The very young eaglet was somehow thrown from its nest in the storm, and they found it cold and almost lifeless at the base of the tree. Warmed, it quickly returned to activity and not without difficulty, was restored to its nest. Parental care was resumed, but Eric's problems as a photographer were not over in the rain and wind. Both nest and pylon hide were swaying in the wind, and not in synchrony, so he had to judge exactly the right moments to fire the shutter. As to the rain, the bedraggled state of the adult eagle in the resulting photographs shows plainly enough that it did not let up.

Not for this expedition was there to be the luxury, albeit in remote surroundings, of the Palacio. In 1960 Bulgarian hotels, Bulgarian food and Bulgarian assistance were all uniformly and monotonously poor. The regime was authoritative and repressive, and for visitors lacking fluency in the language, tense situations were bound to arise. Not many photographers expect suddenly to be confronted with 12 inches of glistening, purposeful steel in the form of a bayonet thrust through one of the observation slits in the hide. Yet this is what happened to Eric while attempting to photograph Rollers. Amazingly, when Eric presented the hostile soldier with a telegram - of uncertain age, it had been in his pocket for some while - the soldier gazed at it, saluted, and left him in peace.

The Iron Curtain was to be penetrated again in 1961, but once

more only after considerable pressure on the authorities from Guy
Mountfort. That year it was to be Hungary, and Eric's particular tar-
gets were Spoonbills and Great White Herons (now often called
Great White Egrets) in the huge reedbeds of Lake Velence. Not
only did the landscape resemble his beloved Norfolk Broads, but
fortunately Lake Velence had its parallel to Jim Vincent in Stefan
Mueller. He knew the reedbeds like the back of his hand, and was
expert in poling a punt through the forest of dense tall stems.
Above all, he knew the reedbed birds, their secrets, their behaviour
and their idiosyncrasies so well that he swiftly became invaluable.
Even Little Crake nest finding was easily accomplished. Not without
a great deal of effort, and certainly under continuous duress from
the flourishing mosquito population, they obtained their pho-
tographs of Spoonbill colonies in full swing. Better still, they were
able to watch the comings and goings, and the magnificent greet-
ing displays, when the filamentous back plumes were shown to
stunning effect, in the egrettry - and for Great Whites, this was a
privilege accorded to very few European ornithologists' eyes.
Wetland work over, they turned their attentions to Hungary's vast
plains in search of the Great Bustard, impressive, even spectacular,
yet for all its size one of the hardest birds to spot. In due course,
careful, persistent fieldwork revealed several nests, but Eric's ambi-
tions to photograph this, one of the heaviest of flying birds, were
to be thwarted. In all, attempts were made to photograph eight
nests: all were doomed to failure. Foxes had taken two clutches,
egg collectors two, and four were destroyed by agricultural machin-
ery. Clearly, if this experience was anywhere near the norm, the
future for the Great Bustard would seem to be extremely gloomy.

The 1963 Mountfort expedition was to a very different habitat,
the deserts of Jordan. HRH King Hussein was personally involved,
and saw the party on its way. He was also deeply concerned over
the rapid rate at which his country's wildlife - especially the larger
desert mammals and birds - was diminishing, particularly under
pressure from so-called sportsmen hunting with lights and power-
ful automatic weapons from four-wheel-drive vehicles. Paramount
amongst these must be the history of the Arabian Oryx, brought to
the edge of extinction. Only by skilful planning and determined
effort has Operation Oryx, the rescue and captive-breeding plan
generated by the Fauna Preservation Society, been successful. This
has resulted in a schedule of releases of captive-bred Oryx at sever-
al sites throughout Arabia.

The expedition's first destination was the oasis at Azraq. Azraq
was genuine Lawrence of Arabia country, and as an oasis was a mag-
net for migrant birds as well as a wonderfully refreshing base for
treks out into the surrounding deserts. The outcome of this, and
subsequent expeditions, was summarised in Guy's book *Portrait of
a Desert*. For Eric, any such expedition demanded an intense period
of planning. It was not simply that the right lenses must be on
hand, and a sufficiency of film stocks of appropriate speeds, but he

researched in detail the lifestyles of the local people, and the implications (often vital) for food and transport. From Asraq, they travelled via Karak (where the Crusaders established a major base many centuries ago) to the shores of the Dead Sea, encountering the inevitable and endearingly comical groups of Tristram's Grackles. Thence to Petra, where the walk in through the startlingly narrow defile in the rock - the Siq - impressed Eric just as much as it did the first Europeans ever to walk its length.

Overall, of course, the birds (and the other desert animals and plants) were as fascinating as they were beautiful. Local specialities like the Sinai Rosefinch vied for attention with a Persian Robin, the first ever seen in Jordan. To British eyes, some of their tallies were scarcely believable - 28 different types of birds of prey, 32 warbler species, eleven different larks and nine different wheatears. All of these, and many more, were able to cope, either permanently or in transit, with the extreme harshness of desert conditions, making for interesting studies despite the tough photographic conditions. It was not simply the tremendous heat during the day, but as much as anything the problems caused as dust and sand crept into even the best-protected equipment.

Eric was anxious to photograph the Pin-tailed Sandgrouse, a pigeon-like, fast-flying, desert gamebird, well camouflaged against the desert background, and with an even-better concealed nest and eggs. This is one of the most fascinating of all desert birds. It had long been a mystery how the nestlings obtained the water necessary for survival out in the desert, but we now know that the males have specially absorbent belly feathers, unique in their microscopic structure and with a better water-holding capacity than any synthetic sponge. On their twice-daily flights to waterholes often many miles distant from the nest, having drunk their fill, the males wade in and 'load up' with water. After a swift flight back to the nest, the young burrow beneath him and drink their fill. After several false alarms, bumpy trips and nest losses (one was trodden on by a passing camel), they got their photographs, the day before the expedition packed for home. The 1965 Jordan expedition achieved another goal that, to date, no other had achieved: Eric gave up smoking, suddenly, resolutely, and permanently!

The next year, 1966, Eric returned to Jordan with George Shannon to take stills and make a cine film, with the conservation message featuring strongly, for the American sponsor, Duncan Read. The trip went well, and amongst many spectacular birds photographed against the impressively stark, yet beautiful, Jordanian desert, they achieved a goal that previous expeditions had missed, locating a Houbara Bustard. Despite wonderful views, the bird proved too elusive for photography - this Eric achieved when a stray vagrant Houbara was found in East Anglia!

The next short series of expeditions was to Pakistan and resulted in Guy's book *The Vanishing Jungle*, as ever copiously illustrated by Eric. Many features stuck in Eric's mind: the colours, the smells

and the human poverty of the Indian sub-continent, the cheerful-
ness of the people and the width of their smiles, and, not least,
their suicidal road manners! The extremely poor living conditions
of many of the people they saw contrasted distressingly with the
opulent luxury in which they were frequently accomodated in vari-
ous palaces as they travelled round. But their business was to pho-
tograph birds, and nowhere better than in the luxurious grounds of
these palaces was the vital importance of water illustrated, attract-
ing a kaleidoscopic richness of birds, many with jewel-like plumage
colours. Even the smallest of roadside puddles attracted its com-
plement of hawking swallows. Larger bodies of water of course
attracted more birds, and a far greater variety. Eric reckoned that
Lake Khabbaki held several thousand larger birds ranging from resi-
dents like Coot and White-headed Duck to migrants like Flamingos
and Bar-headed Geese, the latter freshly arrived from their breed-
ing grounds in Central Asia. Their amazing migratory journey to
Pakistan and India included overflying the snow-clad peaks of the
Himalaya.

The expedition visited several of the more remote Pakistani
wetland areas, with an abundance of wildlife, including Ospreys,
Fishing Eagles, various herons and egrets, several types of kingfish-
er and many others besides. The next year, the expedition visited
what was then West Pakistan, the Indus Delta and the Sunderban
swamps of the Bay of Bengal, made famous most of all perhaps by
its particularly extensive records of man-eating tigers.
Ornithologically, the already extensive resident bird fauna was aug-
mented substantially by incoming winter visitors from right across
the Palaearctic region. By the time of their return to London the
second time, the two expeditions had recorded 423 different
species of birds. Hearteningly, despite the poverty of the nation
and its rather authoritarian government, many of the expeditions'
recommendations were comparatively swiftly brought into action,
protecting the amazingly rich wildlife, and its habitats, for the
future. This, of course, was the main objective for all of the
Mountfort expeditions, and the photographic record contributed
in a major way, enhancing the impact of the written word and help-
ing to drive home - to peoples, to governments, to the world at
large - the conservation message.

The first tour that Eric accompanied as photographer-naturalist
was to the Galapagos Islands with Lindblad Travel. These fascinat-
ing islands which first gave Charles Darwin the idea of evolution
had long fascinated Eric. He commented that "Never before have I
had to run away from birds to photograph them". It was also the
first time that Eric's youngest son David was to join him in the
field, and was the start of a fruitful partnership that continued up
to Eric's death.

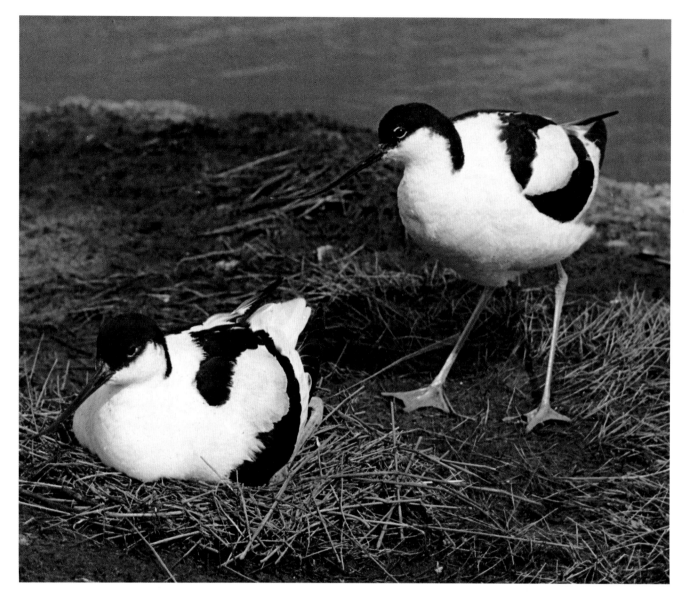

AVOCET

Date
June, 1950

Camera
Brand 17

Lens
Tessar 8 1/2"

Aperture
F/11

Shutter
Fast Luc

Film
Super XX Film Pack

"The RSPB gave me permission to photograph the Avocets on Havergate Island this year and our grateful thanks are due to them for this grand opportunity. The change-over took place every one and half to two hours, some times at the nest and sometimes away from it. I was fortunate in getting the change-over right at the nest.

When one egg hatched, the male had the tip of his bill just inside the shell, and, as he did this, he opened the bill slightly, causing the top to burst open. So, he actually assisted with the hatching of the egg!"

STONECHAT

"We found that Stonechats were quite common near the coast at Minsmere in Suffolk and, in all, we found four nests. We worked on two nests, but, at the first the male appeared to be much more tame than at the other and he visited the nest with food even more frequently than the female. Stonechats are forever flicking their wings and tail, which makes natural looking exposures difficult to obtain, even using high speed flash, but they do almost always use the same prominent perches as they approach their nest. This makes photography away from the nest itself much easier than for most small birds."

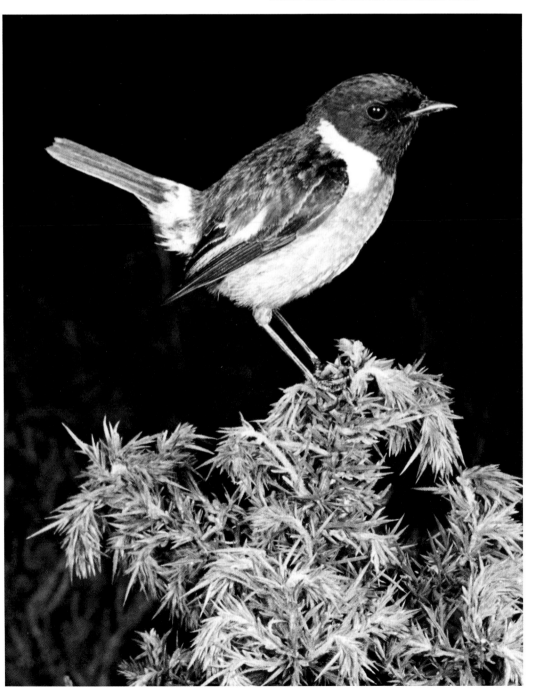

Date
July, 1950

Camera
Brand 17

Lens
Ekta 8"

Aperture
F/36

Shutter:
High Speed Flash 1/500th second

Film
P 1200

HERON

"These Herons nest on an island in the middle of a reservoir within a few miles of the centre of London. Most of the nests were only 25 to 30 feet up from the ground and were so close to each other that it was possible to work on four separate nests without gardening. The returning parent birds always regurgitated their crops full of food, including fish, frogs and the occasional eel, water vole and small bird, into the bottom of the nest. Here the young seized it and gobbled it down, their stabbing beaks passing perilously close to each others' eyes. The noise they made was quite indescribable, as was the smell on a warm afternoon, and there was no escape from it in the hide!"

Date
June, 1951

Camera
Brand 17

Lens
Tessar 8 1/2"

Aperture
F/45

Shutter
Slow Luc

Film
Super xx Film Pack

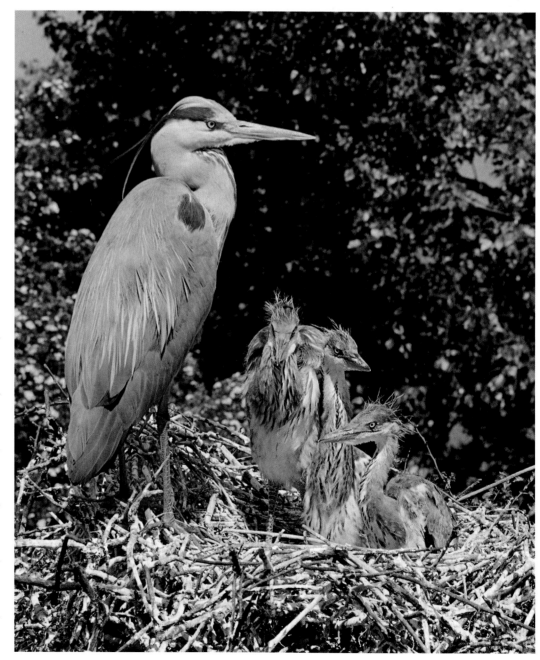

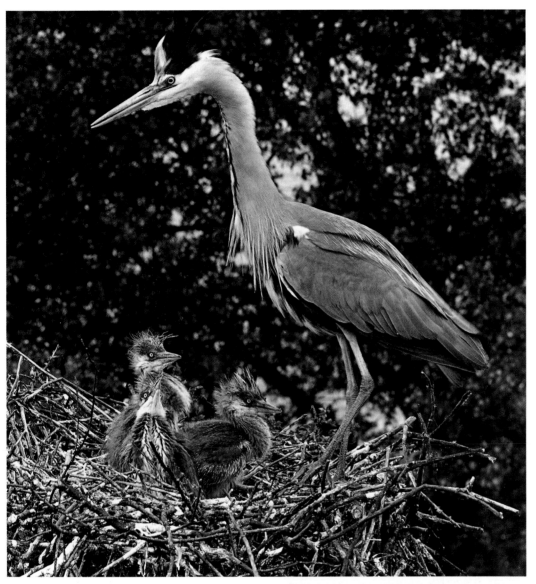

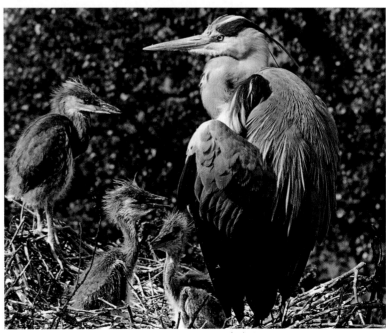

DARTFORD WARBLER

"We were lucky enough to find this Dartford Warbler nest in Hampshire. It is a very secretive, but lovely, little bird, especially the male with his dark brown upper parts, slate-grey head and light brown underparts. I was surprised to notice that the cock was feeding the young about six times to the hen's once. Why? Then I saw the hen collecting material nearby and it seemed that she was already constructing a new nest. The Dartford Warbler is unusual among our warblers in that it stays with us, not migrating south as most warblers do in winter. As a result, it has to endure some pretty severe winter weather, when frost and snow make food-finding difficult for an insectivorous bird. One consequence is that Dartford Warbler numbers on our southern heathlands crash after bad winters, such as those during the war and in 1947. Only now, it seems, are the effects of the losses in 1947 beginning to be overcome, and more Dartford Warblers are flitting about in the gorse."

Date
June, 1951

Camera
Brand 17

Lens
Tessar 8 1/2"

Aperture
F/45

Shutter
High Speed Flash 1/5000th second

Film
Super xx Film Pack

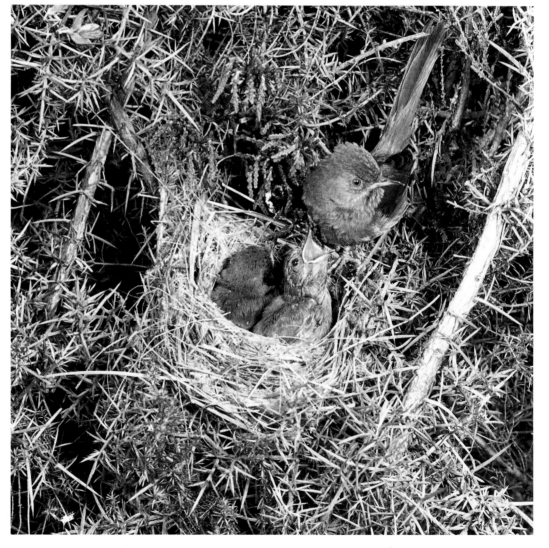

Black Redstart

"In a Blitzed London building within the shadow of St Paul's Cathedral, these Black Redstarts had built a nest in a partition between a ceiling and the floor of the room above. A small pylon was required to get the camera high enough and a clear view into the nest was obtained by removing one lath, 1 1/2" wide by 18" in length. Strangely, several pairs of Black Redstarts have forsaken their typical continental home on mountain screes for the devastated heart of London. Maybe the piles of rubble still remaining look like the screes, and the jagged ruined walls sufficiently resemble mountain crags. Photography was undertaken only at weekends because of the weekday crowds in the city. The food consisted mainly of Cinnabar Moths."

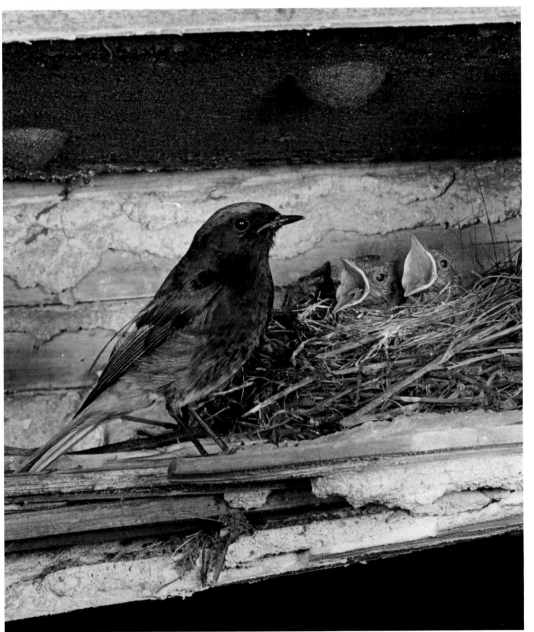

Date
June, 1951

Camera
Brand 17

Lens
Tessar 8 1/2"

Aperture
F/45

Shutter
High Speed Flash 1/10,00th second

Film
Super xx Film Pack

KINGFISHER

"This shot was taken on Walthamstow Reservoir, only a few miles from the centre of London. Several pairs were breeding on the islands in the reservoir. The photograph was taken using a photo-electric shutter release. *Below:* Almost every time they emerged from the nesting tunnel, the adults flew out towards the middle of the reservoir and dunked themselves in the water to get rid of the smelly and slimy coating of decaying fish and droppings that they collected as they scrambled in and out of the nest chamber to feed their young. *Right:* It was not just the Kingfisher's iridescent colours that reminded me of a hummingbird, but also its flight attitude as it hovered just in front of the nest hole before entering. Notice how the fish is carried head foremost. When seized and swallowed by an enthusiastic nestling, it must go down head first or its spines would lodge in the chick's gullet."

Date
June, 1951

Camera
Brand 17

Lens
Tessar 8 1/2"

Aperture
F/32

Shutter
High Speed Flash 1/5000th second

Film
Super xx Film Pack

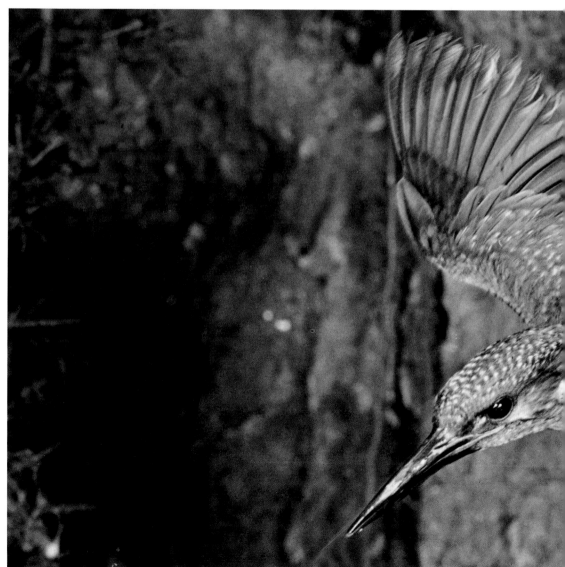

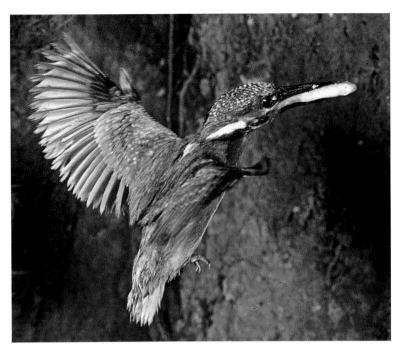

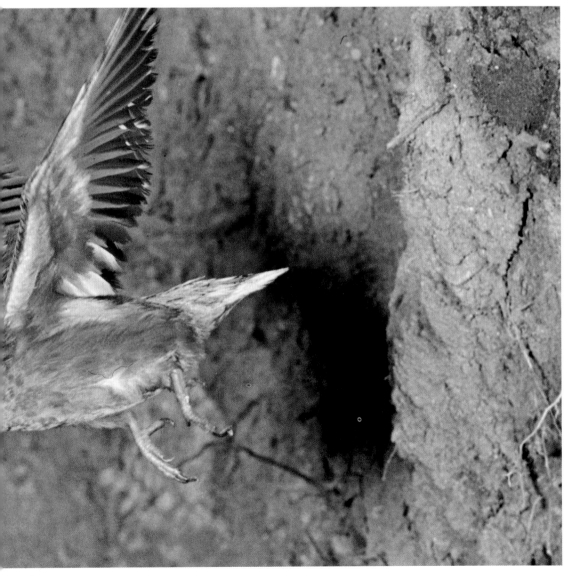

MARSH WARBLER

"This is another species that I have wanted to photograph for many years, but the opportunity did not come until recently, when several nests were shown to us. All were in very dark situations and I doubt whether I would have got them without flash of some sort. The young Cuckoo already amply fills the Marsh Warbler's nest, having ejected its foster parents' eggs. Soon it swamped the nest and totally dominated the Marsh Warbler, which struggled frantically to keep up with its inces-

Date
July, 1951

Camera
Brand 17

Lens
Tessar 8 1/2"

Aperture
F32

Shutter
High Speed Flash 1/5000th second

Film
Super xx Film Pack

sant whining cries for more food. It has always amazed me that the foster parents will keep on caring for a nestling that looks so different from their own. They must have much sharper eyes when it comes to their eggs though. Cuckoo eggs mimic those of their host so closely in colour and pattern, that most birdwatchers would easily be deceived. Should the egg not match in the foster parents' eyes, then they will abandon the clutch and start again."

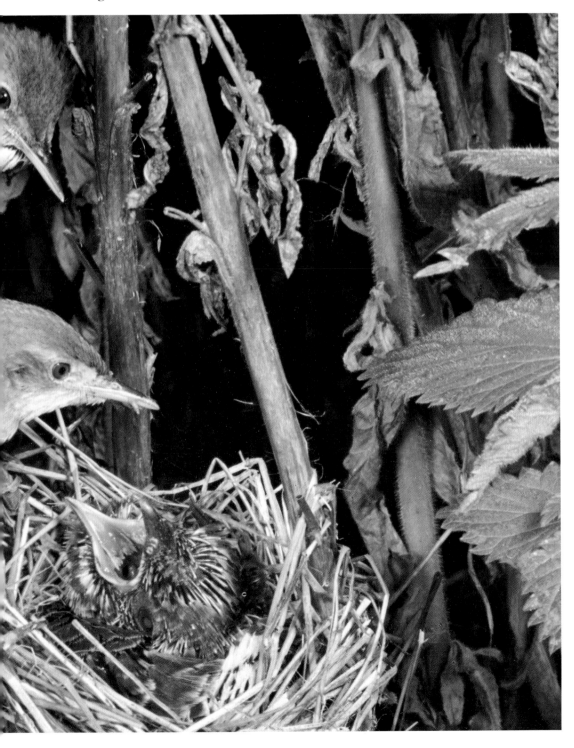

LITTLE RINGED PLOVER

"For several years little Ringed Plover have nested on the floor of the new Girling Reservoir at Chingford, while it was under construction. Last year at least five pairs bred there, but, in September, the reservoir was completed and filled so the plovers will not be able to breed there again."

As more reservoirs are built and gravel and sand pits excavated, Little Ringed Plovers continue to increase their colonised area of south east England. They are a comparatively recent addition to the list of British breeding birds, nesting for the first time in Hertfordshire just before the war. Almost all breeding attempts have been in this sort of man-made habitat, but both eggs and chicks are perfectly adapted for camouflage in these novel surroundings.

Date
July, 1951

Camera
Brand 17

Lens
Tessar 8 1/2"

Aperture
F/22

Shutter
Med Luc

Film
Super xx Film Pack

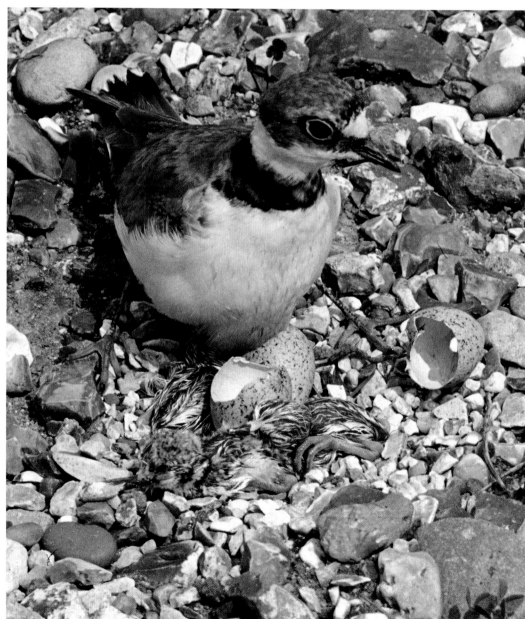

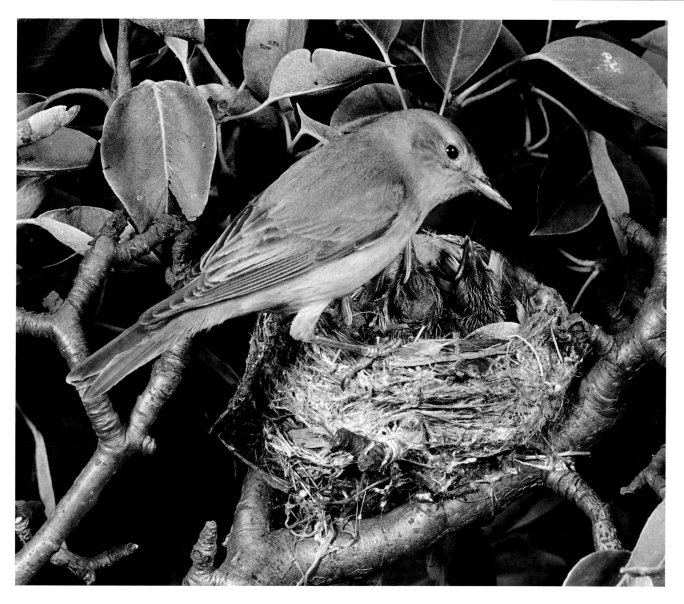

ICTERINE WARBLER

"This is one of many photographs taken during a seven week trip to Holland in 1952. The nest is in a pear tree and was about 15 feet up. The birds look like large Willow Warblers, but with a larger head and much heavier beak: Willow Warblers, of course, usually build a much neater nest, deep in the heart of a tussock of grass. The Icterine Warbler's song was a musical and sustained jingle, to my ears very different from the Willow Warbler's silvery, descending trill. Few Icterine Warblers ever get to Britain except in autumn, when some stray migrants heading south arrive on our eastern coast. However, these strays are gone as suddenly as they arrive."

Date
June, 1952

Camera
Brand 17

Lens
Tessar 8 1/2"

Aperture
F/45

Shutter
Flash 1/500th second

Film
Super xx Film Pack

BLACK-TAILED GODWIT

"This is probably the best of the series I got at this nest which we photographed in Holland last year. I can't help but wonder what effect the great flood of 1953 has had on the breeding ground of these birds and how much the birds have been affected. Being more familiar with this large wader in its drab grey-brown autumn plumage on British estuaries, I was very impressed with the russet beauty of their summer dress. In flight they remain most conspicuous, because of their odd black and white wingbars and black and white tail. In the hide, I was never left unaware of approaching disturbance and possible danger, be it a cow straying too near the nest or a distant Marsh Harrier quartering the meadows for food, because the adult Godwits were among the noisiest birds I have ever photographed." Since Eric took this photograph, the Black-tailed Godwit, extinct as a British breeding bird for decades, has returned, and has established breeding colonies, some on RSPB reserves, in several English Counties.

Date
June, 1952

Camera
Brand 17

Lens
Tessar 8 1/2"

Aperture
F/32

Shutter
Slow Luc

Film
Super XX Film Pack

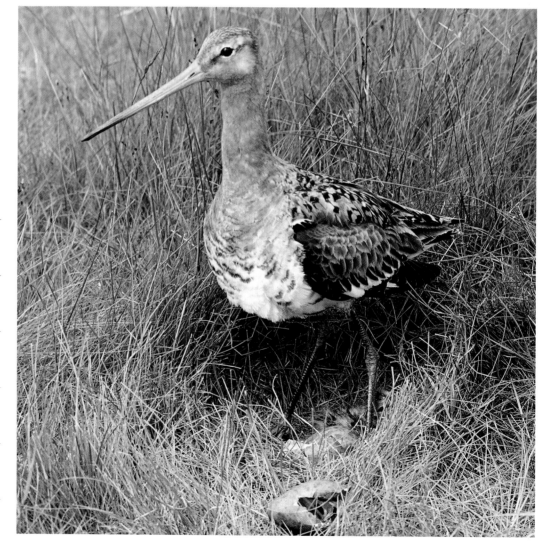

GOLDEN ORIOLE

"Taken in a public park during our visit to Holland, this picture shows the female feeding one of the young with a Silver Y Moth. The nest is slung on the slender branch of an Alder Tree in quite a dark situation so flash seemed to be the best way to photograph it. I am familiar with the way Goldcrests build their neat, tiny nests slung like a hammock in the fork of a branch, but I was surprised to find that a bird like the Golden Oriole, as big and heavy as a Starling, could use the same construction technique and build strongly enough to support its growing brood. The female oriole was very well camouflaged and quiet as she approached the nest, but the alertness of the young gave me a hint that she was coming and that, for them, food was on the way. For all his bright black and gold colours, the superb male also surprised me. He was very difficult to see as he moved about in the bright, dappled sunshine and shade of the leafy canopy, but I could always tell when he was around because of his wonderfully melodious fluting whistle."

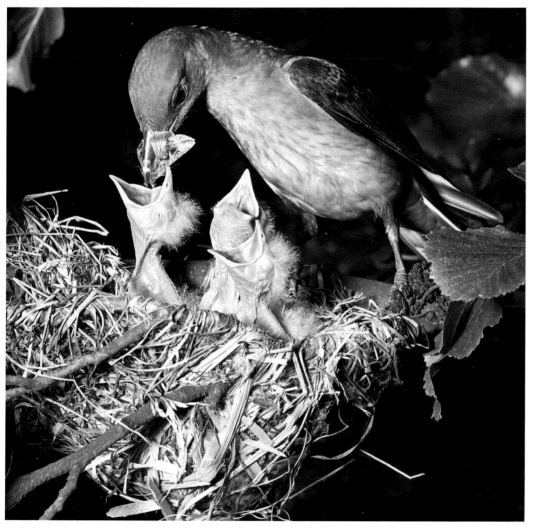

Date
June, 1952

Camera
Brand 17

Lens
Tessar 8 1/2"

Aperture
F/45

Shutter
High Speed Flash 1/5000th second

Film
Super xx Film Pack

LITTLE BITTERN

"One of a long series taken in Holland in 1952. In this print the shadows are rather heavy but I was experimenting with Amudol as a developer for Bromesk on printing paper and still have a lot to learn. The young had just been fed by the female and were gorged, hence their attitude in the nest! My first impression of this secretive bird was just how small it was. The female was extremely well camouflaged for reed bed life, with linear brown streaks on her generally buff body. Unlike our Bittern, where male and female are pretty well identical in plumage, the male Little Bittern is by no means so well camouflaged, and is in fact quite elegant, with a buff wing patch, which is very conspicuous in flight. When the adults approached the nest, I noticed how easily they moved through the reed stems. Long toes prevented them sinking by spreading their weight across the reed stem and roots, but like the Water Rail that I am familiar with in Britain, their bodies are remarkably slim and feathered from side to side, which allows them to slip between the reeds making hardly a sound"

Date
June, 1952

Camera
Brand 17

Lens
Tessar 8 1/2"

Aperture
F/32

Shutter
Slow Luc

Film
Super xx Film Pacs

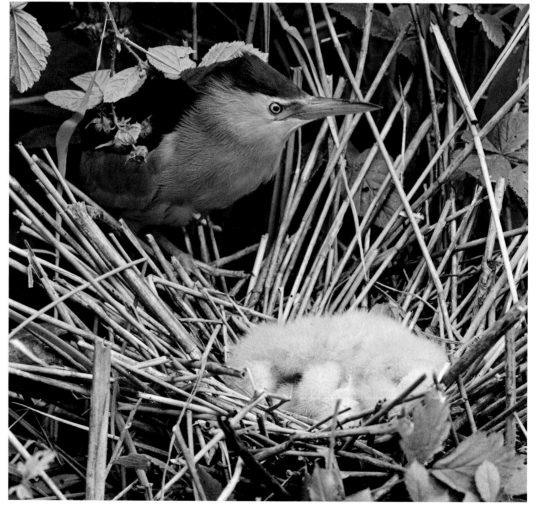

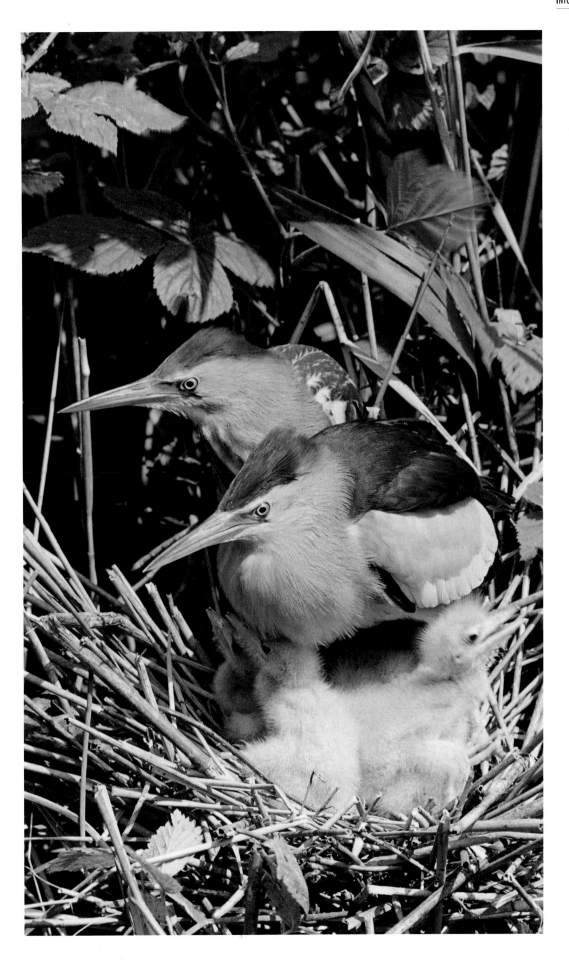

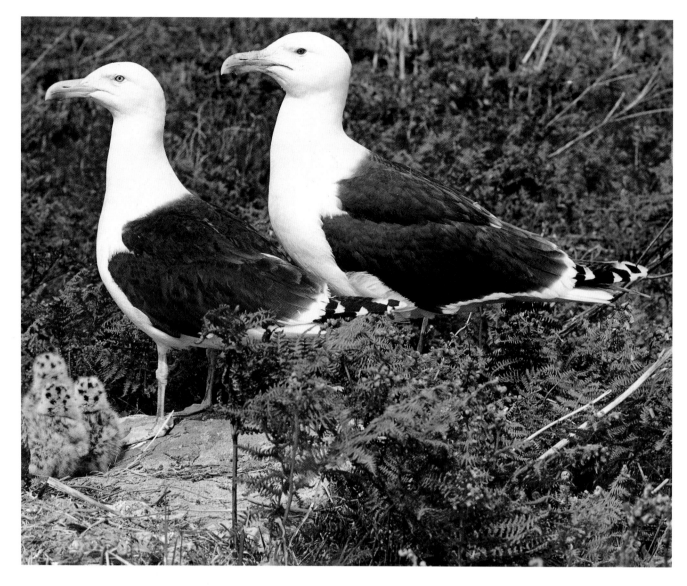

GREATER BLACK-BACKED GULL

Date
June, 1953

Camera
Brand 17

Lens
Tessar 8 1/2"

Aperture
F/32

Shutter
Medium Luc

Film
Super xx Film Pack

"This photograph was taken on Skomer. I had not realized before what a great difference there is in the size of the heads of the male and female. A wonderful and charming bird to see at the nest, but one that does a great deal of damage as a predator on the island. Any unguarded egg or chick on the cliffs may be snatched up and eaten, and some of the Greater Black-backed Gull nests are surrounded by the bones and wings of unfortunate Puffins, Storm Petrels and Manx Shearwaters that have fallen victim to this predatory species. Watching the various nests around my hide, I was astonished to discover, that some Greater Black-backed Gulls are not averse to cannibalism, taking eggs or chicks of their own kind if the parent birds are away from the nest for more than a moment. I was surprised, though, that the returning birds showed no signs of distress at their loss, not even searching for the missing chicks."

GANNET

"As we landed on the island of Grassholm, our boatman said, "There's a blow coming, half an hour is all you have got." We set off immediately for the enormous gannetry. Some 5000 gannets were breeding in an area a few hundred yards square. They nest so closely together that they sit almost within bill distance of each other. In fact, they tell me that the reason for this very precise spacing is that neighbours cannot quite stab each other with their dagger-like, six inch beaks, Although they nest in colonies for safety, Gannets are noisy and aggressive to the birds next door. Nests are decorated with only a few strands of seaweed, but even these are stolen and quickly added to neighboring nests if left unguarded for only a few moments. On a windy day adult birds returning to their nests in the crowed colony must make perfect landings or scuttle back to their home ground between other nests, running the gauntlet and dodging a rain of vicious blows as they go."

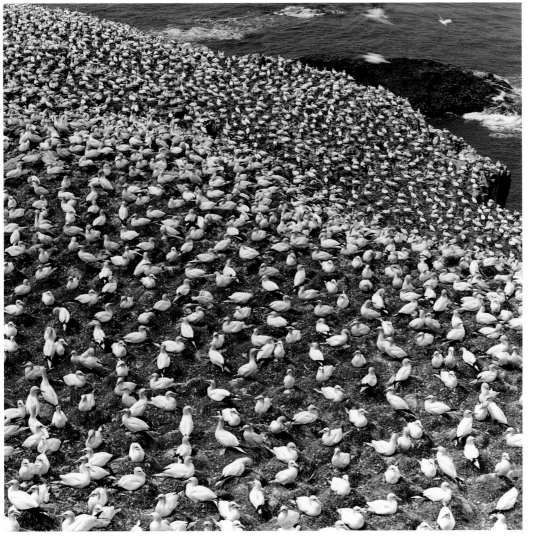

Date
June, 1953

Camera
Brand 17

Lens
Kodak 6"

Aperture
F/32

Shutter
1/25th second

Film
Super xx Film Pack

PEREGRINE

"It is 21 years since I made my first attempt to photograph Peregrines. I failed then, and have been failing ever since! However, we did manage to find a site this year and I got a few results in what I would say was a very difficult and dizzy place. It involved being lowered over a 300 foot cliff on ropes that would have held a battle ship, to a hide that stood on a ledge with barely enough room for tripod camera and ruck-sack. What a magnificent bird the Peregrine is, and how sad that it is so scarce. Of all the falcons, it is the one most prized by falconers for its hunting skills. Its

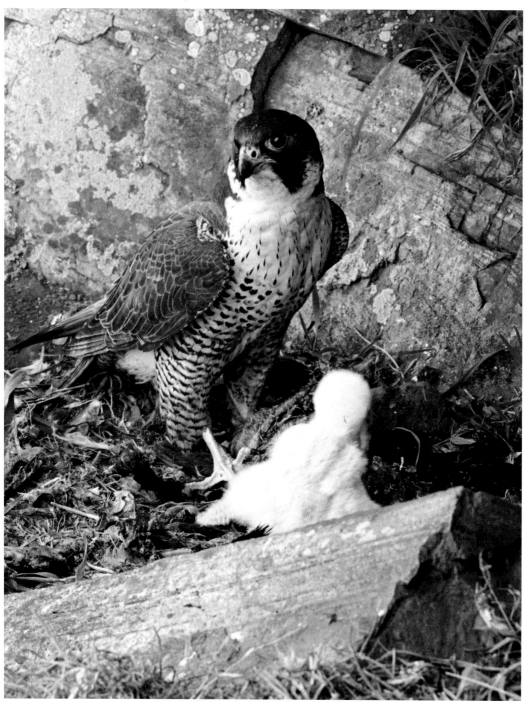

Date
June, 1953

Camera
Brand 17

Lens
Tessar 8 1/2"

Aperture
F/22

Shutter
Slow Luc

Film
Super xx Film Pack

usual technique resembles that of a Spitfire pilot. The Peregrine will climb until almost lost to sight, high in the sky and will wait, circling on outstretched wings, up in the eye of the sun, for suitable prey to fly far below. With the prey, always a bird and often a pigeon or a Golden Plover, but sometimes as large as a goose, in its sights, the Peregrine half closes its wings and dives headlong downwards. Falconers call this power dive its 'stoop', and it often ends in a cloud of feathers and a audible thud as it strikes its prey in full flight. With its lethal talons outstretched, the kill is immediate and the prey is carried off to a favourite perch or taken back to the nest to be eaten."

Since Eric wrote these notes, a masterly scientific investigation by Dr Derek Ratcliffe has revealed how Peregrine breeding success was greatly reduced by pollutants, particularly, DDT in their food chain. DDT was banned from agrochemical use as a result of his work, and, since then, Peregrines have returned to many if not most of their pre-war haunts, and their numbers are as high as ever.

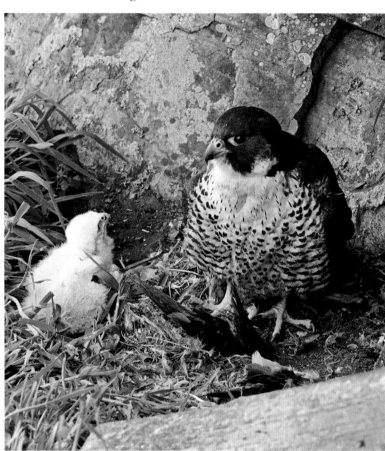

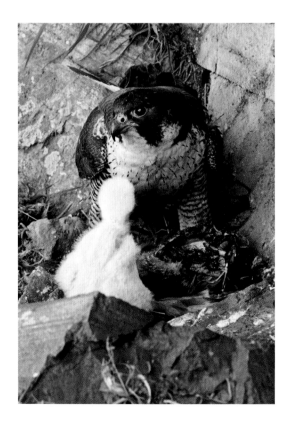

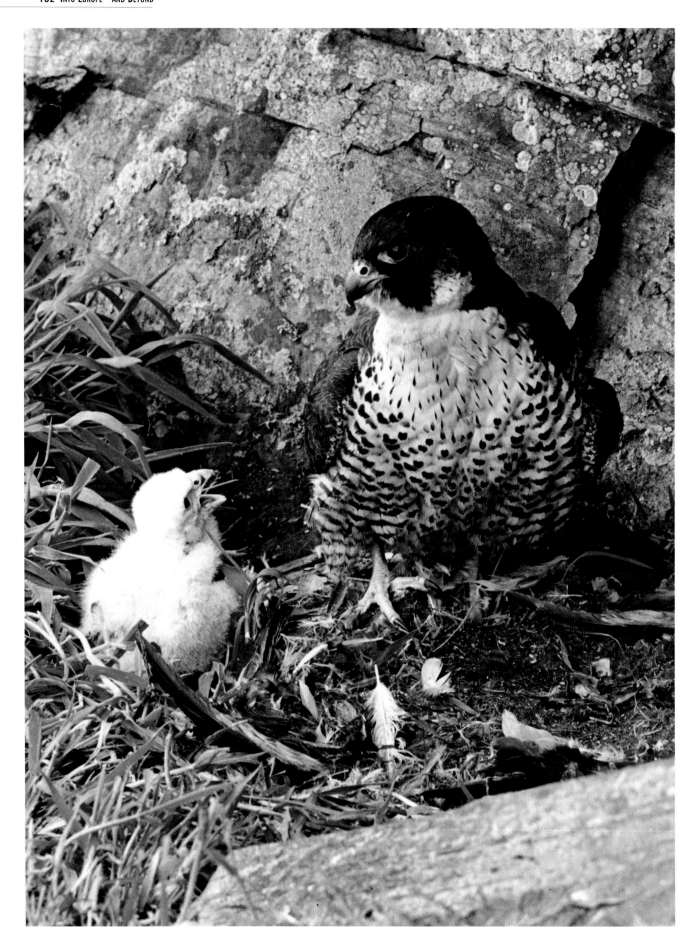

ARCTIC TERN

Date
June, 1953

Camera
Brand 17

Lens
Tessar 8 1/2"

Aperture
F/32

Shutter
Fast Luc

Film
Super xx Film Pack

"Photographed on a day visit to Inner Farne, these fairy-like birds will viciously attack intruders to their nesting territory. One American lady, who arrived on the same boat as us, cried "Do that just once more and I'll wallop you with my umbrella!". With their delicately-curved, slender wings and forked tails, they really deserve their popular name of "sea swallow". This delicate appearance is in sharp contrast to their ferocity in defence of their territory and their powers of flight. Like the Swallow, the Arctic Tern is a long distance migrant, perhaps the champion among all the birds. They nest in northern Britain and further north into the Arctic Circle and winter well to the south of the Cape of Good Hope in South Africa, venturing as far south as the Antarctic Ocean. Most of them must migrate at least 25,000 miles each year between their wintering and breeding grounds, as well as countless miles devoted to fishing trips, because they seem to spend much of their lives on the wing. The Arctic Tern holds another strange record, in that it may see more daylight than any other bird. Breeding near the Arctic Circle, it enjoys the benefits of the 'land of the midnight sun' with almost 24 hours of daylight through the summer. Then its spends its winter in the Antarctic summer, again enjoying almost 24 hours of daylight each day, with only a brief night."

MANX SHEARWATER

"This photograph of Manx Shearwater was taken on Skomer in 1953. On dark nights the whole island is alive with their calls, as they flop to the ground and crawl along in search of their nesting burrows, because their legs are very short in proportion to the rest of their body. They are guided by the calls of their mates, waiting impatiently on their nests. If the light of a torch is shone on them, they remain quite still and are easy to portray. The noise that they make is almost impossible to describe, a cackling and cooing that sounds as if thousands of cockerels have taken leave of their senses. I have been told that Scandinavian legends of trolls owe their origin to Manx Shearwaters colonies high up on mountain screes, and shearwater do sometimes nest some way from the sea. I can well imagine the impact of their nocturnal cacophony on superstitious ears, and no wonder the din was attributed to evil spirits!" Clumsy on land at night and vulnerable to predation by Great Black-backed Gulls if there is any moon, Manx Shearwaters are masters of their element during the day. Holding their narrow wings stiffly at right angles to their bodies, they glide with the speed of a shell, low over the waves. With hardly a wingflap as they twist and turn, showing alternately black and white as first upperparts and then underparts face you, they use every breath of wind and every upcurrent of air of the waves to cover enormous distances at fantastic speed.

Date
June, 1953

Camera
Brand 17

Lens
Kodak 6"

Aperture
F/22

Shutter
1/200th with flash bulbs second

Film
Super xx Film Pack

LITTLE STINT

"This lovely little wader was found feeding in a pool in Rye Harbour early in September. It was quite tame and I got to within 6 feet of it. I only had the Contax Camera with me so I rattled off a few dozen exposures of which this is one of the last." The Little Stint is one of the smallest of the waders occurring in Britain, it is a good bit smaller than the familiar Dunlin, and it is quite easily recognised by its short beak and by the double white 'vee' markings that show clearly on its back and shoulders. In spring, a few Little Stints pass through Britain, not staying long because it is important that they reach their breeding grounds on the tundra in good time to take full advantage of the brief Arctic summer. In the autumn, passage of failed breeding birds often starts as early as July, if the Arctic weather has been bad, but most migrants pass through in late August and September on their way to wintering grounds in Africa. Often they will stay for several days, feeding to recover from their journey and to prepare for the long flights ahead. Little Stints seem to me to choose smaller, shallower pools rather than congregating with other migrant waders out on the open estuary or shore.

Date
6th September, 1953

Camera
Contax

Lens
Tessar 135mm

Aperture
F/5.6

Shutter
1/500th second

Film
Plus-X

CURLEW

"Taken in central Wales this spring, this photograph was taken as the fourth egg was hatching and the adult sat at the back of the nest for some moments, watching the chick emerge. It was no easy job getting a shot of all three young, as one or two of them seemed always to be moving." When lecturing I am often asked how it is that the young Curlew can accommodate its enormous beak in a normal shaped egg. The answer is clearly visible in this shot, where the short, fine and almost straight bill of the nestling immediately in front of its mother, is quite obvious. Like other wader chicks, the young Curlew can scamper around and feed itself almost as soon as its down is dry. Young waders of all species hatch with their legs pretty well developed and often out of proportion to their tiny fluffy bodies. Of course, this helps them be independent and mobile. As they grow, their beaks grow faster than anything else and, soon become long and curved. By the time that they take their first flight, they are much the same size as their parents and have beaks that are just as long and shaped in the characteristic manner.

Date
May, 1954

Camera
Brand 17

Lens
Tessar 8 1/2"

Aperture
F/25

Shutter
Medium Luc

Film
Super xx Film Pack

GRASSHOPPER WARBLER

"As the bird was feeding the young, it fell forward and in trying to keep its balance it spread its wings and cocked its tail, just for a fraction of a second. Of all our breeding birds, the Grasshopper Warbler must be the champion in terms of secretive behaviour. Just to locate a nest is a major triumph and a tribute to nest-finding skills, but to find one suitable for photography without gardening seemed almost impossible. My views on the importance of avoiding too much gardening are well known, because it can cause desertion in sensitive species, but we were lucky with this one. It is easy enough to locate a Grasshopper Warbler territory, because the male sings frequently and in long bursts, day and night. The problem with his song is that he usually produces it from deep in cover, and he seems to have all the skills of a professional ventriloquist, so it is very difficult to pinpoint where the song is coming from. In addition, you can clearly see from this photograph how well camouflaged Grasshopper Warblers are with their streaked olive brown plumage."

Date
July, 1955

Camera
Brand 17

Lens
Tessar 8 1/2"

Aperture
F/35

Shutter
High Speed Flash 1/5000th second

Film
Super xx Film Pack

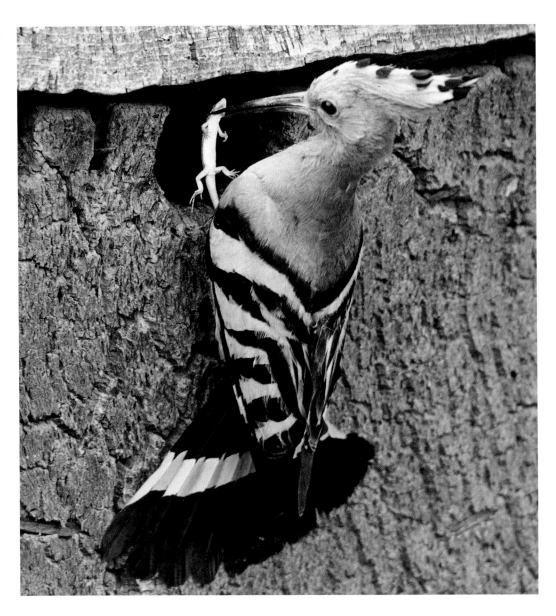

HOOPOE

Date
May, 1956

Camera
Brand 17

Lens
Tessar 8 1/2"

Aperture
F/12.5

Shutter
Med Luc

Film
Tri-X

"The male is holding a lizard, which he is about to give his mate, who is inside the cork oak bee-hive, where the nest was situated. There were eight young and an egg! Hoopoes have a very striking plumage; an unusual shade of buffish pink, offset by the bold black and white bars on the wings and tail. Their flight is so floppy on rounded wings that I sometimes wondered if the food-carrying parents would actually make it to their perch beside the nest hole. Often, when they landed or caught sight of one another, they would raise their crests in a beautiful fan. Less beautiful was the smell from the nest! When the breeze was in the wrong direction, there was no escaping the stench in my hide. With so many young, there were bound to be leftover fragments of food like this lizard and, in the heat, the flesh and droppings rotted swiftly. The birds themselves didn't seem to mind at all, but then birds are said to have little or no sense of smell."

PRATINCOLE

"During our Coto Donana expedition we were lucky enough to photograph this delightful Pratincole. Its large limpid dark eyes, neatly bordered creamy bib and curious sealing-wax red side to the bill made it an interesting subject to portray. Pratincoles are classified as waders, but it has always seemed to me that this is more likely to cause confusion than clarity. On the ground they do scamper around like long-winged plovers, but once they get into the air, any likeness to other members of the wader family vanishes. They swoop around on slender curved wings, hawking for insects for all the world like a giant swallow. In the Coto Donana we often saw the Pratincole hunting over the water in company with flocks of hirundines. This is one of the few places in Europe where Pratincoles are reasonably easy to find, and it is vital that their habitat here is protected."

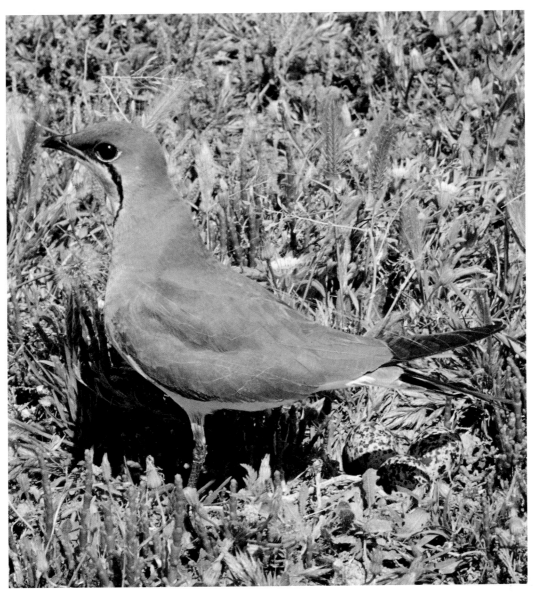

Date
May, 1956

Camera
Brand 17

Lens
Tessar 8 1/2"

Aperture
F/35

Shutter
Fast Luc

Film
Veri Pan

SQUACCO HERON

"The Squacco is rather later than the other herons breeding in the Coto Donana and this pair had only recently selected their nesting site. This they defended against all comers, even us! The male put on this lovely display whenever we went near him. Several species of small herons and egrets have these graceful plumes during the breeding season, but few can match the beauty of the Squacco."

Back in Victorian times, these plumes were nearly the undoing of the egret family. Known as 'aigrettes' the french name for 'egrets', they became extremely fashionable as additional ornaments for ladies millinery. In the summer months, hunters descended on the egret colonies, and a wholesale slaughter took place to supply this dreadful trade. Fortunately the bird protection enthusiasts of the time, many prominent ladies among them, gathered together and reversed public opinion, eventually getting the trade stopped. This was really the beginning of organised bird protection and led to the birth of societies like the Royal Society for the Protection of Birds, which carry out much valuable bird protection work today.

Date
May, 1956

Camera
Brand 17

Lens
Tessar 8 1/2"

Aperture
F/35

Shutter
1/125th second

Film
Veri Pan Film Pack

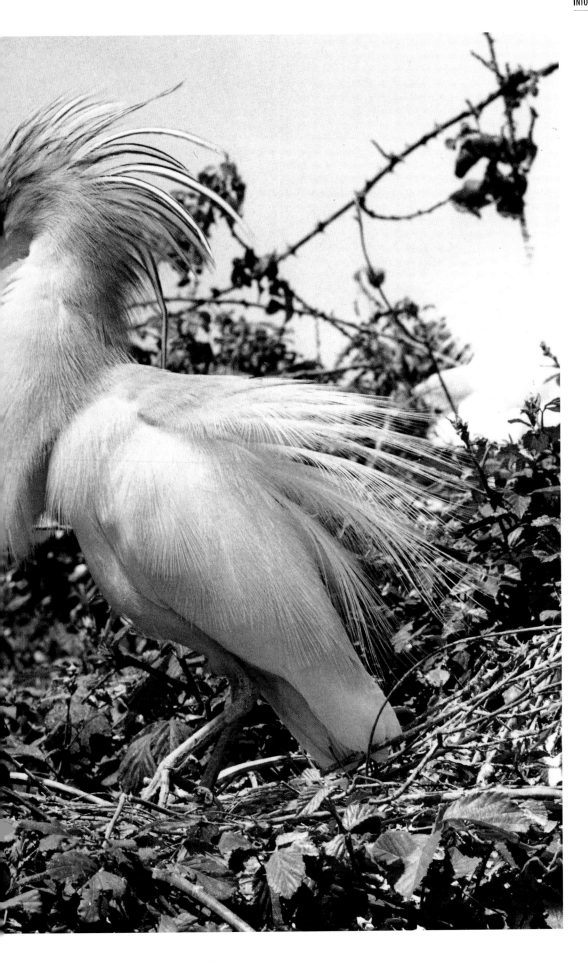

FAN-TAILED WARBLER

"The Fan-tailed Warbler was the smallest of the 23 warblers we recorded in the Coto Donana. The nest was one of the loveliest I have ever seen, being built of gossamer webs and various flower seeds. It was eight inches long with an entrance five and a half inches from the bottom. As it was in a dense patch of *Juncus*. the strong sun made the site almost impossible to work. The contrast between highlight and shadow, as well as the background effect of innumerable grass stems, gave an awful blotchy appearance. So I used high speed flash as a light fill-in to augment the daylight. We had to be extremely careful searching for Fan-tailed Warbler nests in case we damaged them while looking in the tufts of vegetation. The breeding birds themselves were easily located by the strange song flight of the male. Whether he was singing against a neighbouring male or giving a display in reaction to our presence, he climbed into the sky on his tiny wings, and then parachuted down producing his drawn-out 'sweeep' call as he went. With such tiny wings and skulking habits, I doubt if many Fan-tailed Warblers ever move very far from their territory."

Date
May, 1957

Camera
Brand 17

Lens
Tessar 8 1/2"

Aperture
F/35

Shutter
1/150th second with flash

Film
Veri Pan

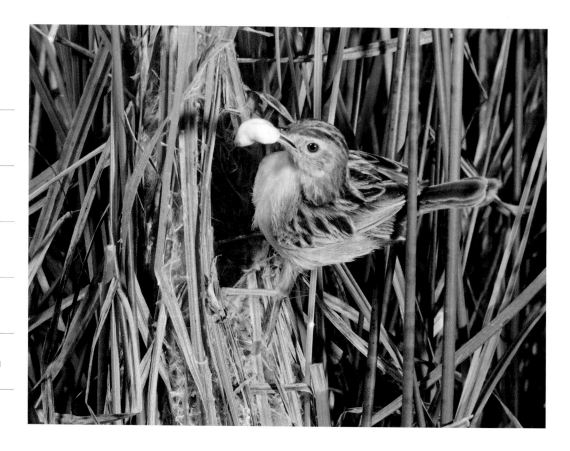

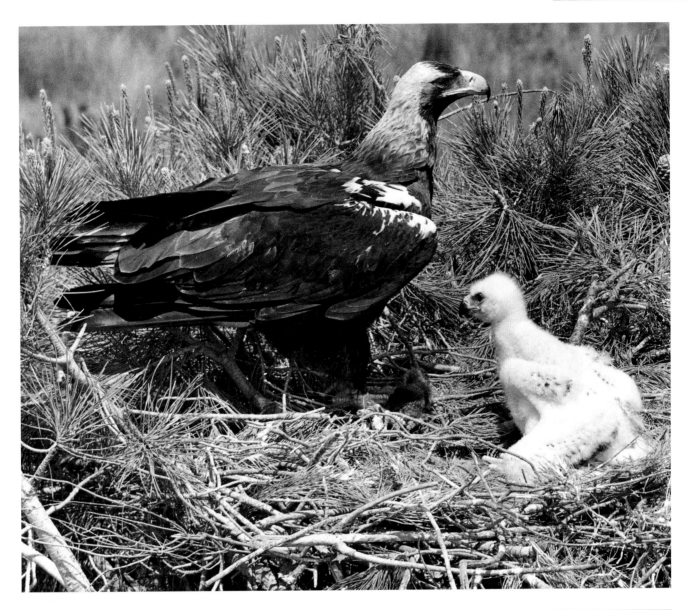

IMPERIAL EAGLE

"It was a tremendous thrill to be able to portray this eagle, one of the grandest and rarest birds in Europe. It has never before been photographed at the nest, an added zest! Very like a Golden Eagle in size and shape, the Spanish form has white patches along the leading edge of the wings . The nest was built in the very top of a Stone Pine, 24 feet above the ground and hardly any gardening was necessary. The great trouble was to deal with the brilliance in the light. The bird is almost black in colouring, and the young absolutely pure, dazzling white! Development of negatives was out by a third and Cold Cathode was used as the illuminant in the enlarger."

This remains the classic series of photographs of this elusive bird, an extreme rarity and very much in need of the protection afforded by the huge Coto Donana reserve. As in any eagle, territories must be large to provide adequate hunting and food for both adults and young, and several adjacent pairs are necessary to ensure the stability of the population in any given area. The scaffolding used in the construction of this pylon hide gave rise to what is probably the only reference to bird photography in *Hansard*, the journal of the House of Commons, when a question was asked in Parliament on why an Admiralty vessel was used to ship scaffolding out to Spain for a private bird-photography expedition. An Official Report was prepared with the help of Lord Mountbatten and Field Marshall Lord Alanbrooke and no more was heard!

Date
May, 1957

Camera
Brand 17

Lens
Tessar 8 1/2″

Aperture
F/35

Shutter
Fast Luc

Film
Veri Pan

SHORT-TOED EAGLE

"This grand Eagle looks very like a harrier and reminds me of an owl about the face. To make matters even more confusing, it has the habit of hovering, almost like a Kestrel but not quite, because it is so massive that its wingbeats are very laboured and clumsy in comparison with that well known falcon. The short toes can be seen well in this picture. The snake is a Water Snake and the commonest of the six kinds of snake we saw in the Coto Donana. The nest was in a Stone Pine and we built a pylon hide from which cine films were made as well as the stills. You can see that the hide was a really tall one, very difficult to build with the wood that was available in this wonderfully remote place, but we

Date
May, 1957

Camera
Brand 17

Lens
Tessar 8 1/2"

Aperture
F/35

Shutter
Fast Luc

Film
Veri Pan

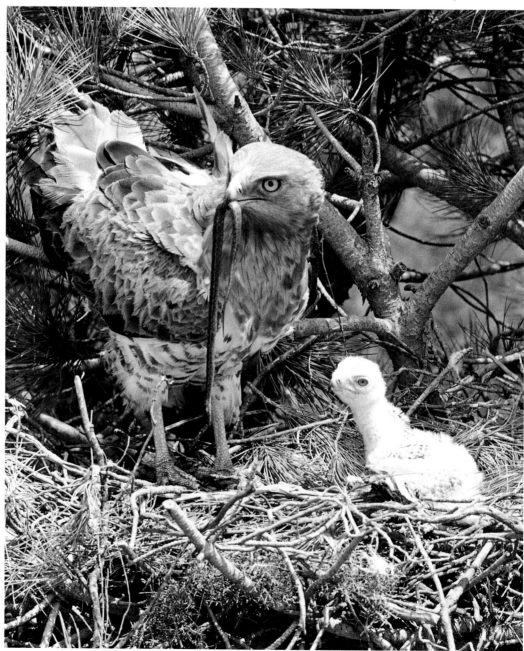

eventually managed. Several strong guy ropes were necessary to stabilise the structure, and I must say I felt much safer once I was in the hide and concentrating on my subject. You can see the strut that we used to keep the distance between the nest, in the top of the pine, and the hide constant, even in a stiff breeze. If the hide and the tree had swayed in different directions, accurate focusing would have been almost impossible. With the strut in place, I could concentrate more on composition and on what was going on, without worrying all the time about adjusting the focus."

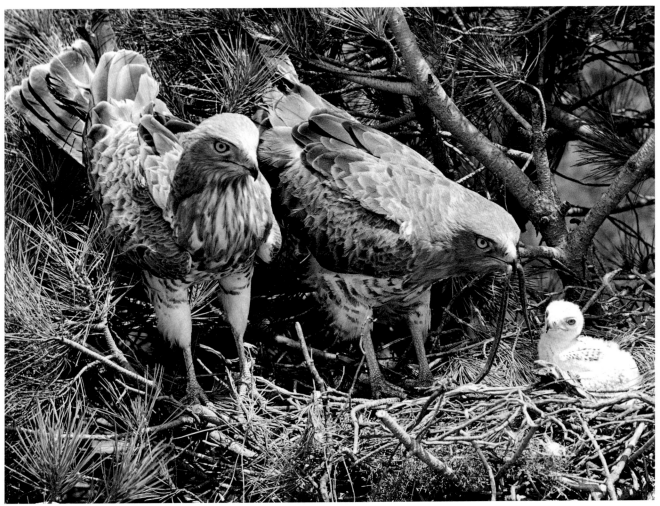

WOODCHAT SHRIKE

"Apart from some of the larger birds we photographed in Spain, we also managed to work on a number of smaller species such as this Woodchat Shrike. In Abel Chapman's day this species nested very commonly in the Coto, but, although we saw many passing through as migrants, we found that very few stayed to breed and this was the only nest to be found. The female is incubating eggs and is being fed on the nest by the male. The Woodchat is one of the smaller shrikes and, to my mind, probably the most elegant. Its black and white plumage is superbly set off by a chestnut crown and nape, larger and richer in colour in the male than the female. I am always taken rather by surprise when I hear one of the shrikes in song. For predators, and their strong hooked beak can clearly be seen, their song is a delightful, quiet warble, interrupted only occasionally by harsher, discordant notes."

Date
May, 1957

Camera
Brand 17

Lens
Tessar 8 1/2"

Aperture
F/25

Shutter
1/50th second with fill in flash

Film
Veri Pan

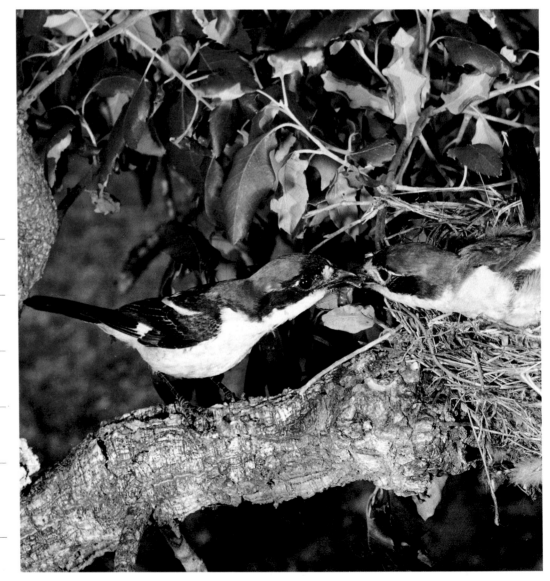

TEREK SANDPIPER

"So far as is known only two pairs of Terek Sandpipers breed west of Russia on a little island of about 24 acres near Oulu in Finland. They have bred here since 1954, but show no sign of increasing. I was able to work on both pairs right through to the hatching of the young. They were tame and confiding birds, but not at all easy to photograph. Being sandpipers, they never seem to stand still near the nest and their tails are always on the move. The comparatively robust and distinctively upturned beak reminded me, in many ways, of a miniature Greenshank, but, of course, the Terek Sandpiper is quite a lot smaller and has the distinctively black streaked back that you can see well in this print. The Terek Sandpiper is a very rare bird in Europe. I think most nest far to the east in Russia and migrate south through Asia. The total world population is probably very small compared with most other waders."

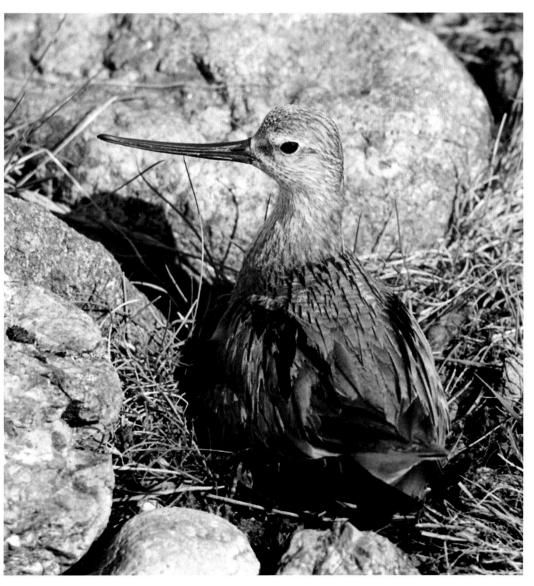

Date
June, 1958

Camera
Brand 17

Lens
Tessar 8 1/2"

Aperture
F/25

Shutter
Med Luc

Film
Tri X Film Pack

GRIFFON VULTURE

"Accessible nests of this vulture are not easy to find and this one was in a precarious position, on a narrow ledge with a sheer 800ft drop below. However, a hide was erected on the opposite side of the gully at a range of 90 feet. No sun penetrated into the nest and lighting conditions were always poor. Most people seem to find the vulture family repulsive, but, of course, they do a good job in clearing up carrion that would otherwise rot and act as a source of disease. At the nest, the adults behaved very gently and astonishingly delicately when feeding, in this case, their single chick. The Griffon Vulture's head, which at first glance appears completely naked, is, in, fact, covered in fine, downy feathers. From the close viewpoint of the hide, the birds seemed to have kept their heads surprisingly clean when you consider where they had been whilst they were feeding."

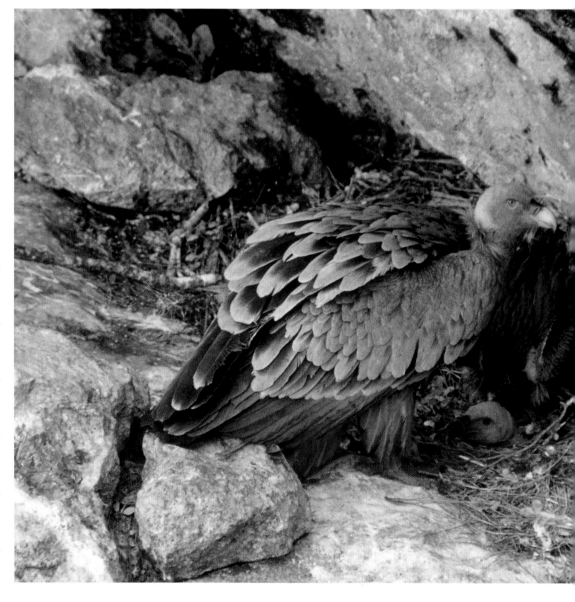

Date
May, 1959

Camera
Contax

Lens
Kilfitt 300mm

Aperture
F/5.6

Shutte
1/10th second

Film
Pan-X 35mm

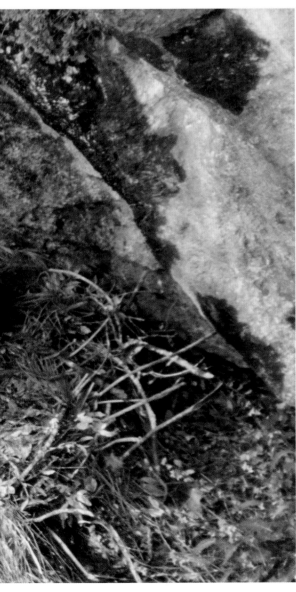

LAMMERGEIER

"The main objective of the Cazorla Expedition was to obtain photographs of what must be the most spectacular and exciting bird in Europe - The Lammergeier or Bearded Vulture. The Lammergeier is renowned for its habit of waiting till other scavengers have eaten their fill at a carcass and then dealing with the bones. It picks these up and carries them to a favourite rock, where it drops them time and again until they break and the Lammergeier can extract the nutritious marrow. Its tongue is tough and horny, and

Date
2nd June, 1959

Camera
Contax with reflex housing

Lens
Kilfitt 600mm

Aperture
F/5.6

Shutter
1/30th second

Film
Pan-X 35mm

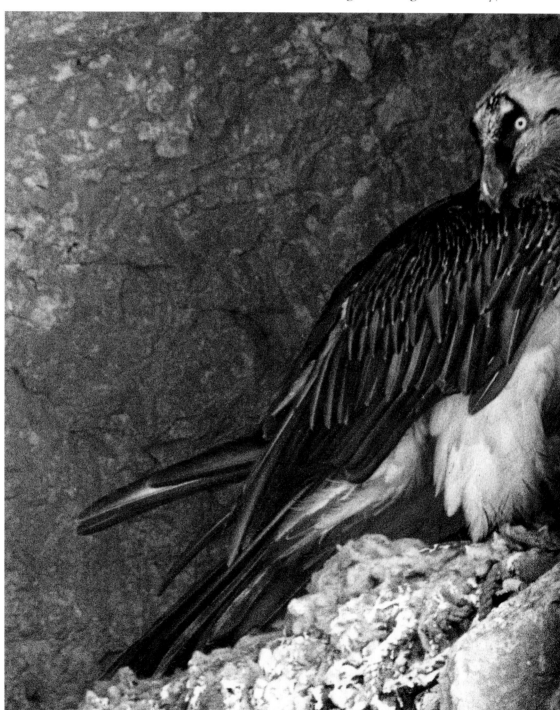

shaped like the marrow scoops that used to be a feature of Victorian kitchens. Before leaving England we knew we were facing a formidable task as this magnificent bird had been photographed in Europe only once before by Antonio Cano. They usually breed in the most remote and inaccessible places at fairly high altitudes, miles away from civilization and, like eagles to which it is fairly closely related, there are years when they don't breed at all! Frankly I felt we hadn't a dog's chance, but I knew it would be a thrilling adventure. It was

perhaps just as well that I did not realize how exciting it was to be. After much searching we saw a huge bird fly overhead. Looking like an outsized falcon with a long diamond-shaped tail. We watched it fly into a cave some 1500 ft above the valley floor. The nearest place to erect a hide was 150 feet away on a narrow ledge over a sheer drop of about 200 feet I was only able to spend one day-long session in the hide because during the next two days tremendous gales swept our hide down the valley."

GREAT REED WARBLER

"During our visit to Bulgaria, we found this Great Reed Warbler nesting in a dense reed bed, about four feet above the water. Even in late June, they still had eggs in the nest and the male fed the female assiduously as she incubated. Notice how well the very substantial nest is firmly anchored to the reed stems, a good example of the skills of birds as master builders in difficult circumstances. Great Reed Warblers are giant, thrush-sized versions of our familiar Reed Warblers, but rather sandier in plumage. When he was not busy looking after the female, the male used to sing from the reed tops close to the hide. I was often struck by the sheer volume of the noise he produced. It must have carried for hundreds of yards. Several members of the warbler family have songs that really do not live up to their names, and I think the Great Reed Warbler must be the champion among them, with its noisy harsh metallic chattering 'song'."

Date
June, 1960

Camera
Brand 17

Lens
Symmar 9"

Aperture
F/32

Shutter
High speed flash duration of 1/1000th second

Film
Verichrome Pan

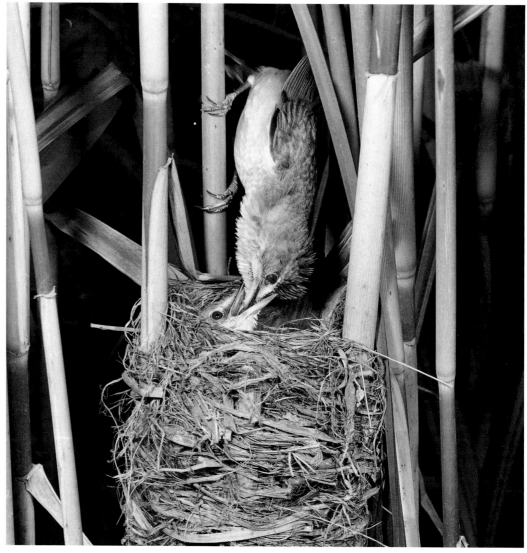

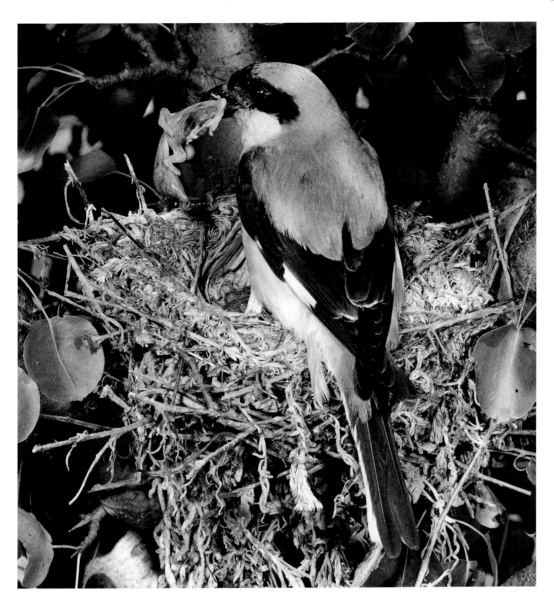

LESSER GREY SHRIKE

"The Lesser Grey Shrike is very common over a wide area of Bulgaria and usually nests in trees at heights between 10 and 20 feet. This nest with seven young in it was in a thorny pear. I used fill in flash to kill the high contrast, spotty light coming though the foliage. The parent bird has brought in a nestling, taken from a nearby nest. All the shrikes are expert hunters and look like birds of prey in miniature. This pair of Lesser Greys brought in everything from worms, beetles and bumble bees to small nestlings, lizards, crickets, grasshoppers and the occasional small rodent. Sometimes, I could clearly see the notch on the upper part of the beak. This is like a second hooked tip, and allows the Shrike to grasp hard, slippery victims like beetles and carry them back to the nest in its beak, not in its talons like a true hawk or falcon."

Date
June, 1960

Camera
Brand 17

Lens
Symmar 9"

Aperture
F/35

Shutter
1/25th second with flash

Film
Tri-X

LESSER SPOTTED EAGLE

"This nest was 45 feet above the ground and a pylon hide, taking 14 days to make, was erected. The nest was in a swamp forest and continuous torrential rain fell for three days turning the whole place into a quagmire. I spent all of the last day in the hide and it rained continually. I could not get a light meter reading at all, so I fired the Luc shutter as slowly as I could, taking about 1/2 to one second I suppose, and used the fastest film I had. Frankly, I am surprised that there is anything on the negative at all. The parent Eagle, far from looking impressive and powerful, was as bedraggled as we were. I know it is wrong to attribute human emotions to birds, but I couldn't help feeling that she was just as fed up with the situation as we were. She certainly looked it."

Date
June, 1960

Camera
Brand 17

Lens
Symmar 9"

Aperture
F/6.3

Shutter
Slow Luc

Film
Tri-X

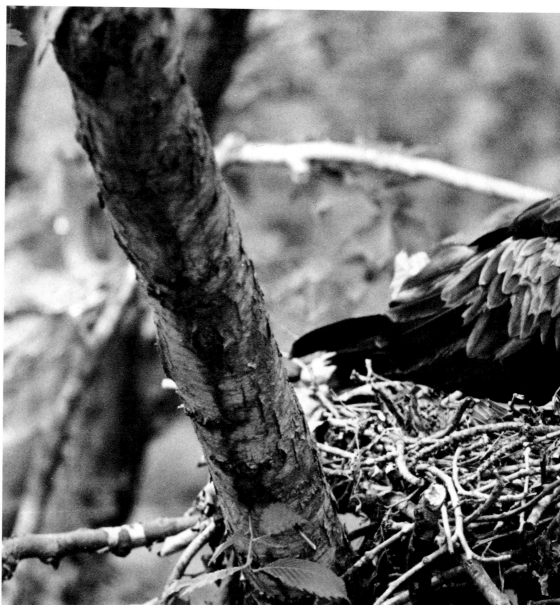

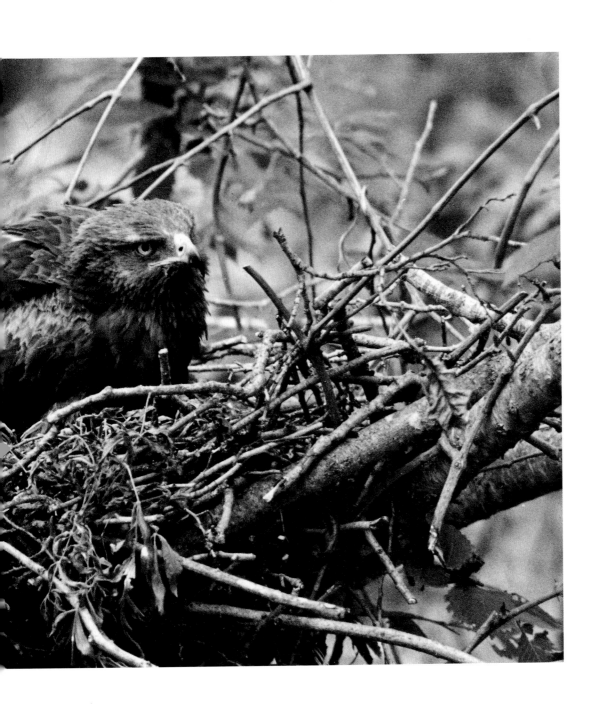

BLACK-WINGED STILT

"We found these Black-winged Stilts to be a very common species around Lake Burgas in Bulgaria. What fascinating waders they are. Evolution seems to have played an unkind trick on them, because while their extremely long, bright pink legs allowed them to feed out in deeper water than any other wader, they were very difficult to manage when it came to sitting on the eggs to incubate them. Other photographs in this sequence show how they stuck out, like giant pink hairpins, well beyond the tail of the incubating parent. Strong winds occasionally swept suddenly across Lake Burgas, shaking the hide. The Stilts then found it difficult to keep upright, leaning into the wind in a comical fashion or stumbling about, as gusts got hold of their bodies. Many retreated into the shelter in the lee of clumps of vegetation, protesting shrilly at the disturbance."

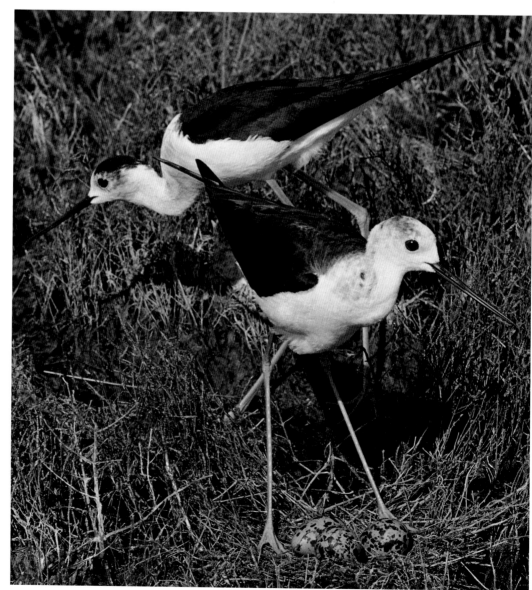

Date
June, 1960

Camera
Brand 17

Lens
Symmar 9"

aperture
F/32

Shutter
1/50th second

Film
Verichrome Pan

EAGLE OWL

"During our visit to Hungary in 1961, we were shown this chick which had wandered about 30 yards from its nest so there was no point in putting up a hide, but it is interesting to note that the parent birds had still left a mole and a hedgehog. One can't help but wonder not only how the parents caught the Hedgehog but also how the chick was going to eat it! Very few birds have given me such an impression of ferocious power as the adult Eagle Owl, and even the chick looked pretty fierce. We were told that they sometimes attack humans near the nest, and that they can take prey up to the size of a fox or a small deer. I can well believe this, as each claw was strong, curved and needle-sharp, and at least 2 inches long. Spread out wide in attack, the Eagle Owl's talons must have just about the same span as a man's hand. They would very effective weapons with the weight of the fast-flying bird behind them, as they struck home."

Date
May, 1961

Camera
Contax

Lens
Nikkor 50mm

Aperture
F/5.6

Shutter
1/100th second

Film
Pan-X

Date
May, 1964

Camera
Contarex

Lens
Sonnar 250mm

Aperture
F/22

Shutter
1/10th second

Film
Pan-X

EAGLE OWL

"Photographed in Norway in May 1964, this is the most impressive bird I have ever seen at the nest, but unfortunately a Fox got the young before I could really get going at this nest. I only had one night, during which only two short visits were made. No photographs were taken on the first visit so I could watch the reactions, where the bird stood etc, and this was the only shot I got on the second visit."

GREAT WHITE HERON

"I had been told that the Great White Heron was an exceptionally shy bird. Having photographed all the other European herons, I found this difficult to believe. However, after only a few minutes in the hide, I realised that this statement was true. The least sound from the shutter and up went her long, snaky neck and she stood motionless, her striking yellow eye glaring straight into my lens. Great White Herons share with the smaller egrets those

Date
June, 1961

Camera
Brand 17

Lens
Tele Tessar 32cm

Aperture
F/35

Shutter
Slow Luc

Film
Tri-X

beautiful filamentous plumes that show so well in this photograph. They only have them at their best early in the breeding season, so by the time I took this shot, their delicate structure was already showing signs of the wear and tear of raising a hungry family. Although they occur almost all round the world, Great White Herons are never numerous, and they are one of Europe's rarest breeding birds."

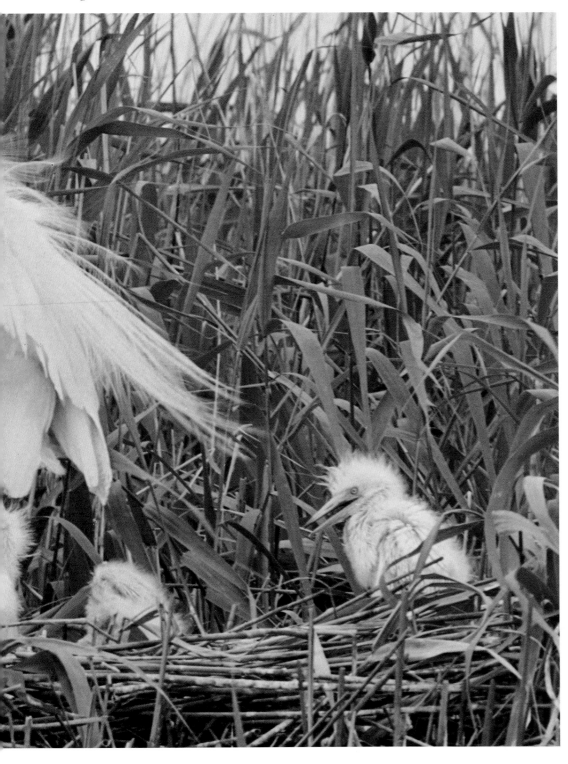

Spoonbills

"Not far from the colony of Great White Herons on Lake Velence in Hungary was a colony of Spoonbills, all on eggs. These three birds had been incubating, but, on the approach of the keeper, they all stood up to watch him! Despite the size and apparently awkward shape of their beak, they were able to pass food to their small chicks with great delicacy. It was interesting to watch them out feeding round the edge of the lake. Quite clearly they were using their spoon shaped beaks to grope for food, mostly shrimps, shellfish and the occasional frog, in the muddy bottom. I have been told that the spoon at the end of the beak is richly supplied with sensitive nerve endings, just like the bulbous tip of a Snipe's beak. They are finding food by touch, a great advantage when the water is so murky."

Date
June, 1961

Camera
Brand 17

Lens
Tele-tessar 32cm

Aperture
F/32

Shutter
1/50th seconf

Film
Tri-x

OSPREY

"While staying with Roger Peterson in America, he asked me if I would like to try out a new lens that he had been given. It was a 20" Zoomar Reflectar with a fixed aperture of F/5.6. To obtain a 20" focal length in so small a space, the image is reflected by mirrors before reaching the film. [Eric is describing an early prototype of what we today call a 'mirror lens'.] Roger was able to provide the ideal subject for me to try it on: this Osprey nest on an island in Connecticut, where, in fact, there are 32 pairs! You will see that the adult bird is ringed, or as Roger would insist, 'banded'. These nests were part of several long-term population studies set up by biologists becase of their concern at the sharply declining Osprey numbers in the United States. Away from the nest, it was fabulous to watch the Ospreys diving for fish, sometimes almost completely submerging in their efforts to secure a meal. Struggling to get airborne again, they would shake off the water in flight, before heading off with their catch. Usually the fish would be held in one powerful foot, often still wriggling, and carried head-forwards like the torpedo beneath a Fairey Swordfish aircraft during the war."

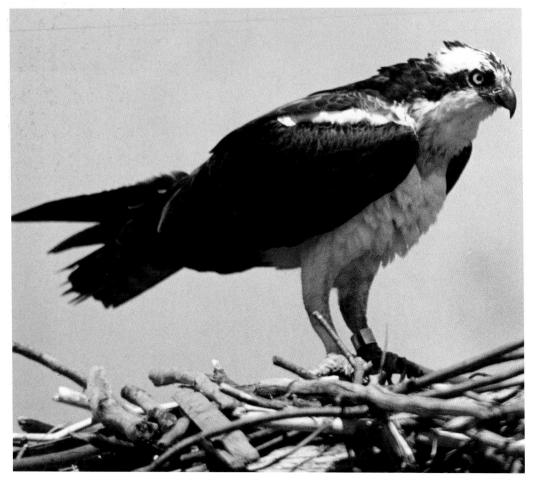

Date
3rd June, 1962

Camera
Exacta

Lens
Zoomar

Aperture
F/5.6

Shutter
1/500th Second

Film
Pan-X

GREAT TIT

"Taken in Eileen Soper's garden where several Great Tits come down to feed and where they often displayed to one another. The food is a mixture of cheese and nuts and is shown in the foreground. Many people do not realise that you can usually tell the sex of Great Tits. Females have a black throat and bib, and a black central line down their breast that soon becomes very faint and then vanishes. Males have a thicker breast line that continues down onto the belly and broadens out to a large black patch between the legs. Adult males tend to have bolder, darker stripes than birds in their first winter, so this bird , in an aggressive pose, is a young male. His white outer tail feathers show up well when the tail is fanned."

Date
February, 1963

Camera
Brand 17

Lens
Tessar 8 1/2"

Aperture
F/22

Shutter
HSF on the bird, daylight on background

Film
Tri-X

SPUR-WINGED PLOVER

"Photographed in Jordan, this male was approaching the nest and, as the female rose, she picked up a small piece of grass and threw it to one side. This handsome bird is related to our Lapwing and is one of the most widespread of waterside plovers throughout Africa. It gets its name from a dark bony protuberance, as sharp as a spur, which points forwards from the 'shoulder' of the folded wing. Often the spurs are concealed behind the breast feathers, but, in display or if a fight occurs between rival males, they are brought into action. Of course the 'shoulder' of the folded wing is actually the bird's wing, and I understand that the bony spur is actually a projection from one of the metacarpal bones of the wrist." Since Eric took this photograph, the Spur-winged Plover has joined the list of European breeding birds, nesting in the extreme south-east of Europe.

Date
April 1963

Camera
Contarex

Lens
Sonnar 250mm

Aperture
F/8

Shutter
1/250th

Film
Pan -X

WHITE-TAILED OR SEA EAGLE

"Taken in Norway last year, the site was in a terrifying situation, 350 feet above sea level and I don't mind confessing that I was scared out of my life climbing to it. The only possible place for a hide was 115ft away so this is a considerable enlargement. The nest was in a cleft where the sun did not penetrate, so photograph was not easy. Yet to get anything at all of this largest of all European eagles was exciting to me. I was interested to see that they were mainly feeding on Eider ducks." Since Eric took this photograph, the magnificent Sea Eagle, long extinct in Britain, has been restored to our list of breeding birds. The RSPB and the then Nature Conservancy Council mounted a joint reintroduction programme, based on juvenile birds mostly from Norway. In Norway, considerable persecution by farmers still afflicts the Sea Eagle, and these young birds were, in effect, rescued to found the new breeding population on Rhum in the Inner Hebrides. The colonists are now well established, and successful breeding has now been accomplished for several years.

Date
May, 1964

Camera
Contarex

Lens
Sonnar 250mm

Aperture
F/5.6

Shutter
1/50th second

Film
Pan-X

WRYNECK

"Taken in Dombas in Norway, where we only once heard a Wryneck in this wood and never suspected it was breeding. However, some local boys took us to a tree where they said a snake was hissing inside a hole! The Wryneck was often called 'snake bird' by old country folks, I suspect more because of the peculiar way it twists its long neck in slow motion like a snake, than because of its hissing. The adults fed the young every two or three minutes on wood ant eggs and larvae. The Wryneck's plumage is one of the most delicately marked and mottled of any bird that I have seen, and this shows up well in the print. You can see the close relationship with the woodpeckers in the way in which the powerful toes are arranged with two pointing forward and two back. Unlike the woodpeckers, though, the Wryneck has soft central tail feathers and does not rely on them as a prop when perching on a trunk." The wryneck, reasonably common in the orchards of Southeast England when Eric was taking many if his classic black and white photographs, is now virtually extinct as a British breeding bird.

Date
June, 1964

Camera
Contarex

Lens
Sonnar 250mm

Aperture
F/16

Shutter
1/60th second

Film
Pan-X

NORTHERN GOLDEN PLOVER

"These Golden Plovers are common on the Fokstua Bog in Norway. Having photographed them before in Wales, it was interesting to note the difference in this Northern race, which is appreciably bolder and brighter in its plumage colours. Standing up, the male was very conspicuous with a striking white edge to his black belly and throat. The back was the most beautiful mottling of gold, grey and black, but what astonished me was how inconspicuous the incubating bird managed to become. Tucked down on the nest, the bold black and white was out of sight, and the gold and black chequers on the back merged very successfully with the mosses, sedges and sundews of the bog. This made the nest very difficult to find, because the bog was so uniform and there was no high ground from which to observe the beeding grounds."

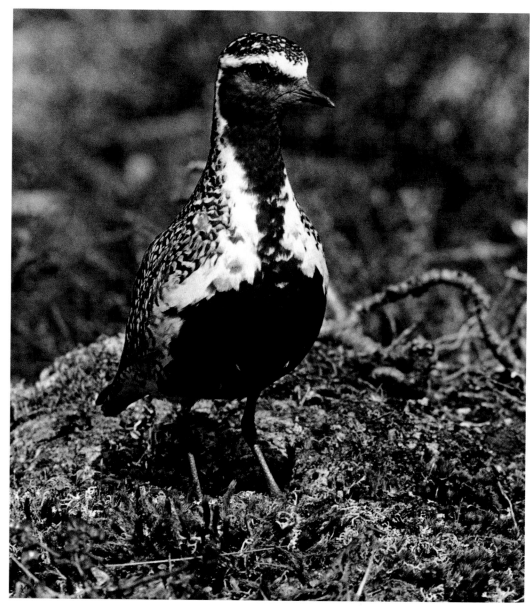

Date
June, 1964

Camera
Contarex

Lens
Sonnar 250mm

Aperture
F/8

Shutter
1/125th second

Film
Pan-X

TEMMINCK'S HORNED LARK

"Taken on my second visit to Jordan in the desert near Azraq. Absolutely no gardening was done here and it is beyond my comprehension how the young survived in the incredible heat; the sand temperature was 120°F with no covering! Yet they were extremely lively as can be seen. Temminck's Horned Lark looks very like the Horned Lark of North America and the Shore Lark which breeds on the tundra above the Arctic Circle and winters on European coasts. I understood from my colleagues in Jordan that the experts are uncertain whether all three of these are actually just the one species. If they are, then I am amazed at their distribution, which has great gaps in it, and even more amazed at their range of habitats. In North America, Horned Larks occur in all sorts of open country, including farmland. In the Arctic, it is a tundra bird, while in Europe and Asia, Horned Larks or Shore Larks occur on alpine meadows in the Himalayas, where temperatures in summer frequently drop below freezing, down to the deserts of North Africa and Jordan, where they must endure the opposite temperature extreme."

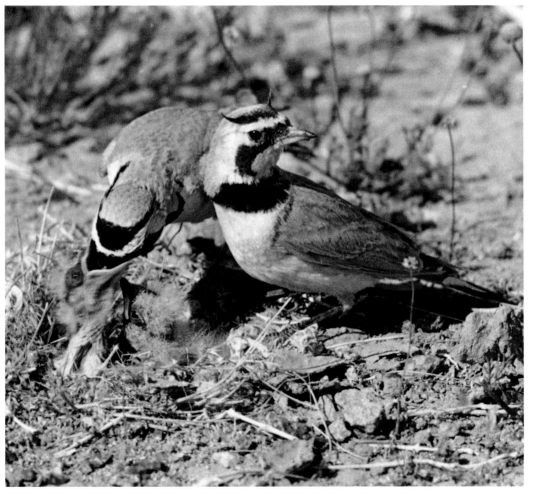

Date
April, 1965

Camera
Contarex

Lens
Sonnar 250mm

Aperture
F/11

Shutter
1/125th second

Film
Pan-X

SPOTTED REDSHANK AND SHELDUCK

"Taken at Minsmere from one of the standard birdwatching hides. It was interesting to see that the Spotted Redshanks took no notice of Shelducks as they fed with heads under the water only inches away. Yet, as soon as another Spotted Redshank came near, the threat display was used, but I suppose this is not too surprising as the bird is defending its food supply. Spotted Redshanks always seem to me to feed in much deeper water than their cousin the Redshank, and occasionally when they get out of their depth they swin well, keeping their tails high like a Moorhen. I have noticed too, that they are far less nervous than Redshanks, which can be the bane of any bird photographers life. At the slightest hint of any danger, Redshanks go off into a stream of piercing alarm calls, frightening everything that is within earshot."

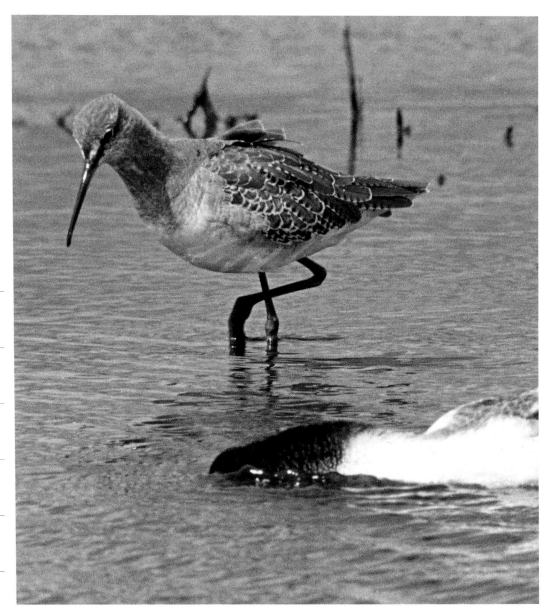

Date
August, 1966

Camera
Contarex

Lens
Kilfitt 600mm

Aperture
F/8

Shutter
1/500th second

Film
Tri-X

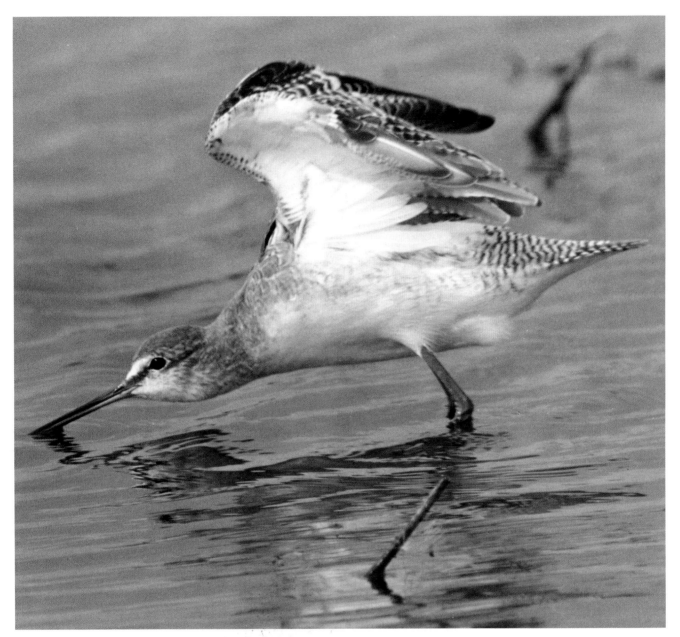

White-backed Vulture

"Taken in Bangladesh. Some 60 of these Vultures were soaring above the carcass of a Water Buffalo, plucking up courage to come down. This is a perfect example of the typical vulture flight silhouette, although as the bird has only just taken off, its head and neck stick out further than they would do, if it were soaring properly. Note particularly the long broad wings with their fingered tips and the short rounded tail. Some vultures, I have seen soaring, have been so far above the ground that I have only found them by using binoculars. They must have absolutely marvellous eyesight to spot their next meal of carrion at this range. I suspect that they space themselves out in the sky, covering the maximum amount of ground, each keeping a careful watch on the vultures next to it to see if they begin to descend. Once a carcass has ben found, all the vultures for miles around seem to be spiralling down to the site, and, within a few minutes, the dead animal disappears beneath an ugly hissing scrum of hungry vultures."

Date
November, 1966

Camera
Contarex

Lens
Novaflex 400mm

Aperture
F/5.6

Shutter
1/1000th second

Film
Pan-X

GOSHAWK

"This portrait was taken in Pakistan last autumn. The bird was being used for falconry, mainly to catch Houbara Bustards. The idea was for the falconer on horseback to gallop round the desert until a Houbara was sighted. As the Houbara Bustard hates flying, it is chased until the Goshawk has seen it, when it is released and flies off to attack the Houbara's head fiercely. In the wild Goshawks are just as fierce hunters in their native forests. Like giant Sparrowhawks, they have short, roundish wings and a long tail. This gives them a lot of acceleration and manoeuvrability, ideal for a short dash in pursuit of their victim. They can match every twist and turn it takes in its frantic efforts to escape. Male Goshawks are about the same size as a female Sparrowhawk, but the females are much larger, about as big as a Buzzard, but considerably shorter in the wing. I am told that in forests on the continent, where both birds occur, Sparrowhawks quite often feature in the diet of their larger relative!"

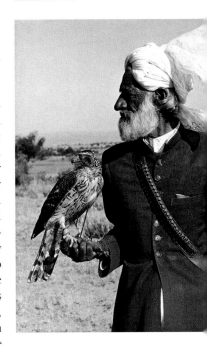

Date
November, 1966

Camera
Contarex

Lens
Planar 50mm

Aperture
F/11

Shutter
1/250th second

Film
Pan-X

SNOWY OWL & YOUNG

"These birds were breeding on Fetlar in the Shetlands. To me it was one of the most thrilling and exciting moments of my life to see this most lovely of all the owls alight at her nest in the British Isles, and it was a great privilege to be allowed to photograph them. Their eyes are the most wonderful I've ever seen. They seemed to look right through one. The female was rather larger than the male, who did most of the hunting, and she was rather darker in plumage, with the heavy

Date
July, 1967

Camera
Contarex

Lens
Sonnar 250mm

Aperture
F/8

Shutter
1/500th second

Film
Tri-X

brownish bars you can see well in the print. The male had hardly any dark bars, and, pure white, made a wonderful sight against the rocky moorland and heather."

Sadly, since the all too brief period when Snowy Owls nested on Fetlar, there have been no more British nests of this magnificent bird. In most years, solitary males, or females, may occur through the summer, but probably Britain, even in the extreme north, is just too far south for them to breed regularly.

RED-BILLED TROPIC BIRD

Date
April, 1970

Camera
Contarex Super.

Lens
Sonnar 250mm

Aperture
F/5.6

Film
Verichrome Pan

"This was taken on Hood Island in the Galapagos, where these Tropic Birds are fairly common, and seem to spend a lot of their time in flight. Their flight is fast, but, as they circle round in almost the same plane, time and time again it is possible to focus at a set distance and wait for the bird to fly into focus. If you examine the print closely, you can just see the jagged edge to the Tropic Bird's Beak, an adaptation to hold small wriggling fish firmly, which I am surprised has not arisen in our familiar tern family. Unlike the terns which fly with their tail streamers outstretched, the Tropic Bird's enormously long central tail feather trail behind it. Most of the nests I saw were in cavities in the lava cliffs, and were quite impossible to photograph in the brief periods we were ashore. We could find them easily by scanning along the face with binoculars. Sitting birds often had part of their tail poking out through the entrance hole, fluttering in the breeze and an awful give-away."

GREAT FRIGATE BIRD

In spite of its huge size and 8ft (230cm) wingspan, the Greater Frigatebird (called by some the 'man-o-war bird') is one of the most agile of all seabirds in flight. The viciously long sharply-hooked beak and astonishingly flexible neck combine to allow Frigatebirds to catch flying fish as they plane low over the waves, or with equal effortless ease to snatch the nestlings of other seabirds from their nests - all while in flight. Most of their food seems to be obtained from skua-like piratical attacks on seabirds as large as boobies returning to their colonies to feed their young. The breeding season is the only time that Frigatebirds come ashore and perch, as their legs are very feeble, and only rarely do they alight on the sea. This male is displaying his crimson inflatable throat sac, used in display and as a resonator to reinforce (boost the volume of) his wierd bubbling calls.

Date
April, 1970

Camera
Contarex Super.

Lens
Sonnar 250mm

Aperture
F/5.6

Film
Verichrome Pan

5 THE PHOTOGRAPHIC GEAR – AND ITS USES

CAMERAS.

In the course of his career, Eric saw enormous changes in the cameras he used, and in their shutter mechanisms and range of lenses. Eric's various early cameras have already been mentioned, particularly the trusty mahogany and brass quarter-plate Sanderson. In general, field cameras were most favoured by natural history photographers, most commonly either a 5 x 4 in. or quarter-plate format, and most were made of wood and brass. Their big disadvantage was that they needed to be pre-focussed: the photographer had to make a precise judgement about where the subject would be at the moment of exposure. However they also had advantages, including a wide variety of movements not available in modern 35mm cameras, such as a swing back or swing front, rise and cross fronts, double extension bellows and various film-back formats. They also allowed a much larger image size and greater background surround, but the large image could lead to depth of field problems and usually necessitated a much smaller aperture than is

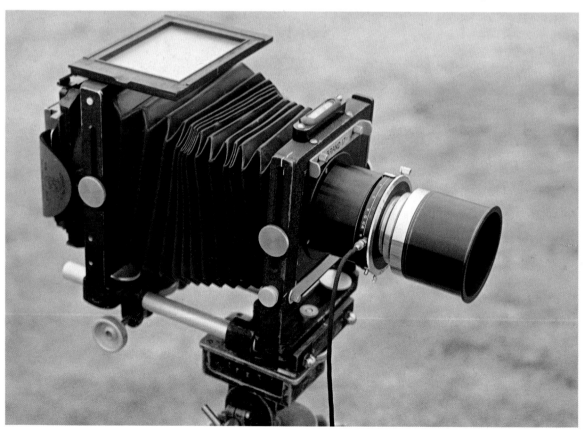

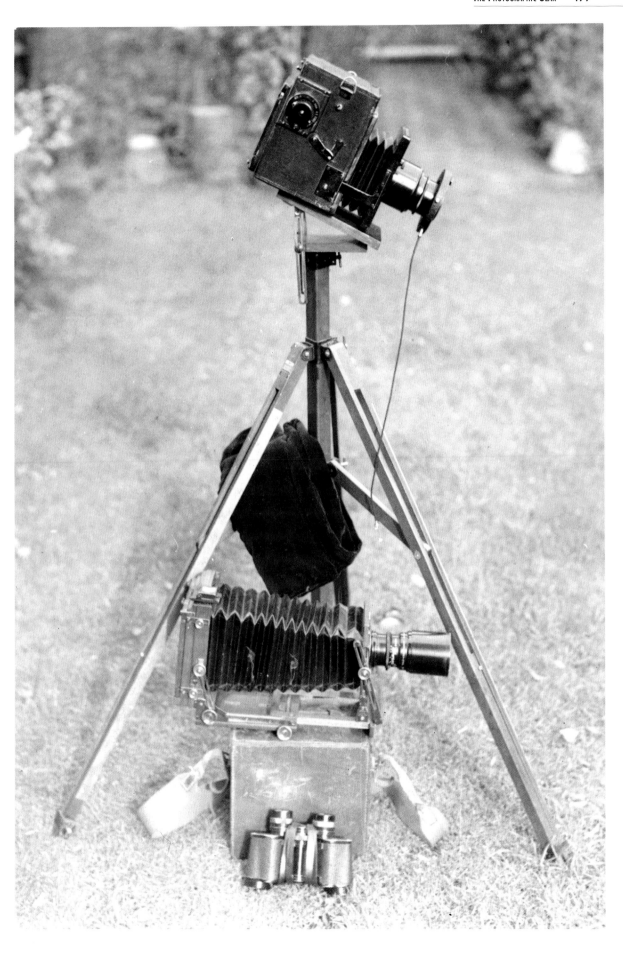

usual today. Most photographers favoured lenses of 8 to 10 in. focal length.

The 'Luc Shutter' often referred to was a sector-bladed shutter more properly known as a 'front of lens shutter', and was originally designed for studio use. It was intended to be fastened to the front of a variety of lenses used in photographic studios, thus obviating the cost of buying several lenses, each with its own integral shutter. It had only three settings, 'Open', Closed' and 'Bulb', which were selected through a small wheel at the front. Exposure speed was entirely dependent on the degree of pressure applied to the plunger of the cable release by the photographer. The fastest exposure was probably no better than 1/40 sec., and even less for lenses of large diameter. Early nature photographers were attracted to the Luc because it was virtually silent until the final click as the blades closed after the exposure had been completed. In the field, it could not be used as intended, mounted in front of the lens, and various ingenious methods of inserting it behind the lens were invented by individual phtographers.

Reflex cameras worked in much the same way as modern 35mm single-lens reflex (SLR) cameras, but with a large mirror and a cloth focal plane shutter, with a good range of pre-set shutter speeds. Unfortunately, although in many respects they overcame the problems of field cameras, both mirror and shutter were very noisy in operation (a problem not unknown to the users of some of today's SLRs!). The viewfinder hood (there was no prism as in the SLR) shading the ground-glass focussing screen was large enough to make the camera sometimes difficult to use in a hide. Many owners ultimately locked both mirror and shutter, and used their reflex as a field camera. In the pre-war years, so called miniature cameras using the 35mm film format, and soon to be fitted with an optical range-finder, began to produce the quality of results that made

them really competitive with the much bulkier quarter-plate. Some of the photographs in this volume were produced by Eric on 35mm camera and lens systems built by world-famous optical names, then and now, particularly Leitz and the Leica, and Zeiss and the Contax, Contaflex and Contessa. Mechanically and optically advanced though these were in their day, far more development was to take place during the 1970s and after. Although Eric was intimately involved in this progress, these new generations of camera are beyond the scope of this present volume.

FLASH

The use of chemical flash powders, usually based on magnesium, stretches back at least as far as 1881 when Ernst Mach photographed, in a primitive but quite successful way, bullets 'stopped' in flight. The first natural history photographers followed suit: Lord Alanbrooke outlined some of his own experiments to Eric, mentioning the use of up to 2 lb of magnesium powder, with the accompanying hazards, first that the explosion (for that is what it often turned out to be) could set fire to surrounding vegetation, and secondly that the enormous noise and confusion generated

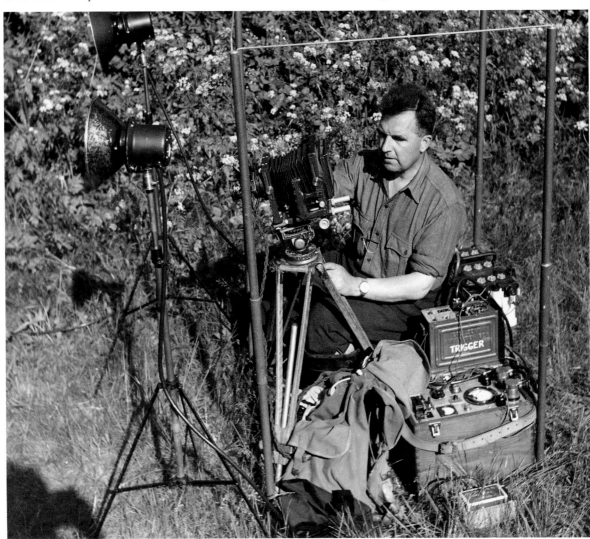

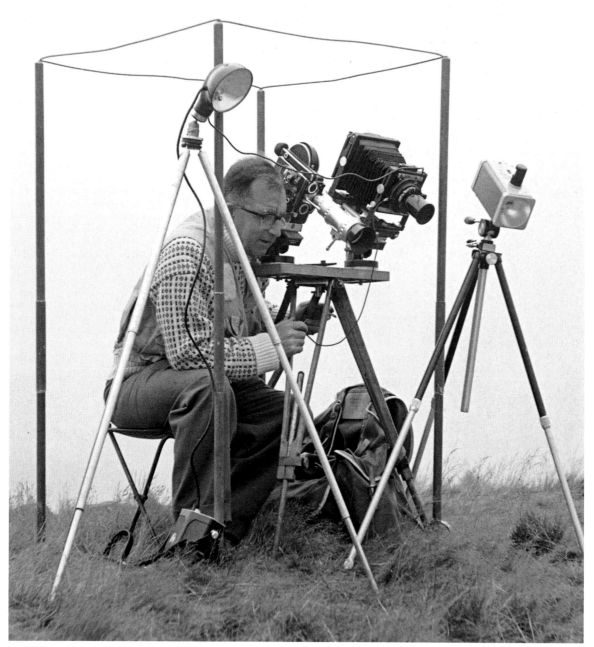

effectively meant that only one exposure could be taken each
night. The nearby wildlife needed time for its nerves to settle
before returning to normal behaviour patterns! Flash powder dom-
inated the scene up to the 1930s: despite sophistication in its igni-
tion, the burst of brilliant light generated was too long-lasting to
stop movement effectively, and the early pioneers had to modify
their shutters to cope, sometimes using two separate shutters to
minimise exposure times. It was during 1935 that GEC began to
market the first Sashalite flash-bulbs. About the size of a modern
100 watt bulb, they were filled with crumpled aluminium foil in
oxygen and gave a flash that lasted for about 1/30th of a second.
Early bulbs tended to explode sending glass in all directions but his
was soon over come by using a clear plastic covering. Although too
slow to stop any moving object, they were fine for taking portraits

and Eric tested these first bulbs on a Barn Owl with a rat in its beak, the tail blurred as it swung in its bill. Flash bulbs were to open up a whole new field of photography which was only surpassed with the introduction of electronic flash ten years later.

As an owl enthusiast, Eric kept very much up to date with developments that would allow night photography. In the 1930s, he had made contact with Dr Edgerton of the Massachusetts Institute of Technology, a pioneer researcher in the technology of high speed flash using a very brief electrical discharge in a quartz envelope containing a mixture of inert gases, usually krypton and xenon. In 1945, Dawe Instruments introduced their prototype 'portable' high speed flash. with an exposure duration of around 1/5000th of a second, which Eric considered adequate for his needs and so he was among the eager first-purchasers of this equipment.

So much do we now take electronic flash for granted, as an integral component of even the cheapest and simplest of pocket cameras, that it comes as a surprise that as recently as fifty years ago, high-speed flash was really still in its infancy. This infancy was an extended one, with many accompanying teething troubles that Eric had to endure. Its weight was one problem, the charging time

another, particularly annoying with bird photography when the time of appearance of the subject can be very unpredictable. Stuart Smith, and particularly Dr Philip Henry, modified Eric's Dawe flash considerably to reduce the drawbacks, but eventually built a unit specially for bird photography. To get adequate light onto a subject several feet away from the flashes demanded a 24-volt battery holding enough power to electrocute the photographer, and the whole outfit was also daunting in its weight, which exceeded 100lb!

After much experimentation, yielding many blank plates and head or tails only exposures of flying birds, Philip Henry also perfected the photo-electric cell and lamp trigger-beam, so effectively used subsequently for many of Eric's best photographs. This automation dramatically reduced the 'photographer errors' in attempting to time to perfection the flight path of a bird returning to its nest, or flying from temporary captivity back into the wild, though Eric was aware at the time of a hardcore of conservative natural history photographers who considered these improvements to be not only new-fangled, but also in some way improper or ungentlemanly. Even with hindsight, the many benefits, outlined elsewhere in these chapters, that the development of high-speed

flash techniques has offered to students of bird flight, behaviour and feeding, speak forcibly for themselves.

HIDES

Early natural photographers like Richard and Cherry Kearton believed that not only should the cameraman be able to see without being seen, but that the hide in which the photographer was concealed should be a life-like mimic, familiar to the subject birds. The Keartons used models of cows and sheep (and at least being expected to be mobile, these hides could move closer to their subject), while another contemporary tried a haystack. It was soon discovered that birds were comparatively undiscerning, so long as nothing flapped or made suspicious noises, and the basic hide, made of canvas or a similar fabric in the form of a small, flat-roofed tent, mounted on four poles set in a square and just roomy enough for the photographer and his gear, soon developed. With Dorothy as his construction expert, Eric quickly developed and built several hides, with the observation and photographic peep-holes in the best position. Improvements were made as experience dictated, and of course several hides were often in use at any one time, set

on the nests of different birds. Even today, photographers frequently use camouflage - like heather or bracken where it is appropriate to conceal the hide better - in much the same way as Chaffinches or Long-tailed Tits use flakes of lichen to conceal their nests.

Far more challenging than building the hide itself is erecting it in position. No piece of land is flat, no habitat simple - even the sand on the beach takes on a special hostility, usually to just one of the four corner poles. For many of his subjects, Eric (often with George Edward's help) had to pit his wits and technical skills not just against the birds, but against the terrain. Dippers, grebes and harriers, for example, demanded hides built over the water, on poles all too ready to subside, unevenly, into the gooey floor of the lake or river. Seabirds and many of the birds of prey use rocky ledges in precipitous surroundings, on which to nest, chosen for their safety from intruders, a safety dependent on inaccessibility. No ledge, Eric discovered, is ever flat, nor ever wide enough to accommodate a normal, reasonably comfortable, hide. Often, some form of subframe had to be built and anchored securely to the cliff before the hide could be erected, a demanding and often hair-raising task.

Once erected and in its final position, Eric's custom was to leave a hide unused for several days, during which time the birds became accustomed to it. Sometimes, too, it became a more important element of the local scenery. Wasps' nests were a routine hazard, but

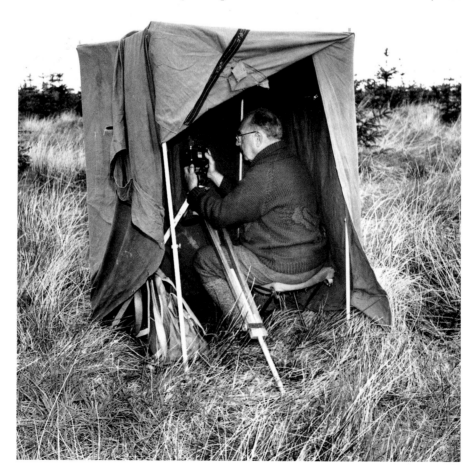

once, photographing grebes, Eric had a confiding water vole build its nest in a fold of the hessian. Fortunately the vole was fairly tolerant, and eventually removed her young, one by one, to a new nest - a fairly common reaction to disturbance among the rodents. On another occasion, a family of Grey Partridges used his hide to shelter from heavy rain, totally ignoring his presence. So much for the need for concealment!

Hides for nests in trees presented a whole range of fresh problems, not least because all too often the nest (for obvious safety reasons from the birds' viewpoint) was high off the ground. Safety for the birds, perhaps, but maybe not so for the photographer, who also lacks the ability to fly away in cases of emergency. Eric was probably among the first to develop the use of a tower or pylon hide, built on the lines of a forestry fire- or deer-watching lookout, having from experience found it difficult if not impossible to work with the hide in the same tree as the nest. His first, at a Green Woodpecker's nest at Staverton Park, was built of local timber, as were many subsequent ones, but in the search for rigidity, strength and ease of erection, Eric bought a quantity of lightweight tubular scaffolding, together with some shorter Dexion lengths for smaller hides, readily carried by car rather than by lorry.

It was very easy, inside the hide and watching your contented subject doze on her nest, for the photographer to succumb to the same temptations and nod off. In this way, many never-to-be-repeated chances have been missed, but not by Eric, whose powers of concentration were legendary. He did, though, encounter other hazards. Cows, and particularly bullocks, are invariably powerfully attracted to hides, and can easily demolish them simply while scratching their sides. Human hooligans, too, can cause untold damage, wilfully and swiftly. Not only that, as Eric found out himself in his smoking days, a pipe, not properly stubbed out, can cause a discomforting fire in the dry hessian many feet above the ground. Less sociable than the water vole and partridges, in the Coto Donana a Lataste's viper slithered into Eric's hide, coiled up and went to sleep between his motionless feet. Several nerve-racking hours later, it slithered away again - but Eric had kept his shutter finger in motion despite the presence of a poisonous snake.

Eric's first encounter with Lord Alanbrooke was associated with a pylon hide. A Hobby's nest had been located near Lord Alanbrooke's home in Surrey - but on private land. Eric and Tony Wootton, who had found the nest, enlisted Lord Alanbrooke's help in securing permission to take photographs. This they achieved, and set about building one of the tallest pylons of Eric's experience, 64 feet high. Nearby Wellington College and a cooperative builder and his men overcame this formidable obstacle - the work planned, in Eric's words 'like a military manoeuvre', not inappropriate in view of Lord Alanbrooke's post as Chief of the Imperial General Staff, the most senior military man in the land. It was a tribute to the camaraderie among bird photographers that this hide,

mounted at the nest of one of the most spectacular and thrilling of all birds of prey, should have been shared by at least a dozen of them, ranging from a fifteen-year-old to a Field Marshall.

Problems like this were to recur for Lord Alanbrooke and Eric in 1957 on the Coto Donana expedition. The first of Guy Mountfort's expeditions to the Coto in 1956 had encountered problems in pylon hide building because of the scarcity of local timber man enough for the job. Planning, again with military precision, for the next expedition, it was decided that the major target, the Spanish Imperial Eagle, needed Eric's duralamin tubing to build an appropriately tall hide. Lord Alanbrooke, through his Royal Navy connections, had arranged for a supply ship to take the scaffolding to Gibraltar on one of her routine voyages. Making due acknowledgement for this help in *Portrait of a Wilderness* precipitated nothing less than a series of questions in the British Parliament. Some members of the Opposition questioned the Parliamentary Secretary to the Admiralty as to the propriety of this expenditure of public funds. Stressing that such aid to overseas expeditions was part of the Royal Navy's remit, the Secretary, with help from senior (and more sensible) members from both sides of the House, was able to allay the questioners' fears after a good-humoured discussion. Hansard for 30th April, 1958 carries the full record.

EXPERIMENTS

Eric Hosking was once accused of using stuffed Cuckoos to torment small birds. This was far from the truth. The bird photographer, often confined in close proximity to the subject, has far more time, far more opportunity, and probably a far better ability to observe bird behaviour than most ornithologists, and more time perhaps to ponder the reasons why. What Eric did, with George Edwards' and Stuart Smith's help, was to explore still further, and attempt to photograph, some aspects of bird behaviour.

True, the stuffed Cuckoo came into it, but they were by no means the first to employ this strategy. Their thinking started at the end of the 1946 summer season, with the vocal and behavioural reaction of a Willow Warbler to the familiar 'cuck-oo' call imitated by Stuart, and ranged during the subsequent winter into prepared cut-outs, dummies, stuffed specimens of various 'hostile' birds and mammals, and into mirrors. Next season at Staverton Park, a Willow Warbler was photographed ferociously attacking a stuffed Cuckoo. Once the Cuckoo was removed, the warbler continued to attack the spot where it had been. A Nightingale at Minsmere behaved in much the same way, giving vent to a full range of alarm calls, recorded with great enthusiasm by Ludwig Koch.

In a subsequent experiment, George made the Cuckoo in wooden sections which as a kit could be fitted together in stages. Close to a Willow Warbler's nest, the body-only produced no reaction, nor did body-plus-tail. At the body-plus-wings-plus tail, the birds took a little notice, but only when the head and breast feathers

were added did their response become violent. Fascinatingly, however inappropriate it may seem, simply mounting the head on its own on a stick near the nest drew forth just as much fury.

The team also sought to examine the displays that in many small birds accompany the establishment of a breeding territory. Using a dummy bird, they photographed the aggression (often physically expressed) of a pair of Ringed Plovers to an intruder near the nest of the 'same' species. Attacks were often followed by threat displays, with the birds puffed out to their greatest and most dominant extent, with black collar rings particularly prominent. They also positioned a large mirror close to the nest, alert to the fact that birds will often display to, or be hostile to, their own reflections. This had its humorous side as, with mounting vigour, the Ringed Plover displayed at its image in the glass - until it moved just too far to one side and 'lost' the image that was the focus of its attentions.

Of more general interest, and photographic use, were their sessions in hides set up over small artificial ponds, often no more than a shallow tin or bowl sunk into the ground, water filled and about 18 inches in diameter. This provided ideal opportunities to photograph many species drinking, and at such a small 'pond', to witness the meetings of what seemed to be intrinsically aggressive birds such as Mistle Thrushes and Hawfinches. This very simple stratagem has a great deal of mileage left in it even today for photographers and students of bird behaviour, young and old. In total, the trio carried out several hundred such experiments, setting out their results, and photographs, in detail in 1955 in the book *Birds Fighting.*

EPILOGUE

Though not the founding father of bird photography, Eric Hosking remained at the international forefront of his demanding profession throughout his long and extraordinarily productive life. He arrived early on the natural history photographic scene, sufficiently early that where he did not actually initiate developments in equipment and particularly in technique, then he was able to be highly influential in shaping the way things progressed.

He saw, too, the many values of natural history photography early in his career. He explored to the full the use of photographs as an illustrative medium for the printed word: as an invaluable aid to education, to bird identification and to the straightforward enjoyment of birdwatching. He applied photography as an integral part of scientific ornithology, dealing with topics as diverse as ecology, conservation and behaviour. His was one of the major roles in establishing birds in the astonishing prime position that they enjoy in the public eye today. His camera made available to a huge public both the grandeur of the spectacle of birds in wild places and the intimacy of their behaviour at the nest.

His career spanned a continuing series of developments and improvements in the camera, its lenses and other accessories, and in film stock, a progression that each generation in its own time would have considered unattainable if not simply unthinkable or unbelievable. Each succeeding generation, however, quickly accustomed itself to the advances in technology and soon regarded them as everyday. Eric's career covered several of these generations, and among his paramount achievements was the ability to accept development, swiftly but not without adequate thought and testing, and then to encourage further improvement along lines suggested by his wealth of experience. He was masterly at adapting his own techniques and skills to exploit to the full the advantages of the fresh opportunities on offer. To the end of his life he was a dynamic driving force, encouraging still further improvements in equipment and in the exacting standards of photography, and photographic behaviour, demanded by natural history subjects.

INDEX